CHILDHOOD *on* FIRE

My Journey from the Hell of Baltimore to High Water

TALISHA HUNTER, MSN, RN

ISBN 978-0-578-73824-6

Book cover and layout design by Iskon Book Design

CONTENTS

FOREWORD

F OR THOSE OF you, like myself, who make it my life's mission to pursue substance and meaning, who seek to understand God's plan for me in this world as deeply as possible, and who can use that understanding as the most powerful tool on earth for doing battle with those dark forces that seek to prevent me from being and becoming my best self, this book is an absolute "must-read."

Like many of us, I came to know this vibrant and powerful author through what we often call "happenstance," when in fact we must all know and take to heart that nothing happens by accident. Just as this fearless woman and author loves to share her experiences and life lessons, so do I look for every opportunity to connect with my Higher Power as it makes its presence known, then seek to help the source of that spiritual inspiration convey its nourishing message. It is truly hoped that you, dear reader, will find sustenance, validation and renewal in Ms. Hunter's words, and that this literary gem will help you acquire a new and penetrating sets of coping skills that will empower you to fulfill your purpose here as well.

Ms. Hunter's personal encounters with destructive forces, and her firm and uncompromising decision to share her challenges, failures and triumphs, will uplift, motivate and change the reader in many remarkable and sustainable ways. The author's head-on collisions with gritty life circumstances will captivate you and have you sitting on the edge of your seat, rooting and cheering for our heroine as she takes you on a spiritual journey that begins in childhood, wends its way through her troubling adolescence, and finally offers you a close-up look at her spiritually mature and dedicated adult existence.

You will learn, as you travel through time with the author, how to develop a lasting and all-encompassing approach to dealing with life on its own terms, and to rise each day and be thankful for the tools and skills you have acquired on your journey. You will come to realize that your potential is far greater than perhaps you ever suspected, and, most of all, you will discover that self-interest, while all-consuming when young, can ultimately be cast aside in favor of a far more rewarding and satisfying life that focuses on the needs of those around you. You will learn that it possible to break the chains of depravity and live in a world that holds great promise. I invite you to engage in this journey with Talisha Hunter.

DR. NEAL BLAXBERG
Baltimore, MD

CHAPTER ONE

Desolation

S HE WANTS NOTHING more than to give love and to be
loved unconditionally.

Talisha is a mildly attractive woman with an even, caramel tone complexion and an average body due to her inconsistent fasting and irregular gym memberships. She's not all that tall in stature, but her 5'3" height makes her feel more lady-like. She has almond shaped eyes that, when accented with heavy black eyeliner, remind the world of her resemblance to an Egyptian goddess. Her fingernails are never a day late from a well deserving manicure. From the outside, she's a well put together middle-aged woman, but that's only on the surface.

"H.J., where are you heading at this time of night with all of your belongings?" uttered a soft, unassuming voice. It was Talisha's mother. She'd been watching Talisha's father pack a small, worn suitcase that was handed down to him from his daddy, Harley Sr.

Talisha's mother wasn't particularly surprised that this day had finally come. Her family lived in a small part of Corona, Queens, and, back in those times, black families lived in close proximity to

one another. Her father's side of the family lived one block from their now broken home, and her mother's side lived one block in the opposite direction.

"H.J.!" she growled, more roughly and in a harsher voice this time. "I guess you movin' in with her now that she's pregnant, huh?"

Tears flowed steadily down her mother's face. The only man she ever knew was leaving her to survive on her own, with four small children. "H.J.! What am I going to do with these kids of ours? With this place? I have no job. Heck! I have no schooling. Please, don't do this to me, to us, to the kids, H.J!"

H.J. slowly turned to face this broken, brittle woman, the lady he'd once called wife, lover. "It's over," he said. "I suggest you move out and go stay with Ms. Sumby."

Diane stood still in front of the doorway, clenching her heart, as if someone had just stuck a sharp-edged dagger in it. She didn't know if she was truly feeling love's first heartache or if she was having a heart attack. She just stood there, speechless, gazing up at this most handsome man who slept beside her every night for the past fifteen years. She couldn't help but notice how his black wavy hair, parted on the side, was brushed just enough to highlight his perfectly arched brows. She thought of how she would gently stroke his hair at night, the memory flashing painfully across the landscape of her mind. She dropped to the floor, clutching onto one of his legs, and began to sob uncontrollably.

"Get up, woman!" he yelled. "You are making a fool out of yourself with all this fussing and carrying on. I done told you repeatedly, I don't want nothing else to do with you. We had our time and it's over." H.J. broke free from Diane's grip and walked out the door, slamming it shut behind him, a devastating exclamation point highlighting his departure. This was it. The world that Talisha's mother had built for herself and family, year after year, brick by brick, had come crashing down in a matter of minutes.

These backstabbing wenches, she thought to herself, while desperately trying to locate her pride, forlornly laying on the ground where her husband once stood. She dragged and crawled her way back into bed, like a victimized dog set free that turns back, missing its captor. She was in denial, but had to pull herself together for her own sanity and for the sake of her children. She struggled to find strength. When H.J. left, he took not only her pride but pieces of her with him as well. Her mindfulness was gone. She couldn't remember to wake the kids or prepare a meal for them to take to school. Her focus was shot. She could hardly see a few feet in front of her, eyes blurry from days of crying. Even her appetite left with H.J. when he walked out the door on that fateful day.

Her ability to feel anything abandoned her as well. She often found herself wearing a winter coat in the dead of summer. The sun never felt so cold, and the night never seemed so long. Talisha's mother thought she would never survive without HJ, and she appeared to be succeeding in this terrible feat. She slowly lost her sense of self, gradually withering into nothingness. She hardly showered, ate, or showed any interest in anything anymore. She was dying inside.

One evening, Talisha's grandmother, Ms. Sumby stopped by. This firecracker of a woman, originally hailing from Kingston, Jamaica, stood five feet even and weighed in at a sturdy 140 pounds. She wore layers of clothing even during the hottest months, and walked and talked like a Caribbean warrior. She had migrated to the States when she was in her late teens and married young. Back in those days, it was normal for a young girl to marry, especially if she was with child, which according to whispers from lips to ears, was exactly what had happened. Ms. Sumby got herself knocked up with a mysterious man, the lips whispered, his name was Clarence, and he was from the South. Diane never knew this mystery man, her father. There were no pictures of him. Every now and again, Ms. Sumby would describe

him, but as time went by, she grew weary of his remembrance, and eventually refused to even mention his name.

Talisha's mother used to fantasize about her father. She would imagine that he would come running back home and tell her this story of how he joined the military to make something of himself, or that he left to start a business and now he had an abundance of wealth to share. That would be surprisingly pleasing to Talisha's mother, especially right now. Her thoughts would be interrupted by a knock at the door.

Talisha's mother quickly jumped up, hoping it would be H.J. Her heart began to flutter. Her eyes were wide open, and she felt a glimmer of hope within reach. She thrust the door open, but before she could say H.J., Ms. Sumby pushed her way in. "Wat ya doing wit pajamas on fir, gal? It's tree o'clock and ya lett'n the day get away, eh? Go on and clean ya self. Me will fix up some stew chicken and rice for me baby gal and pickneys."

Ms. Sumby first prepared a small pot of dark roasted coffee. She literally drinks coffee from sunrise to sunset and even when she stares outside at the sky on moonlit nights. She is a true Caribbean woman. She drinks her coffee black. She's also a smoker. Ms. Sumby can smoke a pack of cigarettes in an hour and have the entire place looking like a voodoo room. She always smelled of peppermints and mothballs. This was Ms. Sumby's way of masking the atrocious odor linked to drinking black coffee and chain smoking.

"Cha! Ya ain't got no chicken or rice for me cooking," Ms. Sumby yelled loudly across the small space in the apartment. The neighbors could hear every word. "H.J. ain't give ya any money for me pickney's food? Me will fix dat bumbaclot!" Ms. Sumby always seemed to have just enough money, and for almost any occasion. Talisha's mother thought that perhaps her father was wealthy and, when he left, Ms. Sumby inherited a small fortune.

"Me be right back," explained Ms. Sumby, then quietly shut the door. Not more than an hour passed when she returned, and she had

in her possession a whole chicken with the feathers still attached. One by one she picked the feathers off. With each plucking, Talisha's mother wrinkled her nose and backed away.

The family ate dinner that night. The kids were famished. Each one inhaled whopping seconds. Ms. Sumby cleaned up the place and tucked the children into bed. She encouraged Talisha's mother to walk down to the welfare line first thing tomorrow morning, but the proposal came too late. The next morning the landlord arrived with a court notice of eviction. H.J. had been gone for months and Talisha's mother hadn't paid one red cent in rent. The family didn't have much furniture or clothing. Talisha had the most items, as she was on the receiving end of her sibling's clothes and toys, passed down over time. Ms. Sumby saw what was taking place from her upstairs window and quickly came over to console her daughter. "Don trouble ya self. Ya and ya pickneys can come stay at me house. It's big 'nuff for all yaz."

Talisha's mother and her children took what they could with them and moved one block over to stay with Ms. Sumby in her two-story end house, complete with a basement. No one has ever seen the basement because there were no steps. There is a cellar around the back of the house that leads into the basement, but it is tightly sealed with a 3/4 inch, double-loop jack chain and master lock. Ms. Sumby is of bizarre character to say the least, but her heart is in the right place for now.

Talisha's mother assumed her position at the vestibule of the house, sitting on a half charred, paisley print sofa next to the front door. She was a faithful woman, and was still yet hopeful that H.J. would return to her. Folks in the neighborhood believed she was too faithful, waiting for a two-timing adulterer, unashamed to have extramarital affairs, then leave his family to start another one. H.J. was an audacious and unsympathetic scoundrel, daring to move around the corner from his former home and take up residence with his mistress. He never returns to visit, to offer a portion of his paycheck,

or to drive the kids to the local diner for their favorite ice-cream float. Every now and again, neighbors would see the pair together shopping for groceries up toward Junction Boulevard. It's a good thing Ms. Sumby hasn't had the pleasure of meeting this woman who set her daughter's world ablaze. Ms. Sumby might be short, thin and old, but God knows she was as strong as a wild boar!

The days were shortening and the nights were getting longer and colder for Talisha's mother. She remained stuck in the same emotional and physical state. She was suffering from complicated grief, the predictable result of losing her husband. With each passing day, Talisha's mother felt as if her heart would stop beating at any moment. She couldn't take it any longer, and began to morbidly contemplate how long it would take for her to die. She had stopped eating and drinking. The little bit of pee that she let out was just enough to keep her from expiring. Nor did she talk much anymore. She just sat there, day and night, with a glazed over facial expression, wasting away, now just a shell of her former self.

Ms. Sumby had grown tired of lecturing her daughter. She would just walk by Talisha's mother, drinking her coffee, piping away on her packs of cigarettes. She tried forcing Talisha's mother to eat, but it was no use. Ms. Sumby was ambivalent when it came to Talisha's mother. Some days she felt Talisha's mother was just too weak. She wished she would've raised her back in Kingston, Jamaica—fed her real Caribbean food, and let her grow up around the natives, so she too could become West Indian strong. But then there was remorse. Ms. Sumby felt sorry for Talisha's mother. Ms. Sumby knew what it felt like when a man showers his charming words and spends most intimate nights with another. Ms. Sumby wanted to wrap her arms around Talisha's mother, but she couldn't bring herself to commit such an act of acceptance. To Ms. Sumby, Talisha's mother's behavior was unacceptable, and coddling her at a time like this would support Talisha's mother's decision to go on this extended strike as she

attempted to end her life. Therefore, anything outside of checking to see if Talisha's mother had a pulse and that she was still breathing wasn't going to happen.

As the sun drew near, spring was settling in again. The air was slightly crisp, yet just a bit warmer on the skin. The birds began to nest and chirp. Bees were swarming about, looking for the brightest yellow dandelions to pollinate, popping up overnight as it were on newly sprouted grass. It was the time of renewal for all things. But for some, that rebirth never came.

Talisha's mother remained fixated on her hope that H.J. would return. She was trapped in inconceivable ambition. The thought of what H.J. would say when he saw this once beautiful woman who had now morphed into flesh and bones, morbidly consumed by deep sorrow, great despair and self-pity, left her hapless and bereft. Surely she was supposed to get over H.J., move on with her life, and find another man to parent her fatherless children. Why couldn't she extract herself from the vestibule? What was holding her back? Was there an invisible force preventing her from living again? Was she cursed by H.J.'s mistress? Where was her vitality, her zest for her life and her kids?

Meanwhile, as Talisha's mother continued to shrink into nothingness, H.J. filed for divorce. It went uncontested, and was easily finalized within a year. H.J. remarried shortly thereafter, as one might expect. Folks in the neighborhood talked long enough about the affair, so H.J. thought he'd quiet the talk around town by marrying his next favorite girl. Little did he know he would turn up the flame on hellfire spoken words about him and his new wife. Whispers grew to talks, talks grew to stirs, and stirs grew to downright close encounters with wives suspicious of their husbands. H.J. and his new wife moved to Brooklyn and as suspected years earlier, H.J. was fathering another child—this time it would be twin girls. The news got back to Ms. Sumby no sooner than H.J. had packed his

last bag, and she was furious! "Me poor chile!" she exclaimed. "Lord knows, him tryin' to kill me baby gal." Ms. Sumby was on the war path. H.J.'s irresponsible and callous nature, coupled with Talisha's mother's slowly decaying body and those four pitiful children, were taking its toll on Ms. Sumby.

Desperation

━━━━━━━━━━

I T WAS NOW late May, and classes were coming to an end. For most children, this was a time to celebrate. Involved parents planned all year for fun and exciting trips for their children as a reward for their passing grades. Many kids were going away with their families on vacations or to summer camps, and those children staying home had plans to attend amusement parks, local zoos and aquariums, but Talisha and her sibling weren't afforded the same end of school year luxuries. There would be no splashes at the pool on hot summer days, bike riding with friends, or scary roller coaster rides at the nearest Great Adventure amusement park. The end of the school year for Talisha and her siblings also meant no more free meals. Talisha was the youngest of her three siblings. She lacked all foresight when it came to the implications of school closing for the year. For Talisha, the end of classes was just like every other day, but for the much older siblings, the end of the school year had just turned into the start of their worst nightmares.

Tasha was Talisha's oldest sibling. Talisha's mother was exposed to the rubella virus when pregnant with Tasha, so Tasha was born deaf and mute. The saying that when one loses one sense and gains another is quite remedial on the surface. Tasha was far brighter than all her siblings. There wasn't a puzzle she couldn't solve in record time

or book too challenging to read. Tasha was also the most daring. She looked forward to the thrills of elevator rides to the highest floor of New York's tallest structures, just so she could daydream about flying in the clouds. If it wasn't for her hearing impairment, Tasha would have been an astronaut or fighter pilot in the military.

She attended the New York School for the Deaf in White Plains, New York. It took her two hours on the bus to get school every day, and regardless of her limitation and time travel, Tasha persevered. She had big dreams of rescuing her family. She was under the impression that her father's absence was purely due to financial strain. She believed that once she finished school, went to college and obtained a well-paying job of her liking, H.J. would return to cure Talisha's mother, and the family would be complete again.

Having to go through the problems the children face is one thing, but it was another thing to go through such atrocities in a world of silence. Tasha was missing the occasional head nods and eye contact that let her know that her actions were pleasing. She yearned for the heavily fragrant, home-cooked meals that reassured her of the peace and harmony within the home. The gentle caress and touch across her hand was also a thing of the young past. In substitution of all comforting measures loomed nothing more than a cold house, now considered home. H.J. was across town with a newly developing family, Talisha's mother was stuck in her own mind, Ms. Sumby was perched at the attic window, chain smoking and sipping black coffee, and the children were left to figure things out. Tasha realized that summer was swiftly approaching and didn't want to lose her grasp of time. She brainstormed later that night and decided the first thing she must do is bridge the communication gap between she and Talisha.

Tasha woke the next morning to the acrid odor of burnt food. Talisha was in the kitchen attempting to make breakfast. She got everything right, except for the food goes into the frying pan. Tasha couldn't believe what she was seeing beyond what she could smell.

Talisha was caked in flour. If there was a prize for a circus act, Talisha would be the star winner for a clown. Egg batter was dripping from the frying pan onto the floor. The handles had more margarine on them than the actual pan. *What a mess*, thought Tasha. She gestured with a few grumbling sounds from her mouth for Talisha to get out the way. She thought to herself that she didn't want to start her morning cleaning up after Talisha. She had other plans.

After cleaning up Talisha's concoction of inedible food, Tasha wrote down on a sheet of paper that she would teach Talisha sign language. Out of all the siblings, Tasha was Talisha's favorite. The two were vastly different in age and had dissimilar interests, but Tasha was more compassionate to Talisha than the other siblings. Matthew was Talisha's brother. He was two years younger than Tasha, the only male child, and very disciplined. He often scolded Talisha about her curious child-like explorations, which confused Talisha about their brother-sister relationship. Then there was Keisha. Keisha was three years younger than Matthew and eight years older than Talisha. Keisha suffered with an unjustified youngest child syndrome. Up until the birth of Talisha, Keisha was the coddled child. Expectations weren't set too high, so Keisha was praised for just about anything. She and Talisha didn't get along. If Keisha had her way, she would have abandoned Talisha at the hospital. She often teased Talisha and told her that she was found under a rock, and it certain that Keisha's insensitive words would frequently ruffle Talisha's feathers. It didn't matter, though, how much Matthew or Keisha displayed their disdain to Talisha. Talisha had her mind set at a young age that she loved her family unconditionally despite their emotional shortcomings.

"Grrrrrr," Tasha called out to Talisha. "Grrrrrr." Talisha came out the bathroom from changing her clothes and ran up to her big sister. "Yes," says Talisha. Tasha holds up a sheet of paper that read, "I am going to teach you the alphabet in sign language." Talisha was overjoyed! She recalled how she used to sit Indian style on the floor, in

the living room at her former home, watching Tasha and her friends communicate in sign language. When Tasha and her friends would sign, it always seemed so exciting to Talisha. Talisha would jump right on in, pretending she was signing with the group.

Tasha stuck out a closed fist, with her fingers folded towards her palm, and her thumb straight up, on the outside of her fist. She wrote down the letter "A." Without moving her hand, Tasha opened her fist, raised her fingers straight up, and placed her thumb across her palm. Next, she wrote down the letter "B." Nearly an hour passes before Tasha realizes she had shown Talisha the entire alphabet in sign language. Talisha's eagerness and sponge-like personality allowed her to breeze through. Talisha was always expecting more. One plus one couldn't have just equaled to two. Talisha believed if she stared at the equation long enough, she would crack the code that everyone else missed. Every now and again, Talisha would make a few mistakes signing, but Tasha expected this to happen. Tasha stopped writing down her words on paper. She forced Talisha to sign, understanding that once Talisha mastered the alphabet in sign language, Tasha would then teach her words in sign language.

There were times when Talisha was feeling too lazy to sign and then there were times when she had more than a few words to say to Tasha, and just didn't feel like signing one alphabet at a time. Talisha would write down whatever she had to say anyway to present to Tasha. Tasha was definitive in her decision. She would refuse to read what Talisha wrote down, forcing Talisha to sign, and doing so angered Talisha.

"Fuck you, bitch," exclaimed Talisha. The intensity of Talisha's emotions began to surface. Talisha turned to walk away from Tasha when a strong force grabbed her arm from behind, and she was faced with a roaring voice.

"What did you just say?!" It was Talisha's brother, Matthew. He had been in the next room, preparing for work when he overheard the

unbelievably explicit language coming from Talisha's mouth. Matthew had acquired part-time employment right away at the local grocery store. He applied for the military but was told he couldn't enlist until his eighteenth birthday. He worked overnight stocking food supplies and items and, most times, he found himself too tired to go to school, so he traded his high school diploma for the equivalency—a GED. "I won't ask you again. What did you just say?" Matthew was growing angrier by the minute. Talisha had never seen her brother this mad. She couldn't understand why those three unintentionally spoken words that her sister couldn't hear anyway bothered Matthew so much? Well, Talisha wasn't going down without a fight. "Let go off me," demanded Talisha. "You're hurting my arm," she cried. Matthew retorted, "You're not going anywhere until you apologize."

Tasha re-entered the room and saw Matthew sitting at the kitchen table, with a visibly angered Talisha in between his legs, and one arm behind her back. Tasha walked up to the pair, with her arms stretched out, asking what had happened. Matthew shouted, "she cursed at you!" Tasha looked down at a remorseless Talisha and walked away, escaping to the opposite room. To get her sister's attention, Talisha began to throw a wild tantrum, but the more she whined and put up a fight, the stronger Matthew held onto her arm. It felt like hours had passed, but Matthew had only been grasping Talisha's arm for a little less than five minutes. "I have to be at work pretty soon. You'd better not make me late for work, so say "sorry!" Talisha looked up at Matthew. She noticed his increasing anger and reluctantly responded, "sorry."

Matthew released Talisha's arm and hurried out the door for work.

Talisha ran toward the front vestibule, bypassing Tasha, and sat near her mother. This was Talisha's first time noticing the enclosed walls to her mother's self-confinement. Ironically enough, the room was such a mirror projection of her mother's state. The vestibule was hollow, and the walls were painted with a fading mint green color. The entirety of the painted wall had chipped away so much that it

looked like falling tear drops, and it wreaked of lifelessness. Low muffles of chanting re-focused Talisha's attention. She pivoted toward her mother and noticed how the once beautiful, well-groomed and vibrant woman was now cachexic, malodorous and virtually lifeless, nothing more than a mannequin. The sight of her mother's condition frightened Talisha. She ran back inside the home.

Family and friends didn't visit much anymore, and Ms. Sumby had grown weary of her family's extended stay. She had little to no privacy. The quiet walls were filled with arguing and bickering. Her savings were depleted, and all she had left was some spare change in her coin purse, which turned out to be mostly pennies. The children went to bed many nights without eating. If the house remained quiet long enough, the grumbling from their empty bellies would ring in the air. The children were becoming desperate.

Tasha found herself at the mercy of friends. Every week she was asking someone for help. She didn't ask for much. All she required was weekly bus fare and her favorite one meal a day—a box of Chinese rice with a pack of soy sauce, and orange juice. She survived on that regimen, up until she fell ill. Tasha began missing days from school. Her symptoms were vague and didn't mimic anything she'd felt before. Some days she'd felt sick on her stomach and just too lethargic to do much of anything. She was also losing weight, as if she could afford to lose another pound. Tasha attributed her acute illness to infrequent and unhealthy meals. She believed that if she ate more of the right foods, she would be able to redefine her health and bring her body back into equilibrium. She never thought about seeking professional guidance from a physician, and if she did, she simply didn't know where to start.

Tasha's condition worsened with the passing of days. The once tightly knit family had now scattered into survival mode, and didn't even seem to notice. Tasha has been in the family room for days, the small space positioned behind the front vestibule. There was one

couch in this room that Ms. Sumby decorated in plastic covering. Tasha and Keisha shared the small space and the couch. Luckily, Keisha has been gone for a few days, affording Tasha the entire couch and room. Tasha missed her own bed. She missed her family. Most of all, she missed her old healthy self. She thought to herself whether death would come overnight and swoop her away while she lay across the neatly laminated sofa. She wasn't sure what death felt like, but if she had to speculate, she strongly believed this to be it. Up until now, no one had wondered why Tasha hadn't left the room or attended school. It was beyond evident that the children were in survival mode, and that self-preservation was their first and only strategy. They were surviving through psychological warfare. Every day they were faced with crushing pressure from being thrust into a premature adulthood, which had insidiously altered their personalities and shaped their faith. Tasha thought to herself that, if death was coming, she must be prepared to ward it off. She mustered up just enough strength to get up from the sofa, then walked to the bus stop. Tasha was going to the hospital.

Keisha rarely stayed at the house. She spent her time with her friends, hanging in the streets. She felt that the streets gave her more love than what she received at their new home. The only time she came in was to grab a new change of clothes. Then she would take off again to be with her friends. Keisha always off-loaded the responsibilities to Tasha and Matthew. She wanted nothing to do with her family. She had developed avoidance behaviors and detached herself emotionally from what was going on around her. Keisha was aware of her behaviors. She believed that staying away was the best recourse when it came to mental and emotional protection. After all, she didn't want to be next in line for a breakdown. To ensure the reality of her waking life didn't pervade her psyche, Keisha self-medicated with recreational drugs. She began smoking cigarettes, drinking beers, and occasionally sneak a puff of marijuana. Folks in the neighborhood considered Keisha

to be this lawless rebel without a cause. They were always gossiping about the family, pretending to care about what happened, and when the family came up for discussion, Keisha was at the focal point of condemnation. Keisha couldn't go too far in Corona without folks staring. Before she knew it, what she was running away from inside had found her outside.

Tasha finally made it to the hospital. When she arrived, the ER nurse took one look at her and immediately took her into a back room. Her vital signs were critical, and she was dehydrated from fluid loss. The ER doctor was called back and performed a brief assessment. He ordered the nurse to start IV fluid replacement stat, and to draw blood. Meanwhile, Tasha wasn't feeling any better. She was curled on her side, in a fetal position, watching the IV fluid drip down into her veins. She was having racing thoughts now. *What will the tests show? I probably have a stomach bug that overstayed it's welcome. If it's a bug, the hospital can give me something to kill it, and I'll be well enough by morning to go to school. I know I will have so much catching up to do with schoolwork. Plus, I want to teach Talisha some new words in sign language this week. Oh my God! I wonder if Talisha is okay. Keisha, please have sense enough to go home and check on our sister.*

Living in a silent world was difficult for Tasha. Most people could share their thoughts with ease. They simply listened to one another and told each other how they felt. Tasha often thought about her limitations and pondered how she was born into the same world, yet shared a different reality from most of the people she knew. Tasha lacked the self-pity gene. Perhaps losing the ability to hear what others were saying spared her the agony of self-defeat. She was always surrounded by her own thoughts, and in Tasha's world, inspiration must always win.

Tasha learned that she must remain in the hospital over the next couple of days. The ER nurse came in with a paper stating that the doctor wanted to run more tests, so Tasha would be staying there for

a few more days. "Someone will be here shortly with a gurney to take you to your room, okay?" Tasha slowly nodded her head in a "yes" manner. She wanted to ask questions but lacked the energy to get up and write, so she closed her eyes, and went back to her world of silence. The ER nurse left the room and headed back to the nurse's station. She called for a gurney while reflecting on the young girl she just left. The baseline test results came back and were indicative of something no one expected.

Talisha was now back at the house by herself, while Ms. Sumby was enjoying her daily stroll to Junction Boulevard. Matthew was catching up on some well-deserved sleep, and Keisha was, as usual, out with friends. Talisha left out the back door and headed for H.J.'s family house. H.J.'s family lived two blocks over. Under no circumstances was Talisha to cross the great intersection of Northern Boulevard to get there, but Tasha hadn't been home, and she was tired of being alone. Besides, Tasha taught Talisha about crossing at the crosswalk and looking to make sure traffic had stopped before crossing. Talisha was determined to make it over.

Talisha swiftly approached Northern Boulevard. She was walking fast enough to save her own life if needed. She did exactly what Tasha taught, and looked up at the traffic pole for pedestrians, and at the traffic light for passing cars. Once the traffic light turned red, she knew it was safe to walk across the intersection. H.J.'s family lived three houses from the corner. She walked up the stoop and opened the door to the vestibule. The second door was locked. She knocked. H.J.'s brother opened the door. "Girl, what are you doing here by yourself?" Talisha responded, "I'm looking for my daddy. Is he here?"

Talisha was always anxious to see H.J. Of course she loved her mother, but Talisha was more of a daddy's girl. H.J.'s brother laughed and said, "Girl, you know he ain't here, but momma is in the kitchen. Come say hi since you here." Talisha peeked around the corridor as she stepped into the large, dark house. A moment of peace fell upon

her as she crossed the threshold. She followed H.J.'s brother down the hallway into the kitchen, where the familiar aroma of home-cooked food tickled her nose and delighted her senses. Talisha stated, "something smells like chicken." A tall, dark-complected woman with a moderately, sharp facial expression approached Talisha. She looked down at Talisha, acting as if she didn't recognize her own kin. "This H.J.'s child?" Talisha was making her way to a lightly golden, crispy piece of fried chicken. "Can you take me to my daddy?" She stuck out her arm to grab a piece of fried chicken but felt the sudden sting of a wet kitchen towel. Pop! "Where's your manners, chile? You don't come busting your way in folks' house, grabbin' on food with dirty hands, lest you ask first!" A shocked Talisha just stood there, holding her empty hand. She didn't know if she should run in the opposite direction or behave with good manners she forgot she had.

"What's wrong with you, woman? This is blood. Can't you see the chile is famished?" A thinly built, well groomed man with a gigantic smile walked in the kitchen. Talisha turned around and almost jumped for joy. The resemblance was uncanny. It was H.J.'s father. "I bet your favorite place is the diner," H.J.'s father said politely. "I'll take you to get a sundae and then take you to H.J. right afterwards. Deal?" Talisha exclaimed, "Can we go now?" H.J.'s father bent down, still smiling ear to ear, as if he had just won the lottery. "We sure can. Come on."

H.J.'s father kept his word and took Talisha to the diner on Astoria Boulevard. Talisha was certainly enthralled by the kind gesture, but deep inside her soul, she was yearning for H.J's attention. After wolfing down a scrumptious, triple-decker ice cream float, H.J.'s father drove Talisha to Brooklyn. Talisha had never been outside of Corona; her world was contained within a ten-block parameter. She was curious about almost everything her eyes could see. Her vivid imagination carried her inside the walls of the city's tallest structures. She then became captivated by the glaring lights from the sun settling in. There were people everywhere, occupying as much space as the sidewalk

allowed. Then Talisha saw something she'd only seen on television and her heart began to pound. They were quickly approaching the Brooklyn bridge. She wondered if they were taking another route. Is this the only way to H.J.? She recalled a Saturday episode when Godzilla attacked a bridge. She suspected that at the very moment of incline, Godzilla would leap out from the murky waters and destroy the bridge, preventing her from reaching H.J. "Here we go," she thought to herself. She tightly closed her eyes, fearing this unbelievably enormous reptile was near and as she opened her eyes, fearing that Godzilla was on the cables of the bridge waiting to bellow, she noticed they were already off the bridge. "I am so glad Godzilla didn't get us," thought Talisha. She revisited the scene of going over the bridge. This time Godzilla surfaced from the water, attacked the bridge, and cars began to plunge into the water below. She imagined H.J. appearing out of nowhere and ushering her to safety. "We're here." Talisha left the fantasy world momentarily, returning to reality. Talisha hadn't seen H.J. in months, and was so excited. She promised herself she would give H.J. the best and biggest hug ever! This way he wouldn't want to let her go again.

H.J.'s father rang the bell. It was an old buzzer loud enough to wake the dead. A woman with a head full of luxuriant curls opened the door. Her eyes were soft, and she was wearing makeup, just enough to enhance her already stunning features. Her smile was camera worthy. "Hi, Mr. Brown! What a wonderful surprise. Please come in," uttered the soft spoken woman. "And who is this lovely person?" H.J.'s father looked down at Talisha and said, "This is his baby girl." He coughed. "Pardon me," he smiled, "This here is Talisha. She is the baby girl from his prior marriage." The woman smiled and nodded, as if the two had rehearsed this moment. Talisha was indeed the youngest daughter, up until the new baby entered the world. In her mind, she was H.J.'s pride and joy. Now she must share that title with someone else. "Well, H.J. is still at work, but she is most certainly welcome to

stay here until he gets home." H.J.'s father thanked the woman for her hospitality and for looking after Talisha. He bade his farewell and headed back to Corona.

The woman took a closer look at Talisha. The stories she had heard were true. Talisha's mother had had a mental breakdown after H.J.'s swapping of beds and the children were on the receiving end of her misfortune. Talisha was filthy from head to toe. From the way Talisha looked, it must have been months since she last bathed and had a comb run through her hair. The woman knew if H.J. saw Talisha in this condition it wouldn't bother him one bit. She had learned of his carefree nature early in the relationship, fearing the day a more beautiful and younger woman would pry H.J. from her loose grip. This was an opportunity to test H.J.'s character. She wanted to submerge Talisha in a box of soapy, hot water and incinerate her clothes, but she wanted even more to see H.J.'s reaction to Talisha's appearance and well-being. She decided to wait.

Finally, Talisha heard a key entering the locked door and a familiar whistling. It was H.J.! He was home from a long day at work. He opened the door and never cracked a smile—not once. "What she doing here? The woman explained, "Your father dropped her off. I'm not…." H.J. stopped the woman from speaking. "Well, she can't stay here. I am taking her right back to Ms. Sumby's house." The woman attempted to interrupt. "But H.J." A hand went up. "Don't but H.J. me! I said she can't stay here." H.J. grabbed Talisha by the arm, failing to pay attention to the tears flowing down her face, and rushed her to his prized two door, heavily polished, Lincoln Continent Mark VII. The car was silent. H.J. hung his left arm out the car window while tightly gripping the steering wheel with his right arm, and scooted as far away from Talisha as possible. Talisha was drowning in her tears, and globs of copious mucus ran from her nose. Why was H.J. so cruel to her? He used to come home from work, tired and grumpy, but one look at Talisha made him

forget about being yelled at all day by his boss. H.J. was speeding across town, thinking how his father was so stupid to hand deliver this unwanted child. Was it not crystal clear the day he left that he wanted nothing to do with his past? H.J. had moved forward and everyone else needed to do the same.

H.J. pulled up to the side of Ms. Sumby's house. He hit the brakes so hard, Talisha caught a slight case of whiplash. "Get out," H.J. told Talisha. A disheartened Talisha slowly looked up at this person she used to call "daddy" and protested. "No. Daddy, I don't want to go in there. Please, don't make me." H.J. sternly replied, "I ain't going to tell you again. Get out my car." The tears were streaming down Talisha's face. She looked up at the house and saw Ms. Sumby in the window, talking to herself and smoking her favorite Salem Lights. She pleaded with her father as if her life was counting on it. "Daddy, why can't I stay with you? I will be on my best behavior. Please? Don't make me go in there." H.J. was looking ahead. He sighed a few times and began landing fists of fury to Talisha's left ribs. Blow after blow was given. He was literally knocking the breath out of Talisha's lungs. He delivered one last blow that caused Talisha to wet her pants. She bolted out the car, running toward the house she had run away from earlier that day, screaming for Ms. Sumby. By the time Talisha reached the iron gates surrounding the house, Ms. Sumby was at the front door, and H.J. had sped away.

Talisha ran into Ms. Sumby's arms, shouting, "Grandma, he punched me! My daddy hit me!" Ms. Sumby took a quick glance at Talisha. There were no visible injuries, but Ms. Sumby wasn't convinced of the damage. She and Talisha walked an agonizing eight blocks up the street, marching into the 115th precinct. Ms. Sumby was furious. She desperately wanted revenge—for her daughter, for her grandchildren, and most importantly, for Talisha. She silently mumbled to herself while walking up to the front desk, "He won't get away this time." An officer greeted them. "Can I help you?"

Under ordinary instances, Ms. Sumby could hold her composure, but this wasn't ordinary times. Ms. Sumby burst out, looked up at the ceiling, and shouted, "Bring it down! Bring down the pits of hell on him head!" The officer remained stoic but attentive. "Ma'am, please calm down and tell us what happened." Ms. Sumby continued with her self-serving séance, "Me gon' kill the blood claat." Two more officers approached Ms. Sumby and a female officer took Talisha to a side bench to talk. Talisha was horribly discombobulated, her mind scattered, her eyes nearly shut from uncontrollable crying, and her pained ribs preventing her from taking deep breaths. The officer perceived Talisha was injured far beyond what she saw and called for emergency dispatch. Talisha was taken to Elmhurst Hospital. Ironically enough, this was the same hospital where Tasha was receiving treatment.

Talisha was immediately assigned a nurse and placed in a private room in the hospital. The nurse entered the room and explained to Talisha that she must put on a hospital gown for examination. Talisha nodded her head. The nurse removed Talisha's clothes, examined her body, and noticed bruises to Talisha's middle and lower ribs. The nurse looked baffled. She asked Talisha, "Were you in some sort of accident, honey?" Talisha was reluctant to speak. She didn't want anyone to know that her own father could be so vicious. No matter how much she tried not to think about what had happened, she couldn't help but relive the moment in her mind. Talisha began to cry. The nurse gently stroked Talisha's hair. "Come lay down and rest for a while. I'll have the doctor order some pain medicine to help you sleep, and when you wake, we can talk about what happened."

The nurse helped Talisha to the hospital bed and drew the curtains closed, just enough to keep a watchful eye. She later returned with pain medication and a light sedative. "Take these. You'll feel better." A few minutes passed before Talisha was fast asleep. She woke intermittently throughout the night, desiring to get up out of bed, but the sedative

effects of the medication had her drowsy. She temporarily gave up on her curious nature and fell asleep.

Talisha slept until ten o'clock the next morning. The nurses convinced the doctor to allow Talisha to catch up on some well-deserved rest. They didn't know Talisha's story. All they could gather was something awful had happened. Talisha turned to crawl out of the hospital bed, but was met with excruciating pain. A doctor and a day shift nurse entered the room, along with another woman that Talisha didn't know. "Hi Talisha. My name is Barbara Flowers. I am a social worker. I am here to help you." Talisha was still groggy from the sedative. After scanning the room, Talisha looked at the social worker and said, "Are you here because of my daddy?" The doctor and nurse exited the room. The social worker sat down across the room from Talisha. She pulled out a large notepad from her briefcase. "Why do you think I'm here, Talisha?" Talisha did not fully understand the line of questioning, nor the consequences that would likely follow. She readily answered, "Because my daddy beat me." The social worker showed great empathy. "Do you know why he hit you?" Talisha found herself on the side of justice. Just talking about what had happened was bringing her temporary relief.

"My daddy hit me because I wouldn't get out his car." Talisha answered each of the social worker's questions and provided answers to questions not asked. "Thank you for answering my questions, Talisha. I want you to know that you're a brave little girl. I'll be seeing you again when you're feeling better." Talisha was unaware of the circumstances at hand. She was a minor child to absent parents and a grandmother deemed unfit. Lawfully, under those circumstances, Talisha just became a ward of the State of New York.

Later that day, a familiar face entered Talisha's room. It was Talisha's sister, Tasha. Talisha's face lit up with joy. As quickly as she could, Talisha jumped up to embrace her older sister, holding her for minutes. Tasha had been staying on the same floor, just a few rooms

down, awaiting discharge. She had been told that she had juvenile diabetes or what the older folks liked to say, too much sugar in the blood. If it wasn't for those extra spent days in the hospital, learning how to inject insulin in her stomach, Tasha would have missed Talisha altogether. Talisha gave the social worker more than enough information to connect the dots. The social worker notified Tasha the night before of the events that had taken place. It was a last measure to see if there were any other relatives that could care for Talisha before placing her in foster care. Sadly, Tasha was very aware of what was going to happen to Talisha.

She had heard horror stories of how kids turned out when taken from their homes. Tasha had a clip board with a sheet of paper that read, "Come on, I am taking you home." Tasha had this look that reminded Talisha of times when they would sneak slices of Talisha's mother's pecan pie. Talisha looked out the room and noticed the hospital guard standing nearby. They made eye contact, then the guard looked at Tasha. The guard had been tasked with monitoring Talisha's room after all the stories she had told. Tasha walked to the elevator, looking back at Talisha, gesturing with her hands for Talisha to come on. Talisha felt as though all the events that had taken place in her life to this point were her fault. She deeply loved Tasha and didn't want any further conflict, so she allowed Tasha to get on the elevator—alone. She wished she had Tasha's courage, but the truth was, Talisha was a child. Up until the point when Talisha's mother fell into a deep depression, courage didn't exist, and expecting Talisha to suddenly develop any fortitude simply wasn't going to happen.

The social worker returned. Talisha was being discharged from the hospital that day. She took Talisha to another location within the hospital, where other children were playing. Talisha was asked to sit down at the table. The hospital's child psychologist sat down in front of Talisha. He showed Talisha a set of different pictures. He then asked Talisha to tell him what she saw. One by one, Talisha began to

identify each picture. "Well, that is a butterfly. That is a square. That is a letter W." The psychologist concluded the tests and the social worker escorted Talisha to an awaiting car, where she would be transported to a group home in Yonkers, New York.

CHAPTER THREE

Unacquainted

————

TRAFFIC WAS BAD leaving the city. What would have normally been a forty-five-minute drive turned into a ninety-minute escapade of jumping in and out of lanes. For the most part, Talisha was thrilled about the ride. She allowed her imagination to take her from adventure to adventure. In her mind, she went from being a superhero flying through the city's tallest structures, to a daring astronaut, blasting into space to save the world from disaster. Talisha had quite a contrasting fixation between fantasy and reality. The writing, however, was on the wall. Her fanatical compulsion to rescue someone else was a simply mirror reflection of her innermost desire to be saved from her own miserable fate.

As the social worker pulled up to the facility, Talisha returned to reality, temporarily putting her efforts to save the world on hold. She noticed three separate buildings shaped like huts, each in different locations. Two buildings were identical and were situated on opposite ends of the grounds, squarely positioned under a group of shade trees. The building to the far-left housed all the boys and the one to the far-right housed all the girls. There was a much smaller building for staff members that sat in between both buildings. As Talisha exited the car, two of the facility's staff members walked up. Talisha was so enthralled with the pastoral scenery that she failed

to hear their greetings. Talisha took a seat while the social worker completed her intake.

The process took about twenty-minutes before the social worker scurried out the door. Then a girl who looked to be about the same age as Tasha walked up to Talisha with a clipboard in her hand. "Hey. My name is Kathy. Let me show you where you'll be staying." The girl began rambling on with her routinely used pitch of how this was one of the best group homes in the area, and that she knew Talisha would be welcomed with open arms. She then handed Talisha a plastic satchel that contained a miniature toothbrush, toothpaste, soap, and a comb and hairbrush. Talisha was escorted down the end of the hall to the last room. "You'll be staying in here with Tanisha. Introduce yourself." Talisha turned the knob, entered the room, and walked into a living nightmare.

The door slammed shut behind her. A much older girl ordered her to, "put up or shut up!" Then someone behind her turned off the light while knuckles make contact all over her body. The beating went on for about a minute before the light came back on. The oldest girl in the bunch then grabbed Talisha by the collar of her shirt. "Listen up! I already don't like you, so every time I see you, I am going to punch you in the face, so make sure you stay far away from me. Got me?" A cowering Talisha, now crying and terrified, shook her head in agreement. The older girl remained towering over Talisha. "I said, do you got me?!" Talisha, awash in humiliation, glanced up and whimpered, "Y-y-yes."

The group exited the room, all except for one girl. She just stood there, on the neatly waxed flooring, reflecting upon the time when she was hazed by Tonya and the group. Tonya was the group's ringleader. She and the rest of the girls had lived at the group home most of their lives. Just like Talisha, the girls found themselves on the unlucky side of fate. Some were born to drug addicted mothers. A couple lived in unsafe environments and the unsuspecting friend who remained

behind with Talisha never knew her parents or family. The group made a pact that they selected who'd go and who'd stay, and if Tonya had her way, Talisha would be on the next bus back to Queens. "Get up off the floor," said the girl who was not too long ago wielding wild fists of fury. "I know that must've shocked you, but everybody goes through the same thing. You're not special, girl. By the way, what's your name?" Talisha had a trusting nature and an even kinder heart. It was so easy for her to forgive and forget people's wrongdoings. "Talisha." The girl pointed to a sheetless twin-size bed, squared against the corner of the room. "Well Talisha, I'm Tanisha. That is your bed, and this is my side of the room. Come on, get up. I'll show you around the place and where you can get sheets and a pillow."

Talisha got up off the floor with a bruised ego instead of a hurt body and followed the girl out the door.

The group was overheard spewing malarkey by the front entrance. Tonya was crouched in a chair, right by the front door, with the group circled around her. They were talking about how a girl at the local skating rink was eyeing Tonya's secret crush last week. Tanisha darted past the group, expecting Talisha to follow suit. However, Tonya stopped Talisha at the door. She grabbed Talisha by the middle of her shirt, bringing Talisha down to her eye level, and said, "I told you to stay far away from me. Didn't I?" At that moment, Tasha's spirit must have taken up residence in Talisha's body. Talisha pulled away from Tonya and landed a windmill of fists. She shouted, "Stop messing with me! I didn't do anything to you," and ran out the door and into the staff building. Talisha burst through the doors screaming, "I hate this place! Take me home! I want to go home!" One of the staff coordinators walked up and consoled Talisha. She was almost certain of the source of Talisha's frustration. For years now, the group home had been a revolving door for children passing through its halls. Year after year, the cries from former occupants echoed along the walls of the girl's dorm, and it was well understood that the group home was

a breeding ground for thick-skinned children. After all, Tonya's brash welcoming words to, "put up or shut up," followed by body blowing initiatives, usually weeded out the weak from the strong.

"Take me home! I don't want to be here," exclaimed Talisha. The staff member attempted to quell Talisha's scream, but it just exacerbated the situation. "What is going on in here?" An older woman, wearing a wig fit for The Supremes and pasty makeup entered the room. The staff member explained, "She just ran in here screaming to leave. I was trying to find out what was wrong right before you came in." The older woman was the facility's administrator. She'd been working at the group home since the doors opened and was on the verge of retiring from a half-century of service. "Leave. Is that so? Well, I guess the place is too quiet for her. I will inform her social worker."

Talisha's social worker was making her way back to the city when the call came into her office. Talisha overheard that she would have to spend the night at the facility to allow her social worker to arrange transportation and shelter, but Talisha's mind was already made up. She wasn't staying the night at the group home, for fear of what was to come at the hands of her tormentors. She would have rather taken her chances and walked home than stay at the facility another minute, so she decided to throw a violent tantrum. "That's it! I've had enough of her behavior. I will take her back to the city tonight," professed the older woman. Talisha was so relieved to get out of there. She immediately reverted to her old self. The older woman went into the back office to retrieve Talisha's file and the keys to group home's van. She grabbed Talisha's hand and said, "Let's go."

The drive back to the city was agonizingly silent. Talisha didn't mind much. She was busy picturing how happy her family would be to see her home. The older woman stopped the van. "Okay my dear, we are here." Talisha looked out the side of the passenger window and noticed that she was back at the hospital. She asked the older woman,

"Why are we here?" but the older woman just opened the door for Talisha and brought her back to intake. It was almost eight o'clock in the evening, and Talisha's social worker had left for home hours ago. Therefore, Talisha had to stay overnight at the hospital.

The next morning Talisha was visited by her social worker and the hospital's psychologist who had administered the picture tests. Before the older woman had left the hospital, she ensured that hospital staffers were aware of Talisha's behavior. She made it seem as if Talisha was some sort of wild child, when in fact, she was the victim in the situation. The social worker attempted to listen to Talisha's side of the story while the psychologist sat in the background, noting Talisha's verbal and nonverbal responses, but Talisha was at her wit's end. She was growing weary of the unfortunate events that kept happening in her short life. Nonetheless, she didn't know of any other way to respond, so she told her social worker what had happened. After Talisha poured her heart out, she expected to be embraced with warm hugs, pats on the head, and affirmations that things would be better. The social worker told Talisha that she wasn't going home and that she was taking Talisha to another group home, with fewer children, where she would stay until her court date. Talisha could not believe what she was hearing. It simply didn't dawn on her that her plan to go back home did not work.

She was confused about her family's situation, about the attack by her father, about being placed with strangers wanting to do her harm, and now she was back at the place where everything started. The social worker literally had to pull Talisha from the seat. "Come on, Talisha." Talisha got up slowly. She had to make great effort just to move her feet. She gazed back at the hospital, as if she'd died the first time there, and was now caught up in an after-life hell.

As promised, the social worker took Talisha to another home with fewer children, and these were kinder to her than the others. Talisha stayed there for less than three weeks before going to court. By that

time, Talisha's mother's side of the family had been contacted, and had traveled to New York just in time for the court hearing.

The day of court Talisha, was taken into a separate room, away from H.J. During Talisha's hospitalization, the judge had ordered H.J. not to come within one hundred feet of Talisha or he would be jailed for failing to comply with a lawful order. Talisha was told to wait in the room until after the hearings. She was unaware that Tasha and Keisha were at the courthouse, along with an aunt she had never met. Hours went by before Talisha was told that her family was at the courthouse. The last time she had seen them was a month ago. Talisha pleaded to see them. Talisha was escorted to the courtroom of the judge that would be presiding over the proceedings. Talisha spotted Tasha and Keisha sitting up front, to the right of the courtroom. She ran up to hug her sisters, nearly choking them with her embrace. Talisha was so overwhelmed by her emotions that she couldn't help but cry. She told Tasha how much she missed her through signing the alphabet, and promised Keisha that she wouldn't get on her nerves anymore and that she loved her to pieces.

Talisha then looked down the row and saw a head peeking out, looking at her. "Who's that, Keisha?" Keisha began to answer but was interrupted. "Talisha, I am your aunt May, your mother's sister." Talisha scrunched up her face with a silly look and replied, "I have an aunt?" Keisha jumped back into the conversation. "Yes dummy, and she's here to take you out this courthouse." Under normal circumstances, Talisha and Keisha would've been fighting over the 'dummy' comment, but after what Talisha had endured over the past month, she was just grateful to be around her sisters again. "All rise!"

The judge entered the room. Talisha tightly held onto Tasha's arm while Keisha poked her pointer finger into the side of Talisha's waste. The social worker attempted to take Talisha out of the courtroom and back into the undisclosed room, until Talisha's aunt Ethel asked the social worker to speak to Talisha with her siblings in the hallway,

alone. Talisha's aunt explained that she had traveled from Baltimore and hadn't seen Talisha since she was a baby, and that it was better and healthier for Talisha to be around her family right now instead of sitting in a room by herself.

The social worker agreed, aware of Talisha's misfortune. She didn't want to be the person to take away Talisha's little bit of happiness.

The family walked out the courtroom and, to their surprise, H.J. and his new bride walked in. H.J. was wearing dark black sunglasses, a button-down shirt, and a pair of dungarees. Folks presumed H.J. had been crying and probably had bloodshot eyes under his shades. The truth was that H.J. did not feel any remorse for what he had done. He reasoned with himself for weeks that this entire ordeal was all Talisha's fault. Had Talisha exited the car as he asked, he would have been at work, and Talisha would have been at Ms. Sumby's house. Talisha could not stop staring at her father as the two exchange paths. She wished that he would have removed his glasses just once, so she would have been able to see his eyes. She wanted to know if he was at least looking back at her, but H.J. kept walking by, without acknowledging any one of his daughters' presence.

Once she was in the hallway, the girls' aunt pulled the three sisters to the side and told Keisha and Talisha that once they were out of the courtroom, they should run like their lives depended on it and not to look back, even if she stopped. She told them to get on the train, and head back to Corona. She then looked at Tasha and gestured for Tasha to run. Tasha was already aware of the plan. She was trying to get Talisha back home when she was hospitalized. Talisha and her family walked out of the courtroom and did exactly as planned. They ran as fast as possible, never looking back. Tasha ran so quickly, she had to stop at each corner to wait for her sisters. Once they reached the steps of the train station, they waited a few moments for their aunt to catch up.

After a while, the sisters' aunt approached, casually walking, as if she hadn't just kidnapped Talisha from the courthouse. She handed

Tasha and Keisha a token and told them to go back to Ms. Sumby's house, then told Talisha to come with her. Talisha turned to look at her sisters as they walked down the stairs to the train station. Her heart sank to the ground, and she started to wonder why she hadn't gone with her sisters, and why her sisters left her with this person that she didn't know. A few moments ago, Talisha felt so confident that she would be on the next train with her sisters back to Ms. Sumby's house. Instead, she was now with an aunt that she had never met until today.

Talisha's aunt waved down a taxi. She told the driver, "Take me to Grand Central." Talisha timidly asked, "Am I going home with my sisters?" Talisha's aunt looked down, gave a heavy sigh, and said, "No, Talisha. I am bringing you to Baltimore with me." Unnerved, Talisha quickly asked, "Baltimore? Where is that?" Talisha had never heard of any place called "Baltimore" before.

She had no idea that Baltimore was a city almost two hundred miles away, nor did she even care if Baltimore was around the corner from Ms. Sumby's house. All Talisha wanted was to be with what was left of her family. Talisha's aunt grumpily replied, "My mother and your mother are sick! There's no one fit enough to take care of you, and you're too young to be running these streets!" Talisha began to plead that Keisha wasn't old enough to care for herself and asked why Keisha wasn't coming too. Talisha's aunt's tone changed. "Child, I already told you once. I ain't fitting to say it again." Talisha put her head down and sat in silence.

The taxi pulled up and Talisha swore that there must have been hundreds of cabs outside. She had never seen so many yellow cabs in one place. Talisha's aunt grabbed her hand and hurried her through the station. "Come on girl, we about to miss our train." The doors were just about to close when Talisha's aunt handed over their boarding passes. "Whew child. We made it in the nick of time." Talisha felt so empty inside. She didn't know where she was going, how long she'd be staying, or when she'd see her sisters again. She became numb.

The train arrived at Baltimore's station a few hours later. Talisha was tired and just wanted to sleep at this point. The pair walked up a flight of stairs to a bunch of men standing around asking people if they needed a ride. Talisha didn't know if her imagination was going too far this time or if this was a living nightmare. Where was she? The buildings looked so dull, as if she were watching an old western. She even spotted a raggedy looking horse towing a fruit cart. There was a man in the front of the horse, pulling the horse's strap toward the train station. He kept repeating, "cantaloupe, watermelon, tomato." Talisha's racing thoughts took a temporary halt. She and her aunt got into a long automobile. The door was so heavy that even Talisha's aunt had a hard time closing it. The man driving said, "Where ya headin', darlin'?" Talisha's aunt blushed and said "Take me to eighteen-o-four Carey Street." The man responded to the blushes more than the words, and said, "Yes ma'am, right away."

Minutes later, Talisha and her aunt arrived at their destination. She was a bit surprised at how short a commute it had been, and even more surprised by how close the attached homes were to each other. Back in New York, Ms. Sumby had a single-family home, squarely positioned on the end of the block. There was enough square space on the end for an in-law suite or a 2-car garage. But this place was different in many ways. Talisha began to reminisce about New York, her sisters, and her brother. She missed them sorely, and wondered if they missed her too. She whispered to herself, "Tasha, please come get me."

Once inside, Talisha's unknown expectations began to shift from nervousness into a state of calm and serenity. The house was immaculate. Back at Ms. Sumby's house, there was so much dirt and dust that Talisha used to pile it together and pretend it was a stuffed animal. Talisha's aunt's house, however, did not have any dust anywhere to be seen. There was an octagon-shaped, brass etagere in the front room with a display of various ornaments. Talisha paused

briefly to take note of one shiny object. There was a ceramic ornament depicting a woman's breast. Talisha was astonished at what she was seeing. She hadn't reached the age of maturity yet, and hoped that her future breasts were just like the ones on the shelf, a rich, deep mahogany color, perky and not gigantic like her mother's. She quickly thought about her mother and then shifted her attention to her aunt's home. Over the past few weeks, Talisha had been on an emotional roller coaster while going from home to home. She wasn't sure of what the future would hold, but she was emphatically happy to be in a clean environment.

Talisha's aunt asked if she was hungry. She told Talisha that there was tuna fish and saltine crackers on the table and that she could help herself to a few bites. Talisha then heard feet trampling around upstairs, accompanied by a croaky voice, "Ma! That's my tuna fish! How dare you give it away!" The footsteps were coming downstairs, headed for Talisha. Talisha took a gulp. Her heart began to pound, her eyes dilated, and she felt her soul reaching for the door. It was a teenage girl the color of those breasts on the etagere and the size of a small bear. Her face was complete with an unwelcoming sentiment. "Don't touch my tuna fish. My mother should've never told you that." Words fled from Talisha's mouth, "I......" Talisha's aunt walked in with a practiced look of disgust, "you know, you are just too damn greedy. You got to eat up everything in the damn house if it ain't nailed down to the floor." The oversized girl grabbed the bowl of tuna fish, gluttonously blurted out, "so what," then paraded upstairs, harboring Talisha's dinner. Talisha's aunt rolled her eyes and said, "that's my daughter, well one of them."

"My other daughter is in jail. You'll meet her when she comes home and then I have a son, upstairs sleeping." Talisha asked, "Who was that, the girl who just came downstairs?" Talisha's aunt replied "Joy," and walked away. Talisha followed her aunt like an adopted puppy in its new home. Talisha walked upstairs, skipping on each

step, just so she could hear the wood make popping sounds. Talisha's aunt turned around and shouted, "Stop jumping on the steps! Walk like everybody else." Talisha smiled, "Okay auntie." Talisha's aunt went into the front bedroom and began to shut her door. "You will be sleeping with Joy. Torey sleeps in the back room." The door shut in Talisha's face. Her heart began to pound again. She didn't want to enter Joy's room, but she was curious to know more about Joy and her new sleeping quarters. Talisha skipped into Joy's room. "Auntie said I am sleeping in here with you." Joy was reading a book in bed, her tuna fish nearby. She placed the book down, slowly lifted her head, and with a stern look mumbled, "No, you're not. You better go back to where you came from."

Talisha was the youngest of her siblings and she was still a child at heart, always looking for a fun time. She ran back to her aunt's room and banged on the door. "Joy told me to go home! She said I can't sleep with her. She said I am supposed to sleep with you." Talisha heard a faint echo from behind her. "Snitch." Joy tiptoed up behind Talisha, huffing and puffing with resentment. "Ma, why is she here? I mean, come on already, you don't say anything about this girl, and the next thing I know, you telling me she has to sleep in my bed. That's not fair." Talisha observed the seriousness in Joy's reactions. She noticed Joy wasn't playing along. She was expecting to be called a blabbermouth, a tattletale, and maybe endure a quick pop upside the head, followed by a crooked smile. Instead, Talisha felt as if she was back at the group home, standing in front of Tonya, waiting for her shirt collar to turn into bacon again. Talisha attempted to explain. "I was just playing," she said. Joy walked away grudgingly, stating, "Ma, you better get her, before I hurt her. I'm not playing with you, little girl."

Talisha heard her aunt's footsteps slowly approaching. She opened the door. An air of somberness followed her out of her room. She sighed heavily. "Joy, this is my sister's child, and not you or anyone

else is going to talk to her like that. Now, if you have a problem with her being here, you can get out, and don't let me tell you this again."

Joy slammed her bedroom door. Then Talisha's aunt slammed her bedroom door. Talisha became saddened by what she saw. She felt hopelessness fill the pit of her stomach. She was in another city and in an unfamiliar place, with feuding people she didn't know. With nowhere else to go, Talisha explored the downstairs. She found a door in the dining area that she hadn't seen earlier. She slowly turned the doorknob, making a little noise as possible. She felt that she was already in hot water with her aunt Joy and didn't want any more doors slamming in her face. Her imagination took a front seat in her mind, and she started to wonder if there were monsters worse than Joy waiting to pull her down the steps, into a large hole of bloodthirsty goblins. Maybe there was lost treasure hidden down there, and it was her job to find the map! She peeked down the steps, but it was pitch-black.

She felt for a light switch on the wall, found it, turned it on, and dared to enter the abyss. She crept down each step, anticipating that she might have to run as fast as she could back up the stairs and through the door to safety. She was almost certain that a hungry monster was waiting for her, but that it wouldn't come out until she was in full sight. Her foot touched the last step. She looked to her left, and saw an empty room filled with dust and dirt, a small gated window positioned to its far side. She looked to her right, but was unable to see what waited ahead. She noticed a light socket on the ceiling without a bulb. She desperately wanted to know what was on the right side of the basement but dared not go any further. She looked at the light bulb on the other side, hoping to briefly swap one out for the other, but the light socket was out of her reach. She decided to give up exploring and headed back up the steps. The basement door slammed. She heard a click. *Oh no!* she thought. Talisha ran up the rest of the steps. She turned the knob, but the door wouldn't

open. She began screaming at the top of her lungs, "Auntie! Auntie help me. I'm stuck in the basement!" Talisha kept looking down the steps, fearful that whatever was on the right side of the basement was about to reveal itself. She banged harder. Finally, she heard her aunt's voice ringing downstairs. "Open that damn door before I knock your goddamn head off!" Talisha heard snickering, then a click. The door cracked open and Talisha bolted through. "Torey! Get your tail up these steps," yelled Talisha's aunt.

Talisha shut the door at once, hoping to find the lock so the basement monster couldn't get her. Meanwhile, Torey was laughing uncontrollably and watching Talisha panic in fear. Talisha turned around to catch her breath and said to Torey, "That was mean." Nonetheless, she couldn't help but laugh at her own pain. After all, Torey had an infectious laugh that complimented his childlike nature. Everyone at school and in the neighborhood called Torey the class clown. He loved a good joke and even better, a good prank. "M-m-m, Ma told me you-you-you you're from New York. You aunt's C-c-c." Out of nowhere, Talisha's aunt slapped Torey on the back of his head. "Leave that girl alone. Your fat tail always doing something. You make me sick."

Talisha noticed the family's resemblance with weight. This was her first time seeing pleasantly plump people. It's not that Talisha had seen many people outside of Corona, but for the people she had met so far in life, none had matched waist sizes with Torey and Joy. She refocused her attention on Torey. She was grateful for the smile and laughs, even if the laugh was on her. She passed by her aunt, anticipating a similar smack to the back of the head, so she ducked by on her way upstairs. She walked through Joy's room to get to Torey's bedroom, and of course, she was greeted with Joy's reclusiveness. She entered Torey's room, and noticed the bathroom was the next room over. Torey had a smelly hamster in his room, along with G.I. Joe and Transformer toys. "Oh wow! You have Optimus Prime. Do you know how to make him into a truck? This is so cool."

Torey was receptive to Talisha being in his room. Unlike Joy, he was more personable and approachable. Torey was also highly observant and had a unique way of relating to people, outside of poking fun at them.

He just sat there on his bed, looking down at Talisha, glancing out his window, wondering what could've happened back in New York to make his mother return with Talisha.

Things that Were Left Unsaid

———

TALISHA FELL ASLEEP that night in Torey's bed. The next morning Aunt May woke Talisha up with what the old folks refer to as *waking someone up with lightning*. This was Aunt May's method of discipline. She would go into the chest that sat at the foot of her bed, and retrieve a wide, double-stitched leather belt, then strike her victim so fast that the belt looked as if it never left her hand. This was the waking someone up with lightning method.

As noted by generations of victims, Talisha did not know what had hit her. She just felt a stinging pain and woke up to Aunt May hovering over her, a look of disgust on her face. Aunt May screamed, "Get up out of Torey's bed! What's your problem? Don't you know you don't sleep in the bed with boys?"

A disoriented Talisha was more concerned with the intense pain coming from her legs than what Aunt May was saying. "Do you hear what I am saying child? Get up now!" Talisha jumped up out of Torey's bed so fast she fell onto the floor.

"Get your goofy tail up and get in the bathroom. Ugh!" Aunt May realized what she'd done. Talisha had gotten so scared that she peed herself.

Aunt May was relentless with her attacks. Even after she had struck her victims, remorse never set in. Aunt May called to Joy. "Joy, look

at this girl. She is too big to be pissing herself and now she got it all over the floor." Joy was eager to see Talisha's shame. She quickly came over to Torey's room, just to see Talisha draped in embarrassment. She looked at Talisha and said, "M-m-m, what a shame. Ma, now you have to clean up that mess."

Aunt May looked at Joy with her chest puffed out and said, "Who? Not me. I ain't cleaning up nothing. She's going to clean up her own mess."

Meanwhile, Torey remained still in bed like a 'gator nestled under pussy willows. His eyes were partially open, his body rigid, his breaths shallow. Torey understood that if he raised a brow, he would've faced Aunt May's belt of lightning. Luckily for Torey, Aunt May had errands to run that morning. She turned to walk away, then quickly retraced her steps. With a stern facial expression, Aunt May told Torey, "She is not to sleep in your bed ever again." Then she yelled across the room to Talisha, "Make sure you wash your underwear out by hand. I am going to Epstein's to buy you some more panties and I'll be right back."

Torey and Joy had school that day, so Talisha stayed in the house alone until Aunt May returned. Aunt May left a bowl of oatmeal on the table for Talisha to have for breakfast. Aunt May didn't know that Talisha loathed oatmeal. In fact, Aunt May didn't know anything about Talisha, outside of her being family, and to be quite frank, Aunt May didn't care about what Talisha liked or disliked.

When Talisha's mother used to make oatmeal for the family, every time Talisha would set sight on a hearty bowl of oats, she would become nauseous, nearly to the point of retching. She would tell her mother she couldn't eat the oatmeal because it looked like a bowl of slimy boogers, and that the sight of it alone made her start to drool sickly, in anticipation of hugging the toilet.

Talisha kept staring at the clock and then looking over at the bowl of oatmeal she pushed way across the table. Boredom was settling in.

It was nearing eleven o'clock in the morning, and Aunt May was still out running errands. Talisha decided to watch television while waiting for time to pass by. Aunt May had a thirteen-inch television in the dining room with an antenna twice the size of the set. There was a small set of pliers on a broken-off knob conveniently placed to change channels. Talisha turned the knob, squeezed the pliers a few turns to the right, to the Price is Right channel. She instantly felt a small twinge of happiness. The room was filled with sounds, laughter, and people cheering one another on. Then there was some small bickering between the guests with bidding, but that quickly resolved. The show was a pleasant reminder of her family back home in Corona.

Then she heard a key turn at the front door.

Aunt May was home.

Aunt May walked in, hurling insults at Talisha. "Who told your nappy head to turn on my tv? Huh?" Talisha froze up in undisguised fear. The last thing she wanted was to be at the end of Aunt May's belt again. She felt her soul leaving her body, but realized she had to pull herself together and just say something. "But Aunt May." Aunt May sliced into whatever excuse Talisha was about to conjure up. Aunt May's mind was already fixed on the verdict. Talisha was guilty. "Look here little girl, let's get one thing straight. You don't put your hands on anything of mines lest you ask me first. You only been here for a little bit, and you already got my pressure up."

Aunt May was tired from the morning's adventure. The bus stop was a few blocks from her destination and the guys offering rides were not at their post. Aunt May reluctantly walked six blocks in a pair of shoes that was a half inch smaller than her shoe size.

"You got my damn bunions hurting, girl. Shoot!" Aunt May approached Talisha with two brown paper bags. She bought Talisha five outfits, two packs of panties and five pairs of socks.

Aunt May was a corner-store gambler. She played the lottery every day, never missing a chance to play her numbers. Aunt May wasn't just

a gambler either. She was a winner. She knew exactly what numbers to play and when to play them. Her favorite three-digit numbers were two and twenty. She played the lottery last week and won five hundred dollars. When she would hit the lottery, she would never tell a soul about her winnings. She would go on with her day as if nothing extraordinary happened and occasionally, when she was in one of her better moods, she would treat her kids to something nice. Although she wasn't in the best of moods during the morning, she knew she took Talisha from New York without a stitch of clothing. Therefore, just this once, Aunt May had to share her winnings.

Talisha's hormonal response shot through the roof. She forgot that she was about to have round two with Aunt May and her leather-strapped belt a few moments ago. She was jumping up in the air, thinking how lucky she was to be with Aunt May. Talisha grabbed the two bags and started to tear up to her room, but quickly remembered Aunt May's rules about skipping and running up the steps.

Talisha was so overjoyed to receive new clothes that she couldn't contain her happiness. She couldn't wait to peek inside. For the most part, everything she ever received was passed down from her sisters. She couldn't recall a time in her short life when she had received something new.

Talisha went into the bathroom, almost forgetting to shut the door. She ripped the plastic off the packs of socks and bit the tags off the clothes. She didn't know which outfit to try on first. After admiring all the items, Talisha chose to wear an olive-green jumper with a red T-shirt, and rainbow socks. She then went downstairs and hugged Aunt May, forgetting about the morning's lashing.

Aunt May smiled back, but with a look of uncertainty. She had an inkling of excitement for Talisha, but she couldn't help to think that she had neglected to meet the needs of her own children. Aunt May's oldest daughter, Michelle, had asked for a hundred dollars to be sent to the prison's commissary. Torey had needed new pants for school

and Joy had needed school supplies. For a slither of a moment, Aunt May reasoned with herself that Talisha needs were more important.

"Talisha, what time is on that clock?" Talisha was still wearing her happiness from the purchases. She looked up at the clock and counted by fives. "Auntie, it's twelve thirty." Aunt May replied, "I want you to run up to the store and get me a bag of plain Utz potato chips. You can have fifty cents to buy something." Aunt May took out a book of food stamps and handed Talisha a one-dollar food stamp coupon. "Go on now."

Talisha walked out the front door with a glow bright enough to blind the sun. She felt all eyes were on her. She walked liked it too. She skipped all the way to the corner store and picked out the first bag of potato chips she saw. She couldn't help but pay attention to what Aunt May had asked. Talisha's attention was focused on the eyes of a young boy in the store. She wondered if he lived nearby and if he went to the same school. The boy was shy. He had noticed Talisha's piercing eyes and walked out of the store. Talisha picked out a few pieces of candy and paid for the items with the food stamps Aunt May brandished like a hundred-dollar bill. She returned to Aunt May's house, licking on her hand, so she could put the tattoo wrapper on her hand.

"Auntie, here's your potato chips." Aunt May was in a snarky mood just that fast. She was pointed and ready. "Did I have any change?" Talisha was completely oblivious to the change in Aunt May's mood. "Nope." Aunt May snatched the bag of potato chips out of Talisha's hand. "Give me my stuff girl." She then read the label and noticed Talisha didn't buy "Utz." Aunt May was locked and loaded. "Talisha! Didn't I tell you to buy me a bag of plain Utz potato chips?"

Talisha was too excited earlier to have recalled every word that Aunt May had said. Her attention had been focused on the new items and she had wondered why Aunt May was making such a fuss over the brand. After all, she had asked for potato chips and that's what she had received.

"Auntie, you said potato chips. I didn't hear Utz." Aunt May sharply replied, "Stop lying! You know damn well I asked for Utz. You're going to take your lying tail back up to that store and get what I asked for. Now!"

Talisha was visibly annoyed at Aunt May's behavior. She snatched the bag of potato chips out of Aunt May's hands. "Wait the hell one minute! Did you just snatch this thing out of my hand like that?" Talisha was growing tired of Aunt May's charade. She replied, with a little more attitude, "No, I didn't snatch anything." Talisha huffed and walked away.

Aunt May felt like Talisha was acting like a spoiled brat. Aunt May wanted to take all the things she had just bought Talisha and hide them in the closet, but she knew that method of punishment wouldn't last long. Aunt May resorted to her lesser form of discipline. She grounded Talisha to the house again for another month, and this time, Talisha lost access to her area in the basement.

Aunt May's children came home around five o'clock. They scarfed down their dinner and retired to their rooms for the evening. Talisha stayed in Aunt May's room. During that night, she felt a slight sense of cognitive dissonance. She didn't like Aunt May, but she had no other choice but to deal with her unlucky situation. She made a sleeping quarter on the floor, next to Aunt May's bed, right under the window with the box fan. It was late September. The house heated up to unbearable temperatures from taking direct heat from the unrelenting sun all day. There was only one window fan in the entire house, and it was in Aunt May's room.

Joy and Torey found themselves taking several cold baths that night. Aunt May tried to bring them some relief. She turned off all the lights and the television, turned the old window fan backwards, and left her bedroom door open.

When Joy and Torey thought Aunt May was asleep, they tried to sneak downstairs to the refrigerator for a cold drink, but Aunt May

heard the wood creaking beneath their heavy footsteps and ushered them back to bed. Eventually, Torey found another way of cooling off. He just let the cold water run in the bathroom sink for a few minutes and then placed both palms of his hands together under the running water, sipping as much cold water as his stomach allowed. But the more he sipped, the hungrier he became. The urge to have a late-night meal chipped away at him all night.

As the week went by, Talisha started settling in with her newfound family. Joy warmed up to Talisha just enough to tolerate sharing her bed, and Torey was telling everyone at his school that his cousin from the Big Apple had moved to Baltimore to stay with the family. Aunt May was especially pleasant to Talisha. The State's Attorney called Aunt May every day that week, threatening to put Aunt May in jail for kidnapping a minor and fleeing the state. Aunt May was petrified. She recalled the letters her oldest daughter had written to her while in prison, detailing jail fights, and ensuing prison lockdown.

Aunt May was tough around the house, but there was no way she could cope with a prison sentence, not even for one day. She feverishly explained Talisha's situation to the prosecutor, emphasizing how well Talisha was adjusting, and that staying with the family was the best outcome, as opposed to having Talisha exposed to different strangers.

The State's Attorney arranged for a social worker in Baltimore to review the case and ultimately decided that Talisha was in a safe environment, then closed the case.

Aunt May enrolled Talisha at school the very next day. The school was two blocks away from Aunt May's house. All the neighborhood kids around Talisha's age attended the school. Talisha jumped right in with the curriculum and after-school activities, signing up for dramatic reading, dance class and music lessons. Some of the kids were a little slow with warming up to Talisha. Almost all the kids were from the neighborhood and had grown up with each other. Talisha was the outsider. Her dialect and accent highlighted this fact, coupled

with her eagerness to impress the class with her know-it-all attitude. As much as Talisha wanted to fit in, she stood out like a sore thumb every time. This wouldn't be so dismaying if the sore thumb had been situated to one hand.

For Talisha, this awkwardness with her differences was also felt at Aunt May's house. Talisha knew she wouldn't get anywhere with being kind to Joy, and Torey grew weary of her company as well. Although she didn't have her own bedroom like Joy and Torey, Talisha received clothes, toys and gifts. Joy and Torey resented her presence, as the wealth wasn't always shared. Torey broke a few of her toys in a jealous fit, and then there were times when Joy threatened to throw her belongings away. Talisha knew what she had to do in order to protect her precious items. Keeping them out of sight, and storing them in the only place in Aunt May's house where Joy and Torey dared not venture, was the basement.

One by one, Talisha relocated her items to the basement. She would've never guessed that the place she once deemed a monster's hideout turned out to be her haven. Talisha spent hours after school in the basement. She practiced playing the clarinet and preparing for upcoming dramatic reading contests until Aunt May brought Talisha a stand up, black chalkboard and multiplication chart. Talisha pretended she was a teacher, instructing the class on English and Math. She called out numbers and words until the streetlights came on. At times, Aunt May would walk past the basement and hear Talisha talking to her imaginary class, uttering under her breath, "She's going to be just like her mother."

Eventually, Talisha didn't have to pretend to have friends. Neighborhood children were knocking on Aunt May's door every day, asking if Talisha could come outside. Depending on Aunt May's mood, Talisha could frequently enjoy a few moments with her friends. Aunt May was bothered by the knocks and laughter of Talisha and her friends, and would often tell the kids to get off her steps, go home and

then scold Talisha for having the children knock on the door. Aunt May was correct for scolding Talisha, because knew Talisha coached her friends into asking if she could come out. She also knew Talisha was too timid to ask, and even more frightened to confess that she had bribed her friends into knocking on Aunt May's door.

Seeing that it wasn't going to work if friends kept knocking, Talisha became crafty. At times, when Aunt May worked double shifts, Talisha would rush home, do her homework, and head outside to play with her friends until one hour before Aunt May was due home. Talisha thought this plan was foolproof until Joy caught Talisha outside, well past allowed hours, and told Aunt May. Talisha was punished for almost a month. Her punishment felt like a slow death. She could hear the children's laughter and watch from the basement as they were turned away. Aunt May made it clear that Talisha was punished and that if they returned the next day, she would extend Talisha's punishment.

Talisha was on her best behavior, making sure to perform all her daily chores. When she was done cleaning, not a dust bunny was in sight, just the way Aunt May liked it. She complimented Aunt May on just about everything, from her nail polish to her jewelry, and even on Aunt May's wigs. Talisha was weighing on Aunt May and she had been on good behavior, so Aunt May allowed Talisha to go outside with her friends. Talisha was so excited that she ran through the house and slammed the front door. Before she could reach the bottom of the steps, Aunt May had her head out the window telling Talisha, "come on back inside." Talisha was devastated. *What did she do, that quick?* she wondered. Talisha came inside and asked from the bottom of the stairs, "Yes?" Aunt May replied, "don't yell through my house! Come upstairs." As usual, when Talisha was faced with a challenging situation, her heart would pound. She didn't know what to think other than something was wrong. She walked up the last step like a pirate walking the plank, then tiptoed through the hallway until she

reached Aunt May's room. "Yes, Auntie," said an unnerved Talisha. Aunt May stood up and pointed her finger at Talisha. "Don't you ever run through my house and slam my door. What's wrong with you?" Talisha was baffled. She didn't even remember running through the house or slamming the door. The thought that Aunt May was lying popped into her mind. "I said what's wrong with you. You've been here long enough to know you don't act like some wild child in here." Talisha couldn't think of anything else to say other than, "I'm sorry, Auntie. I didn't mean to do it." Unfortunately for Talisha, an apology wouldn't pardon the unforgivable crime. Aunt May was already set on exerting her authority and power. In Aunt May's mind, she was the judge and jury, and it was time to hand down Talisha's sentence.

The words, "You're punished," fell from Aunt May's lips, to Talisha's ears and traveled down to Talisha's fading heart. She couldn't understand the abrupt changes in Aunt May's moods. Talisha went into the basement, shuffled towards the window, and gazed out at the cheerfulness in the air. She watched as the neighborhood children chased each other up and down the block, screamingly wildly at the top of the lungs. She giggled when the children caught each other, wishing she was outside to share the joys of childhood friendship. The four walls, however, were a stark reminder that she was now a prisoner, and the perilous awakening had been so unnerving, all Talisha could do was cry.

The next day, Aunt May was back to her better self. She told Talisha she could go outside after school, but that when Joy came home, she had to come inside for the night. Talisha did not expect for Aunt May to let her off punishment so soon, but she didn't question her decision. She told Aunt May how much she loved her and promised to be on her best behavior. As agreed, Talisha did her homework in less than fifteen minutes and changed from her school clothes into her play clothes in record time.

Talisha sped for the door, turned the knob, in anticipation of feeling of the joy she saw just yesterday through the glass of the

basement window pane. She zoomed down the street to the last house on the block. Knock! Knock! Ring! Ring! Talisha wasn't even aware that other children were lining up behind her, awaiting her next move. Everyone was so thrilled to see Talisha outside having fun, especially after being repeatedly told Talisha was punished.

Talisha suggested playing hide and seek at the local park located one block over. The park didn't have much of a scenic view. There were no swings, slides or monkey-bars. No matter. Talisha wasn't interested in the ordinary games. Her sole purpose of going to the park was to have fun in the park's rocket ship. Talisha's imagination would blast her off in the rocket, straight to Ms. Sumby's house. While traveling across state lines, she would visit the stars and explore other planets before she reached her destination. Talisha went to open the door to the rocket ship and a familiar face came passing by. It was the shy boy from the store. "Hey, wait!" The little boy went whooshing down the slide. Talisha jumped on the slide, patterning her movements after those of the little boy. "Hey, I know you. I saw you in the store the other day. What's your name?" Talisha couldn't take her eyes off her newly discovered crush and the little boy felt the same. He had seen Talisha before on her walks home from school, but never asked her name. On the days when he had built up enough courage to ask, Talisha was confined to the house.

A squeaky voice uttered, "Hi, I'm Michael. What's your name?" An eager Talisha blurted out, "I'm Talisha. I'm in the fifth grade. I'm from New York. I stay with my Aunt May and my cousins. Do you live around here?" Michael blushed. He admired Talisha's friendliness. "You ask a lot of questions. Are you always this talkative?" Talisha couldn't help that she was a chatterbox. There was little to no communication at Aunt May's house, outside of dictating rules and punishments. Talisha asked, "Where's your house?" Michael replied, "Right behind your aunt's house." Talisha grew confused, "Huh?" Michael chuckled and restated, "I live right behind your aunt's house. Come here. I'll

show you." Talisha wanted to know more about Michael, but the day was getting away from her, and she didn't remember seeing Joy come home from school. Talisha told Michael, "I think I should go inside now. My Aunt is really mean and if she catches me outside when she gets home, I'll be punished again." Michael looked at Talisha with a furrowed brow and said, "You get punished?" Talisha swiftly answered, "Yep, and beatings too." Michael slapped his forehead with the palm of his hand and suggested Talisha go home right away. "Come on, I will walk you to your door."

Talisha hurried inside. She noticed that neither Joy nor Aunt May were home. Ring. Ring. The house phone was buzzing. Talisha reached for the mustard colored phone that was nailed to the kitchen wall. "Hello?" An angry voice shouted through, "Where were you, girl?! I've been calling you for the past hour, and you just now answering?" Talisha tried to explain, but once again Aunt May had her mind fixed on what she was going to do for Talisha's absence when she called. "Wait 'til I get home. First of all, you're punished and when I say you're punished, it will be a long time before you ever get the chance to go outside again." Talisha fretted Aunt May's words. She tried to explain, but the more she tried, the more Aunt May became fired up. In the end, Talisha just agreed to the punishment. "Do you hear what I am saying to you, little girl?" A brokenhearted Talisha placed her head down and sadly replied, "Yes." Talisha took off her dirty play clothes and prepared for bed. By time Aunt May finished her double shift, she was too tired to fuss or do anything else, other than go to bed.

Aunt May kept her word with Talisha's punishment. The only time the sun kissed Talisha's skin was when she walked to and from school. Michael tried to plead on Talisha's behalf. In the beginning of Talisha's punishment, Michael would wait for Aunt May to open the back door. He would climb over the fence, getting halfway into the backyard before Aunt May came galloping out. "Nope! She ain't coming out, so save your breath." Most times, Talisha would overhear

Aunt May's shouts. She would run to the bathroom window, only to see Michael walking away in dismay. Aunt May stormed up the steps shouting at Talisha, "Every time one of your friends come knocking at my door, I will add something else for you to do, so you better let them know to stop knocking. You're punished and you're not going outside until I tell you to!"

Aunt May off-loaded a disproportionate amount of daily house chores on Talisha. When Talisha came home from school, she was told to sweep down the steps inside the house, sweep the entire first floor and take out the trash. In addition to Talisha's chores, on Saturdays Talisha was to scrub the front steps with Ajax and a bucket of water until the white marble was visible again.

Talisha looked forward to Saturdays. It was the only time she was allowed outside. Talisha would scrub the steps for hours, just so she could savor the fresh air.

Talisha couldn't speak to any of her friends while she was outside performing her dutiful punishment. Aunt May would be sitting right in her bedroom window, like a viper waiting to attack an unwitting victim. Even if someone looked at Talisha, Aunt May would pop up like a Jack-in-the-box , and yell "She's punished!"

Talisha grew tired of her overall treatment. Months went by and Talisha remained on punishment. She was tired of talking to her imaginary class and didn't want to play her clarinet anymore either. She had a major crush on Michael and wanted nothing more than to be in his presence.

One late afternoon when Talisha came home from school, she walked into a room full of people. The air was unusually thick, and the house guests were crying hysterically. Aunt May waved her hands wildly in the air, gesturing for house guests to calm down. Someone looked at Aunt May and asked, "Talisha don't know?" By the confused look on Talisha's face, it was obvious that she had no inkling as to what she was about to be told. Aunt May went around in a circle

and introduced Talisha to her house guests. The people weren't blood relatives. Rather, they were life-long friends of Talisha's mother. Aunt May took Talisha by the hand and directed her into the other room. She sat Talisha down at the table. "Talisha, I have some very bad news to tell you. Your sister was found dead in New York."

Talisha's first reaction was disbelief. She couldn't grasp what Aunt May was saying. "My sister? Who?" Aunt May grabbed Talisha by the shoulders and said, "Tasha, honey. She's gone and I am so sorry." Talisha fell to the ground, kicking and screaming, "No! This isn't true! She's not dead! You're lying!" Aunt May tried to console Talisha, but Talisha refused to be touched. Talisha went into a full-blown panic attack, hyperventilating and claiming her right to her personal space. "Don't touch me! Leave me alone! You all are a bunch of liars!"

Aunt May had never seen Talisha react this way, and for the first time since Talisha's arrival, Aunt May gave Talisha a meaningful hug. Talisha in return, welcomed Aunt May's embrace. By the time Talisha released her clench fists, Aunt May's blouse was soaked in Talisha's tears. Aunt May wasn't sure if Talisha cried for Tasha alone. Aunt May suggested, "Talisha, would you like to lay down? I will help you get ready for bed." One of Aunt May's house guests walked over to Talisha. She looked at Aunt May, and with a sweet, soft voice she said, "May, let Talisha stay down here with family. I haven't seen her since I left New York, when she was just a baby. It'll be good for her to be around kin right now." Aunt May sulked and walked away. "Do what you want. She's hard-headed anyway."

The sweet, soothing voice continued, "Talisha, you don't remember me. Well, you wouldn't remember me 'cause you was just too young. I am your cousin Terry. Your Uncle Otis was my godfather." Talisha began to feel at ease, like a ton of bricks was lifted off her shoulders. Terry went on to tell Talisha that Keisha was moving to Baltimore and she was expected to be at Grand Central Station the following week. Talisha eyes lit up with hope. "My sister is moving here to be

with me?" Terry frowned, then explained, "No, sweetheart. She'll be staying with me. Don't worry, I'll come get you on the weekends."

Talisha had waited almost four years to lay eyes on her sisters again. She was told one would be seen in a casket and the other on visiting weekends. Talisha's sorrow overtook her completely. She stayed downstairs on the living room sofa that night, talking to God and pleading with Him to rescue her from her crumbling life. Aunt May was tempted to make Talisha get up off the sofa and get in bed, but her empathy lasted just a little while longer.

Several days passed and Talisha found herself in the same area of Aunt May's house. She feared that Aunt May was becoming like her mother. Aunt May tried to force Talisha to eat, but Talisha's appetite evaporated the night she had learned that Tasha had passed away. She yearned to see Tasha one last time and to be in the company of Keisha. "Talisha, you have to eat something or you gonna make yourself sick, and if you get sick, you won't be able to go to the funeral."

Talisha sensed a threat in Aunt May's statement, but let her logic dictate her decision. If she missed the opportunity to see Tasha one last time, she believed she wouldn't want to go on with her life. Talisha found the strength to pull herself together. "Go upstairs and pack two outfits. We are leaving in the morning for New York."

Talisha, upon hearing that she was going to New York in the morning, felt all her energy and motivation return. It was astonishing how quickly her mood had changed.

Terry came to Aunt May's house the next day with a car packed with so many people that Talisha had to sit on someone's lap all the way to New York.

Approximately four hours later, the caravan of people arrived at the church that was just three doors down from Diane's old apartment. Diane didn't belong to the church. She attended a smaller church where she felt like she was more of an integral part of what went on there.

Talisha felt like the sky was folding in as she walked up the large cobblestone steps. The dreary day stood in contrast to the great spectacle of light inside the church. Her eyes fell upon Tasha's lifeless body, then to Matthew and Keisha who were seated in the second row from where her dead sister's corpse rested. They were both sobbing uncontrollably. Talisha walked toward her siblings, forcing her eyes to stay on Keisha. She sat in between the pair and asked, "Where's mommy and daddy?" Matthew looked at Talisha with a glazed over expression on his face. "They're not coming." Talisha wanted to know the reason for her parent's absence and apparent disdain, but at that moment she couldn't focus on them and their ongoing refusal to shepherd the precious lives they chose to bring into this world. There was a light hanging over Tasha's body that captured the attention of every available eye.

After the burial, Matthew and Keisha went their separate ways. Matthew had enlisted in the military and was granted special privileges to attend his sister's funeral. His leave was for one day, but the emotions were too high for Matthew's liking, and he drove back to the military base as soon as his legs could get him up and out. Keisha returned to Corona, departing with her friends. Aunt May and Terry decided it was best to stay overnight. Terry was physically and emotionally exhausted and needed to rest. The family stayed with Aunt May's brother.

Aunt May didn't have the best mother-daughter relationship with Ms. Sumby or the best sibling connection with Diane. Folks used to say Aunt May would grow up to be a cobra in disguise because her heart was filled with venom. Aunt May was stricken by colorism. She and her siblings were all dark-pigmented except for Diane, and there wasn't a day that passed by that Aunt May didn't remind Diane of her distinguishing feature.

"I'm going to walk over to Ma's. I haven't seen her or Diane in a while. I'll be back." Ms. Sumby was perched in the attic window when

Aunt May walked up to gate. "Ma, come open the door." Ms. Sumby was partially relieved to see Aunt May standing at her door, but she was reluctant to let Aunt May in. Given Diane's circumstance, Ms. Sumby would've allowed just about anyone inside her home if they promised to fix Diane. "Wa ya doin here, gal?" Aunt May looked at Ms. Sumby with a blank stare. "Ma, what do you mean what am I doing here? Tasha's funeral was today. The question is why wasn't you there?" Ms. Sumby looked Aunt May in the eye, "Gal, me don gwo to see no dead body. Tasha wit tha lord now. Plus, me was there chile. I was sittin' in da back. Me stayed for a few moments and left fir home." Aunt May's snake-like tongue was ready to fire back, but Ms. Sumby gave Aunt May a look of defeat and walked away.

Aunt May walked into Ms. Sumby's house and was instantly overpowered by the odor of ammonia-like urine. "Good grief!" Aunt May couldn't believe her eyes. Diane was skin and bones. She was unkempt. Aunt May was in utter disbelief. "Diane, honey. I came by to see how you were doing. You know it's time for you to get off this porch. "Your children need you, Diane." Diane just rocked back and forth, as if Aunt May was invisible. Diane had a Bible neatly aligned on her lap that she referenced. After reading a few scriptural passages, Diane chanted something incoherent, then retreated back into a blank stare.

Aunt May stormed out of Ms. Sumby's house. "She won't even look at me. I am her sister! What happened to her?"

The next morning Aunt May told Talisha to get herself ready for the trip back to Baltimore. Talisha protested, saying "I don't want to go back with you." Aunt May almost forgot to be diligent with her alter ego. She grabbed Talisha by the arm. "Little girl, I don't have time for this." Talisha felt like this was her only chance at survival. She believed she wouldn't last another day with Aunt May. Talisha sat on the floor. She looked up at Aunt May and said, "No! I am not going anywhere with you. I didn't even know you when you took me and all you do is yell and beat on me!"

Joy charged out the room, "Who you talking to like that?" Aunt May hushed Joy from speaking. "Joy, don't worry about it. She can stay right here in New York with her crazy mother. She'll be out of my hands." Terry intervened. "Aunt May, we can't leave Talisha here to fend for herself and she's already been through enough. Stop talking to her like that."

Aunt May's internal furnace was heating up and she was about to blow a gasket. She was armed and ready to drop "F" bombs all over the place, but she didn't want the family to know her sinister side. She simply replied, "Well, if you feel so strongly about the situation, then you keep her." Talisha stood up and asked Terry, "Can I stay with you? Pretty please?"

Terry already had a full house. She agreed Keisha could stay although she was at capacity, but Keisha was almost at the age where she was self-reliant, and Talisha was just hitting her teenage years. Terry also had doubts about Talisha in general. Aunt May had subconsciously programmed anyone in reach to believe that Talisha was a "wild child." Terry looked down at Talisha and replied, "Talisha, let me think on things for a bit and let me see what I can arrange. I have to run things by my husband first and, like I told you before, when Keisha comes down, I will come get you on the weekends."

Aunt May couldn't help but interject. "Yeah, if she's not punished, you can take her." As always, when Talisha was faced with great adversity, she would allow her imagination to save her. She melted back to the floor, hoping to seep through the cracks and end up back with her complete family. That never happened. Things would never go back to the way they were before.

Enough was Enough

THE DRIVE BACK to Baltimore took over five hours with all the rest stops, but Talisha didn't even notice, nor did she care. She was convinced that she didn't want to stay with Aunt May any longer, and unlike before, she had a plan and an escape route.

Before Terry left, she gave Talisha her telephone number and address. Terry believed Talisha would need it at some point. Then she left like all the other people in Talisha's life. Talisha dragged herself into Aunt May's house, and Aunt May didn't wait one second to pounce. "So, you wait until we get all the way to New York to show off? Had me looking like the bad guy!" Talisha was so numb to her reality she walked past Aunt May without realizing what was coming next. Pop! Pop! Aunt May started whipping Talisha left to right and from top to bottom. Talisha quickly returned to reality, hollering and screaming, "I hate you! You are evil. I hope you die!" Talisha ran out the front door. She didn't even notice that she had peed herself. Her brain was moving at lightning speed, trying to locate safe shelter. She thought about her friend at the end of the block, but then she quickly realized that the distance was too close for comfort. Talisha's underdeveloped brain and emotional heart led her to Michael.

Not surprisingly, Michael was outside drawing up a sketch for school. He had big plans to become a successful architect.

Talisha ran up to Michael teary-eyed, welts beginning to blister all over her arms from Aunt May's belt. "Oh my God," Michael cried, "who did this to you? Wait. Your Aunt did this, didn't she?" Talisha's mouth and throat were so dry from screaming and running, all she could do was nod her head. Michael was infuriated. "I am calling the police."

Talisha was so naïve and immature, her imagination didn't accord with the real world. She made the false assumption that an underage boy, living with his parents would care for her the same way H.J. should have done back in New York. She watched Michael dial 911 and anticipated the feeling of sweet revenge. She wanted the police to place handcuffs on Aunt May and haul her straight to jail, and if she was lucky, Aunt May would be treated with a couple of doses of her own discipline.

Michael looked down at Talisha pants. "You're wet. Oh geez." Talisha turned beet red with shame. "My aunt did it. She made me pee on myself when she hit me." Michael was in pure disbelief. He glanced over at Talisha a few times and thought about what Talisha must have endured. He wanted to save her, but he understood the situation, and also was much more aware than Talisha about his limitations.

A few moments later, a patrol officer arrived. He was the big and brawny type that commanded the attention of a crowd with his presence alone, and he spoke with such great force that if a person was thinking about causing trouble, they would reconsider their decision. "What seems to be the problem?" he asked firmly. Talisha was tongue-tied, so Michael spoke for her. "Sir, my friend was child abused." The officer had already conducted a visible assessment. He observed Talisha's incontinence and the marks on her arms. The officer replied to Michael, but looked at Talisha, "Child abuse? By whom?" Michael began to answer, but the officer silenced him. "Son, where are your parents?" Michael became indignant. "In the house." The officer tipped his cap. "Good, go get them." Then he looked at Talisha and

reached for his radio. "Dispatch come in. I have a minor female child in need of medical treatment. Send an ambulance."

Talisha still didn't understand the weight of the situation. She always viewed things from the fantasy part of her mind. She literally ran away from one problem to another. Talisha was not an emancipated child. Aunt May had legal guardianship over Talisha, and it ultimately would be her decision what would happen to Talisha. "What's your name and address?" the officer asked. Talisha thought about the question. She knew her full name but didn't want to claim Aunt May's address as her residency. "Talisha Jackson and I don't have an address. I'm from New York." The officer gritted his teeth and replied, "Don't get cute with me, girl. You're not in New York, you're in Baltimore. Now where are you staying in Baltimore?" Talisha hesitated. She wanted assurance. Before she disclosed Aunt May's address, she wanted to be clear that the officer wasn't taking her back to Aunt May's house. Talisha believed going back to Aunt May's house would be certain death. "Are you taking me back there?" The officer's words provided Talisha with just enough confidence to tell him Aunt May's address. "No Talisha, you are not going back to that residence. You are going to the hospital to be treated."

Hearing the words "hospital" and "treated" being used in the same sentence, Talisha woke up from her slumber. "I don't want to go to the hospital. I'm fine." Talisha remembered the last time she went to the hospital and how she ended up a ward of New York State. She thought about having to meet another Tonya again and having to endure being shipped around from house to house. "No! I am not going!"

Just then, Michael and his parents arrived on the scene. Michael's mother was one for theatrics, and did most of the talking. "Michael, who is this and what in the hell is going on here?" Michael wanted his parents to see Talisha's condition before he explained. He thought Talisha would receive additional sympathy if she was seen soiled and hurt, but the ambulance arrived before Michael could offer his

presidential speech as to why Talisha should stay with him and his family. The officer spared Talisha the agony of further humiliation. "Ma'am, everything is under control. I'll take it from here. I just wanted to make sure that there were parents were in the home before I left." Michael's mother responded, "Well, you see we are here, but I still want to know what's going on. You are here, the ambulance just pulled up, and now you telling me everything is under control, I need to know what happened."

The officer replied, "Ma'am, you might want to ask your son. Apparently, he knows more about the situation than I do." Talisha was taken into the ambulance and examined at the local emergency room. On the way over to the hospital, she concocted a plan to ensure she never returned to Aunt May's house. Talisha told the emergency room nurse everything that came to mind. She even added a few things from one of the shelves of her vivid collection of memories, some real and some made up. Talisha blabbed out about her mother, H.J., being placed in group homes and foster care, how Aunt May kidnapped her from New York and secretly traumatized Talisha almost daily.

The problem with Talisha was her vision was always short-sighted. She would put on the best performance of her life, but she lacked the foresight to see her plan through. Talisha was 400 miles from her family and her only next of kin was Aunt May. Talisha thought about Terry after the fact, and how nice it would have been to live in the same house with Keisha, but Aunt May would've never given her approval, especially after the short visit with the officer. After Talisha was hauled away in the ambulance, the officer drove around to Aunt May's house. Aunt May was the victor in most instances and she always had quite the rebuttal. That day was no different. Aunt May peppered up her story just like Talisha. After a while the officer grew tired of Aunt May's rant. He asked, "So will you allow her to come back here?"

Bingo! Aunt May thought, grinning and already starting to plot revenge for all the trouble Talisha had caused. Aunt May placed her

hands on her hips and stuck her neck forward almost three inches. Gritting her teeth, she bellowed from the pit of her stomach, "Put her away!"

Aunt May wanted blood for Talisha going outside the family and telling authority figures about family business. There would, however, be no blood shed. The final decision was made. Talisha was not to return to Aunt May's house. Instead, Talisha was placed in an institution for unruly juveniles.

When Talisha heard the news that she wasn't going back to Aunt May's house, she was both elated and disappointed. She was certainly happy to be away from the grasp of Aunt May's claws, but her decision to run away from Aunt May distanced her further from Keisha. Talisha had waited years to be with her family again, and even if she couldn't have her entire family back together, the thought of being with Keisha was satisfying enough.

Talisha wallowed in her thoughts for some time, stuck in a state of ambivalence. She wondered if she had made the right decision by running away or if she should have stayed and tolerated Aunt May's abusive ways just so she could have seen Keisha.

Talisha spent thirty days in an all-girl juvenile facility before being placed in another group home. This time there were no courtrooms or last-minute plans to free her from the system's way of doing things. Talisha was now on her own.

On the day of discharge, a social worker transported Talisha to the Florence Courette Group Home for Girls, near the heart of Baltimore City. The group home was inside the walls of a mansion that had been renovated to accommodate thirty-six teenagers, but only housed twenty at that time. The east wing of the mansion was unoccupied. The west wing was divided into two levels. The lower level was for pregnant teens and the upper level was for those expecting. Non-pregnant teens shared rooms and the pregnant teens had single rooms.

Talisha was ushered into the administrative office of the group home where she watched the social worker and the group home's director exchange lengthy paperwork. Talisha remained quiet while the two processed Talisha's admission. If it wasn't for the hard-plastic chairs, Talisha would have fallen asleep until someone woke her up. She was a stickler for day naps. After an hour, which seemed forever to Talisha, the social worker left. The administrator stepped out from behind the U-shaped desk and introduced herself to Talisha.

"Welcome to Florence Courette. My name is Mrs. Scott. I will show you around the place, introduce you to the young ladies, and then show you where you'll be sleeping. Alright?" Talisha nodded her head. She was used to people pretending to be friendly and courteous, and then, in the next breath, turn into a viper like Aunt May.

Mrs. Scott walked down the hallway, talking at machine gun pace, but Talisha wasn't listening. Talisha set her body on autopilot while her mind transitioned back into fantasy mode. Talisha was enthralled by the cathedral ceilings, elongated hallways, and vast amounts of space. She had plotted the areas she wanted to explore first, thinking there must be more than what she could visibly see, until enormous amounts of sunlight halted her creative exploration. Mrs. Scott explained, "This is the solarium. Many of the girls come here to sunbathe or play games. As you can see, there is a ping-pong table and an area for arts and crafts. Down the hall is where you will attend school, and you are expected to attend Monday through Friday, like everyone else." Mrs. Scott assumed a pointed position and gently stated, "I promise you will learn many things that will help you along the way. All I ask is that you follow the rules, and everything will be copacetic."

Under normal circumstances, Talisha would have been doing jumping jacks and cartwheels all over the place. But this time, Talisha felt it was necessary to protect herself from yet another disappointment. The group home was a lovely place, but it wasn't home. There were no familiar faces or welcome voices.

Mrs. Scott introduced Talisha to the other residents and staff. Talisha took note to how some of the girls seemed guarded and how the staff seemed unrealistically happy. "Talisha, let me show you where you'll be sleeping." Mrs. Scott and Talisha walked up the stairwell to the second level and before they reached the top of the steps, Talisha's imagination started revving up. The upper level was massive and divided by a bridge. Mrs. Scott walked to the west wing of the floor, but Talisha found herself drifting toward the east wing. Talisha was curious about this other side. Unlike the west wing, there was no signs of life. All the lights were cut off and someone had pulled down all the drapes to block the sun from shining in.

Before Talisha could get too far ahead, Mrs. Scott called out to her. "Talisha, no one stays over there. You will sleep in the west wing. Please come along." Talisha was burning to explore the eerily quiet east wing. Her imagination had already created so many story lines of what happened over there and why everyone had to be isolated to one side, but she didn't want to return to the juvenile facility or Aunt May's house, so she followed along.

Mrs. Scott patiently waited for Talisha to walk over, then opened two folding doors. "This is the laundry room. You are permitted to wash your clothes once a week, only on Saturdays. Mrs. Birmingham is our coordinator. You will meet her shortly. She will give you toothpaste, a comb and a brush, soap and soap detergent." Mrs. Scott then realized Talisha didn't have any luggage with her. "Talisha, where are your belongings?" Talisha responded, "I don't have anything else." Mrs. Scott was astounded that the social worker didn't mention that Talisha needed clothes. "What a shame. Well, I think we have a few items your size in the office. I will check after I show you to your room."

Mrs. Scott walked down a bit further, then stopped at the middle of the wing. The door was closed, but a melodious voice singing along to a love song could be heard from within. Mrs. Scott knocked on the door. "Denise?" The music came to a halt, followed by a brisk

opening of the door. The young girl who had been singing like she was practicing for Star Search emerged. "Oh! Hi Mrs. Scott. What's up?" The young girl didn't see Talisha behind Mrs. Scott. She thought the knock on the door was another request to lower her radio volume. "I want you to meet someone." Mrs. Scott turned around and gave Talisha a gentle push on the shoulder. "This is Talisha. She is your new roommate." Talisha stood there waiting for the young girl to get mad, throw a tantrum and demand Mrs. Scott find Talisha another roommate, but that didn't happen. Instead, the young girl was excited about having a roommate! All the other girls on the wing had "roomies" except for her, which wasn't a problem until it was time for bed. Most nights she was able to get a restful night's sleep, but then there were times when she laid in the bed and listened to the other girls talk about boys and giggle.

The young girl grabbed Talisha by the hand and swooped her into the room. Mrs. Scott smiled, "Perfect. It seems you two will get along just fine." Mrs. Scott closed the door so the two could get acquainted.

The girl didn't waste any time probing Talisha. "So what's your story? Like where you be? How old are you? I want to know everything." Talisha was still in cautious mode. She was delighted by the young girl's warm welcome, but she didn't want to run the risk of trampling on deep waters and end up drowning again. Talisha pretended to have a headache and laid down on her newly assigned bed. "We can talk when I wake up."

Talisha fell right asleep. She had been exhausted from staying at the juvenile center. It wasn't like the group home setting. Even if the girls were kind to the core, they had to put up this tough girl act, or risk being exploited by a real bully. Talisha didn't have any trouble while she was there. Most times she was planning her getaway in her mind and other times she worked on puzzles and kept to herself.

"Hey you, you're awake." The young girl skipped dinner, waiting for Talisha to wake up from a much deserved sleep. Talisha couldn't

believe that she had slept the entire afternoon away. She yawned. "Whoa, what time is it?" The young girl replied, "Girl, it's almost ten o'clock. You must have been exhausted," she giggled. "Anyway, Mrs. Scott brought you some clothes and blankets. They're at the bottom of your bed. Do you like them?" Talisha didn't want to move from her comfortable position, but she wasn't the type of person to pass up a surprise. Mrs. Scott gave Talisha a couple of outfits for the time being, a care package filled with toiletries, and a crochet spread to place over the bed. Talisha said, "I should thank her. This is really nice."

The truth was that Talisha didn't want to thank Mrs. Scott. She felt that those items came with the territory and not by some kind gesture of the heart. Talisha wanted some space from the overbearing young lady and equally important, she wanted to explore. "Um, where do you think you're going?" Denise inquired, puzzled. Talisha turned around and looked at the young girl with her best poker face. "Downstairs to say thanks." The young girl laughed. "You're silly. Mrs. Scott is gone for the night, girl. She'll be back tomorrow. Besides, it's bedtime. You can't walk around here like you're home." Talisha looked confused. "I can't walk around?" The young girl replied, "Nope, so you might as well get back in bed, and wait until the morning for whatever you want to do."

Talisha was still drained, so she took the young girl's advice and laid back down. The young girl placed a scarf around her neatly brushed hair and said, "Don't think I forgot our talk." She turned the bedroom lights off and turned her radio on. "Does the radio bother you?" Talisha never had a radio to listen to at night, so she wasn't sure how to answer. She went with the safest and easiest solution. She said no.

Talisha was awakened the next morning by the sweet aroma of waffles and syrup. The cook came in around five in the morning to have breakfast ready before class began. Talisha showered and got ready for her day. She followed her roommate downstairs into the kitchen

hall, and then she gasped. There was a buffet style island in the middle of the kitchen with a literal smorgasbord of food choices. Talisha looked at the young girl and asked, "Can we eat whatever we want?"

The young girl enjoyed the joyous look on Talisha's face and even took pleasure knowing that they both were in a safe place. "There you go being silly again. Yes, you can have whatever you want, but don't be too greedy, eating everything up." Then Talisha heard a voice from behind her. "Let me tell you what you do newbie. The kitchen is locked after dinner, so if you want a midnight snack, you better get it now, run to your room and put it under your pillow for later. That's how I do it."

Talisha looked behind her. It was one of the pregnant teens hoisting several individual boxes of cereal and milk. Once she had stacked both arms, she ran back to her room and hid the items under her pillow, like she told Talisha to do. Talisha's roommate argued against stealing boxes of cereal and milk. She felt the staff did enough for the girls.

Talisha agreed with her roommate. There was plenty of food for seconds if not thirds. Besides, Talisha was the newest resident at Florence Courette and she wanted to make a good impression.

Following breakfast, the pregnant girls went to a separate area for schooling. They were being taught about home economics and how to care for a new baby. Talisha and the other girls were instructed on general education, and on how to type, sew and crochet. Talisha enjoyed all the activities, especially typing. She was an avid learner at heart, looking for the next task to take on. It wasn't long before Talisha learned to type thirty-five words a minute on that old manual typewriter. She kept busy out of school, practicing her crafts. She made a list of everyone she missed and promised herself to sew pillows and crochet blankets for each. However, her commitment to character building was short-lived. While Talisha wanted to showcase her newly discovered talents and snub her family for missing out on her growth and development, she ending up becoming more interested in other activities.

Impending Doom

———

TALISHA'S ROOMMATE HAD worn her out with her neediness, so Talisha began spending time on the first floor with the pregnant girls. For the most part, she was curious about their pregnancies until she fantasized it was her laying in bed with a poking belly. Talisha's naturally wanted to know more about her developing body, as would any teenage girl, and spending time with those already proficient in that area only piqued her interests further.

She and pregnant girl named Danielle became relatively close. The friendship developed in the same manner as Talisha's roommate and bloomed overnight. The two shared common traumas with family dynamics. They discussed intimate details about misunderstood rebellion and overnight detainment, physical and emotional abuse, parental abandonment and how these incidents would shape their future selves.

The early morning and late night talks were not without unexpected consequences. Talisha was already scarred from childhood maltreatment and parental abandonment. The unobstructed formation of a bond with another person experiencing the same traumas reignited memories of her past experiences, much like a recurring nightmare. Talisha would often think to herself and openly profess, "When I have kids, I will never leave them! I will never give

up on them." Her emphatic words were instrumental in providing both healing and hope. They clearly outlined and gave voice to past hurts, her expectations as a current child, and her dreams of becoming a future mother.

One afternoon, during a visit to the local art and crafts store, Danielle decided to give Talisha a lecture on sex. "Girl, listen. My old man is so funny acting when it comes to down there. He makes me wash my coochie seven times before we can do anything."

Talisha asked, "Girl, why he make you do that?" Danielle wasn't going to let Talisha off the hook, but since she initiated the discussion, she thought she might as well provide all the supporting details. "He like to eat cootie-cat. He told me it better not stink, or he will punish me, so I wash it seven times before we do it." Talisha looked at Danielle, baffled. Danielle quickly asked, "Girl, you not doing it?" The colloquial expression was a direct question, demanding to know if Talisha had had any sexual experiences outside of her imaginary pregnancy. Talisha wanted to feel mature and experienced and she didn't want to look like the outsider given the circumstances. "Girl, yes! Plenty of times." Danielle eased up a little. "Oh, for real? Tell me about one." In a matter of seconds, Talisha was fabricating a sexual encounter that never happened. Danielle grabbed Talisha by the arm, "Didn't it hurt? Girl, oh my God! I thought I'd die the first time we did it. I just grabbed the pillows and the sheets and bit down real hard."

Danielle wanted to know more. "So, where he at?" Talisha looked over across the street. The pressure was mounting, and she was running out of details. "Your boyfriend. Where do he live?" Talisha replied, "Oh, he don't live far from Florence Courette." Danielle hit Talisha on the shoulder, "Girl! Oh my God! Do you ever go see him? My old man lives way across town. I wished he lived close. We would be getting it on right about now."

Talisha wasn't too far from the truth. She had met someone while at the store, but he wasn't her boyfriend. In fact, he wasn't her age,

but Talisha didn't care. It was pleasing to her to be noticed, even if the intentions weren't pure. Talisha continued with her imaginary story. "Girl, yes. I see him when I can. All I do is page him when I want to come over."

Danielle was bored at the group home and Talisha's story was delivering some much-needed action. "Can you page him when we get back? We should go over there this weekend."

Talisha entertained the idea. She had talked to this person on the facility's payphone for the past few weeks, and he had seemed easygoing. She decided to plan a weekend getaway, but there was one thing standing in the way of her plans. The girls were prohibited from leaving the grounds. Mrs. Scott had made that very clear to everyone on admission.

Danielle asked Talisha, "Girl, how are we going to get out?" Talisha smirked and said, "Leave that up to me."

Friday couldn't come fast enough. All week Talisha concocted all sorts of ideas to get the girls out the building. She knew the weekend staff was more liberal with the in-house rules. She thought about faking an illness that required a visit to the emergency room, but then considered how the distance would be an issue. She telephoned Keisha and asked her to call the facility to say their mother was sick, and that she had to leave immediately. Keisha hung up. Everything she thought of failed.

There were only two people on the weekend shift—one was an older woman who slept most of the time on the living room couch, and the other was a middle-aged man named Mr. Brown. Mr. Brown had a laissez-faire attitude, and Talisha thought she was cunning enough to exploit it.

The two girls went to the administrative office where Mr. Brown was preparing to watch his favorite television shows for the night. Talisha busted through the door so fast, it almost launched Mr. Brown out of his seat. "What the devil? What are you two doing barging in here like

that?" he yelled. Talisha apologized. "We are so sorry, Mr. Brown. We came with an urgent request." Mr. Brown took a couple of breaths to calm himself and asked, "What is it?" Talisha looked at Danielle and got straight to the point, "Mr. Brown, we got a date, and if you let us out just until eleven tonight, we promise to be back on time." Danielle felt compelled to add her niceness to the plea. "Please, pretty please." Mr. Brown bent his head down, slowly glanced at both girls and said, "Absolutely not. I ain't unlocking these doors for you. What do you think this is? You have a date. If you don't go to your rooms, and you, you're pregnant. Don't you think you had enough dating?"

The girls were terribly disappointed. Talisha had promised her acquaintance that she and Danielle would be stopping by soon. Talisha hated disappointments. She had also developed a nonchalant attitude. It was her against the world.

The girls went back to Danielle's room to conjure up another plan. Talisha stopped at the pay phone to page her waiting friend. She wanted to let him know that the two would be a little late. Once back at Danielle's room, the girls thought of every possible scenario that might land them outside the doors of Florence Courette. None of them seemed workable, except for a most daring attempt that was almost certain to have them removed by morning. The girls didn't care at that point. They were risk takers and excited by the adrenaline pumping through them now. Talisha told Danielle, "We are going to start a riot." Danielle looked at her wide-eyed and replied, "Girl, what do you mean?" Talisha was happy to explain. "Since Mr. Brown is holding us hostage, we will tear this place down until he either calls the police or let us out. Either way, we ain't staying here any longer."

Danielle wasn't certain about Talisha's plan. She wanted to leave the premises for a few hours, not indefinitely. "Talisha, I don't know about this. What happens when we can't get back in?" Talisha assertively said, "We go find our families. They will let us stay." Danielle agreed, "Well, that's true. I have an uncle over west, and he will let us stay."

Talisha bolstered her own argument, "See what I mean? We have people to go to. We don't have to stay here to follow these stupid rules. I am fifteen years old. I am tired of being treated like a child."

The girls' plan was simple—rebel, act out and leave. She decided to initiate the fiasco by stealing the daily logbook. This was the facility's records of daily activities and it was guarded like the Holy Grail. Talisha waited for Mr. Brown to use the bathroom, then she snuck by the sleeping old woman and heisted her leverage. She hid the logbook over the abandoned east wing, in one of the ceiling's tiles, and when Mr. Brown returned to his seat, she informed him of her deed.

"Oh, Mr. Brown, you made a mistake," Talisha taunted. Mr. Brown was not pleased with the pair's actions. He had already ordered them to their rooms once, and this would be the second time around. "What are you two up to?" he asked, not smiling. Talisha answered, "You left the office door unlocked and we took the logbook. If you want it back, let us out. If not, you will have some explaining to do come Monday, and you know Mrs. Scott ain't playing with you."

Mr. Brown frantically searched for the logbook while the pair returned to their stations. Most of the girls were waiting by the hall entrances, ready to partake in the action as the plot unfolded. Talisha walked up the steps to the second floor. She was confident that this plan would work, and it did. Mr. Brown charged out of the administrative office and approached the pair of troublemakers. He stopped by the sleeping woman on his way upstairs to inform her of what happened. Mr. Brown was met with resistance midway up the steps. The girls had the corridor blocked off with furniture. Mr. Brown was at his wit's end. "What is this foolishness? You mean to tell me you two are doing all of this just to go see some pissy behind boys?"

Some of the girls decided to have a little fun of their own. They threw so much baby powder and Ajax at Mr. Brown that half of his face looked like the Phantom of Opera. The girls-turned-dissidents were completely out of control.

Mr. Brown telephoned Mrs. Scott who then instructed him to call the police. Talisha's plan had worked. Mr. Brown and the sleeping employee waited for the police in the administrative office, ensuring to lock the door this go around. Talisha and Danielle waited at the bottom of the stairwell, hiding in the telephone booth.

Moments later, a pair of officers arrived. Mr. Brown calmly explained the situation. Just as Talisha expected, the officers asked to speak to the girls. Mr. Brown asked the older woman to stay in the administrative office while he took the officers through the barricade. As soon as the entrance was cleared, Talisha and Danielle whizzed pass.

"There they go!" screamed the older woman. Talisha and Danielle ran past the older woman and out the door. They ran as fast as they could, darting in and out of dark alleys, looking over their shoulders to make sure that they weren't being followed. Once they were a few blocks away, they stopped to take several deep breaths of fresh air. Then they gave each other high fives and boasted about how they outsmarted Mr. Brown and the police. Danielle looked at her watch. "Girl, it's almost eleven o'clock. Do you think he's still up?" Talisha replied, "I paged him earlier letting him know we would be late." Danielle replied, "Oh, okay. Good thinking."

The girls walked about a half mile before reaching the boy's doorstep. Talisha had an old piece of chewing gum in her pocket that she quickly popped in her mouth. Danielle rang the buzzer. A young man in his twenties opened the door. He was holding a cup of liquor. "Oh, look who decided to show up. Come on in." The girls were outnumbered. There were five men in the house. Four were seated at a table, playing cards. The young man that opened the door seated the girls in the living room. "Hey, y'all want something to drink?" Danielle looked at her stomach and said, "I can't, but Talisha can." The young man brought back two strawberry Daiquiris and some Seagram's wine coolers.

Talisha didn't waste any time gulping down the refreshing drink. She finished both bottles just as her acquaintance walked into the

living room. He was a young man in his early twenties and very easy on the eyes. He had an even, dark complexion, short wavy hair, and an athletic body type with bowed legs. "You were pretty thirsty, huh?" The young man looked at Danielle. "And what's your name?" Danielle replied, "You first." The young man laughed. "Uh, it doesn't work like that. You stepped foot in my house, but I am a nice guy, so I'll play your little game. I'm Darnell. Your girl didn't tell you my name?"

Talisha had started feeling the effects of the wine cooler. She thought everything was funny and wasn't paying attention to the conversation. She was living in the present, numb from all the hurt and pain, and free from the grasp of both Aunt May and the rules of the group home.

It was getting late and the girls were getting tired. Darnell asked, "Well, when are y'all going home?" Talisha didn't tell Darnell that she stayed at a group home. She wanted him to think she came from a traditionally normal and loving family. Talisha lived in an imaginary world most of her life, pretending to be at other places, with other people, and that her life was perfectly normal. When asked about her true feelings, her answer would be along the lines of how she expected to feel, instead of how she was actually feeling.

Talisha was good at keeping secrets and even better at acting. If Talisha's life was a reality show, she would win the Best Actress award of the century. Talisha had a slight buzz from the wine coolers, but she pretended to be a sloppy drunk. She staggered all over the place and plopped down on the couch, citing she was too drunk to walk.

Darnell saw right through Talisha's shenanigans. For the first time, he noticed Talisha was a child and he didn't want to be accused of any wrongdoing. Talisha was on the couch, pretending to snore, when Darnell started speaking to her like he was her older brother. "Listen up. You two can stay downstairs in the back room, just for tonight. I have to work in the morning, so when you leave out, make sure you lock the door."

Talisha kept her face plastered to the couch, crediting herself for an ingenious plan. Darnell's friends headed out and Darnell went upstairs for the night. The girls had had an eventful night, to say the least. They retired on the available bed in the back room.

Talisha's plan was short-sighted. She was the type of person that lived in the moment, forgetting about what tomorrow may bring. There was no master plan of shacking up with Darnell and there was no plan "B."

The next morning Talisha woke up to a strange man lying next to her in bed. Danielle was gone. "Who are you?" Talisha asked the unwelcome intruder.

"That's not important," he said.

Talisha asked, "Where's my friend?"

The strange man said, "Oh, she's okay. She's in the living room sleeping. Are you worried about her?"

Talisha reluctantly replied, "Yeah, she's pregnant."

Talisha was starting to get scared. She didn't remember seeing the man at the table. She wondered if he had broken into the place and was going to kill her. Perhaps he already killed her friend, and she was next. Talisha sat up in the bed.

"What time is it?" Talisha asked a bit too quickly.

The strange man looked down at his left wrist. "It's ten o'clock. Are you hungry? You must be hungry. I can order you a pizza."

Talisha's heart began to palpitate, as the strange man's hazel-brown eyes looked piercingly into hers. He had a sly grin that increased Talisha's fear. She felt he was up to something. She began scanning the room, now that it was daytime, looking for an exit. She looked to her left and saw the opening to the living room. She then looked to her right, realizing she was in the middle room, and that there was a back room, filled with sunlight. She wondered if the strange man came from that part of the house, but she wasn't sure. Talisha and Danielle had only been in two rooms and couldn't say for sure who else might

be in the house. Talisha quickly removed the bedspread from over her and jumped out of bed.

The strange man straddled the bed. He took a stance like a lion would right before he attacks his prey.

"It's late and we've been out all night. We better get going."

The strange man's grin grew even more sinister. "Wait for your pizza," he sneered.

Talisha was slightly discombobulated from the alcoholic beverages she had drank the night before, and from waking up in an unfamiliar house next to a strange man. "I'm okay." She called out to Danielle, while continuing to look for an immediate exit to get away from the strange man. Talisha entered the back room.

She immediately took note of the tiny room that had one gated window. The walls were painted mint green. There was a twin-size bed alongside the left wall and a chest almost wedged against the bed due to the lack of space. Talisha turned around and noticed that the strange man was in the room with her. He had closed the door.

The strange man's intentions were beyond evident. He unfastened his belt and unzipped his pants.

Talisha began to plead with strange man. "Please, don't do this. I need to go home. Please."

The strange man, now looking extremely menacing, approached Talisha. He spoke to her in a low tone, attempting to keep her calm. "Sssshh, you will wake your friend."

For a quick second, Talisha forgot her friend was somewhere in the house. Talisha yelled, "Danielle!"

The strange man grabbed Talisha by both arms. She was wedged in the tiny space between the twin-size bed and chest. "Stop! Get off of me!"

Danielle was awakened by Talisha's screams. She rushed to the back room and pounded on the door. "Get away from my friend!"

The strange man jumped off Talisha to move the chest against the door. He didn't want any further interruptions. Talisha tried fighting

the man off. She even tried moving the chest to break free, but the strange man overpowered her. He threw Talisha onto the twin-size bed, pinned both of her arms above her head with one arm, and with the free arm, he removed his erect penis and abruptly penetrated Talisha's tender pearls.

Blinded by the sudden, horrific invasion, and paralyzed with deep pain and fear, Talisha cried out relentlessly. She wasn't sure if the strange man would kill her next. She tried to fight harder, but her energy was depleted, and the strange man was much stronger.

After what seemed like an eternity, Talisha's violator ejaculated inside her and on the bedspread. He got up off Talisha and placed his genitals back inside his pants, then zipped up and fastened his pants as if he had just urinated. He looked at Talisha and said, "See, that wasn't so bad. You still want your pizza?"

Talisha was sitting up on the bed with her knees bent to her chest. Her eyes had begun to swell. She was numb with disgust. "Just let me out of here," said Talisha.

The strange man moved the chest aside and opened the door. Danielle was on the other side of it. She never moved. She was stricken with grief for Talisha.

Danielle ran to Talisha, holding her and trying to comfort her, never taking her eyes off of the strange man. "Did he rape you?"

Talisha was fearful that if she said the wrong thing the strange man would finish what he started and permanently silence her. Talisha settled for a safer answer and replied, "Girl, come on. Let's go."

Talisha and Danielle left the house. Danielle was crying. She sincerely felt terrible for Talisha. "Talisha, I am so sorry this happened to you, but you need to tell someone."

Talisha buried Danielle words. She was still in shock from being raped. The girls had nowhere to go. Danielle was confident that her uncle would allow them to stay, but it was too far of a distance to walk, and Talisha was in pain.

The girls returned to Florence Courette, silent with each other the rest of the way. When they opened the door to the large mansion, heavy regret rested on their shoulders. They were almost positive they would soon be met with the strongest force of removal, but that didn't happen.

Mrs. Scott was at the facility upon the girl's arrival, coming in shortly after their escapade had concluded. Mrs. Scott was bottled up with frustration, especially over Talisha hiding the logbook. She, other staff members, and some of the residents looked everywhere for the logbook, but to no avail.

Mrs. Scott wanted to strike the girls down with the mightiest force of selective words. However, the blank stares from the girls' faces changed her stance. Mrs. Scott restrained herself and employed the highest degree of emotional intelligence. "Where have you two been? We've been worried sick."

Danielle uttered, "We went over my uncle's house. He was sick and had to go to the hospital." Mrs. Scott didn't believe one spoken word from Danielle's mouth. She had already been briefed on the events. Mr. Brown and a few of the residents told her everything. Mrs. Scott had authority to remove the girls from the premises immediately, but due to the possibility of unforeseeable consequences, she exercised caution. Notwithstanding, the owners of the facility were contacted, and a collaborative decision was made to discharge the girls immediately. The matter was out of Mrs. Scott's hands.

Mrs. Scott delayed the discharge paperwork. She desperately needed the girls to return the logbook, which held every detail of the facility's operation. Without record of its entries, the facility would lose quarterly subsidies. Additionally, Mrs. Scott wanted to explore where the girls went, and if anything happened to them while they were left unsupervised.

Talisha had returned to her room by this time. She needed to shower. The memory of what happened replayed in her mind. She was

back at the facility, safe and far away from the strange man and his evil intentions, yet she kept seeing his face, as if he had taken her hostage all over again. Every time her mind went back over the deplorable events, she scrubbed her body even harder.

Danielle checked on Talisha throughout the day. Mrs. Scott told Danielle that Talisha was being discharged Monday morning, and if Danielle wasn't pregnant, she would be discharged as well. Danielle considered herself lucky. That was the second time her unborn child saved her from catastrophe. Danielle cared about Talisha. She didn't know how to feel. She was grateful to have been given a second chance, but was genuinely concerned about Talisha.

"Hey girl, you okay? You haven't eaten all day." Talisha turned from her side to face the low voice. It was her friend, Danielle. "No, not really." Danielle was thankful that Talisha was finally talking. "Girl, you should call the police. That bastard should not be getting away with what he did to you."

"Danielle, think about everything. Who is going to believe me after what I've done?" Danielle became furious. "No Talisha! Don't think like that. I was there. I know what happened. I heard you screaming through the door. Don't you remember?"

Talisha began to cry again as she revisited the searing, painful memory. She felt like a foolish little girl. Every time she thought about the situation, she blamed herself.

Then Danielle remembered seeing a pamphlet for anonymously reporting domestic violence. "Talisha, if you don't want to tell anyone or call the police, you can report it without giving your name and address."

Talisha's eyes widened with curiosity. Danielle continued. "It's a 1-800 number. I have it downstairs. No one will ever know you called." The cloud of dark shame that hung over Talisha's head began to dissolve. Talisha had found a silver lining.

Talisha wanted someone to know, but she was terrified that the strange man would find out and come after her. She also worried

about her reputation. She remembered how Aunt May used to call her "wild child." She thought that if the other girls found out she was raped, she would be accused of bringing it on herself.

Then Danielle said something that turned on the bravery switch in Talisha's mind. "Talisha, what happened to you was not your fault. You didn't even know him. We didn't even go over there for that. Did you even tell your friend Darnell what happened?"

Talisha thought about Danielle's words and how they were making sense. She didn't know the strange man, not even his name, so just telling an operator about what happened without giving personal information was completely safe.

Talisha went downstairs to the payphone and dialed the number Danielle provided. An older woman answered the line right away. "Hello, you've reached 1-800 anonymous. How can I help you?"

Talisha had choked up with anticipation just thinking about relating the events. Her voice began to tremble. "Um, uh, hello."

The woman asked, "Hon, how can I help you?"

Talisha began by stating, "Something happened to me today."

"Okay hon, let's start by telling me your name."

Talisha adamantly responded, "I don't want to give my name out."

"Okay, that's fine. Let's talk about why you called, okay?"

Talisha agreed. "Okay."

The operator remained in silence for the most part, rarely interrupting, and allowing Talisha to tell the story at her own pace.

"Me and my girlfriend went to go see a friend of mine. We stayed the night and when I woke up, there was a strange man in the bed with me."

The operator then began asking pointed questions. "Hon, did he touch you in the wrong way?"

Talisha held the receiver on the phone, looked up the stairwell to make sure no one overheard her in the passing by. She reluctantly answered, "Yes."

"Okay. Hon, have you showered today?"

Talisha continued to answer the operator's questions. She wasn't critically thinking about the line of questioning and didn't foresee the outcome of her call.

The operator, however, specialized in these types of calls and she had gathered enough information that warranted police contact. There was only one missing piece; Talisha's personal information. The operator understood that if Talisha hung up at that moment, there was no way to trace the call, and the incident would have been reduced to a lasting memory. She had to surreptitiously gather Talisha's personal information, which wasn't very difficult following the exchange.

"Hon, I am going to ask you a couple of questions for research purposes. It won't be recorded or given to anyone else. Okay?"

The operator's statement didn't sound threatening to Talisha. "What else do you need?"

"Tell me your first and last name and where you're calling from."

Talisha snapped at the operator. "I am not telling you where I am calling from. Nope, I am not doing it."

The operator clarified her statement. "Hon, that's fine. I don't need to know your address. Give me the number you're calling me from."

Talisha piped down a few notches and looked at the number typed in the middle of the payphone. "Oh, okay. It's 1-555-764-5321."

The operator was relieved by Talisha's cooperation. She thought that if most of her calls would have been this easy, she might be able to help more victims tell their story.

Before hanging up, the operator reassured Talisha. She convinced Talisha that she was safe and that what happened to her was not her fault. Talisha was comforted by the operator's words, but she still felt highly emotional and shaken up about the situation. Talisha looked at the receiver as she hung it up. It was symbolic. The operator was gone and so she thought was her story. She headed back to her room, but made a quick stop on the first level to tell Danielle that she had made the call.

When Talisha returned to her room, it wasn't even five minutes before Mrs. Scott came knocking at her door. "Talisha, can you come with me to the office please?"

Talisha was receptive to just about anything at that time. She was stricken with survivor's guilt. She followed Mrs. Scott to the administrative office. Mrs. Scott closed the door and closed the blinds. "Have a seat."

Talisha looked at the seat and noted it was the same mint color as the room where she had been held captive. She wondered why she never noticed the color before, but took a seat nonetheless.

Talisha wasn't aware that the operator had contacted the facility. The operator provided Mrs. Scott with Talisha's statement and suggested that she be sent out to the nearest hospital for testing. Mrs. Scott agreed. Talisha was beginning to realize that her secret was out, whether she liked it or not.

Mrs. Scott was extremely sympathetic about the entire ordeal, and truly felt sorry for this girl. She saw so much potential in Talisha. Sadly though, she wouldn't get the chance to see Talisha maximize any of her prospective opportunities. Mrs. Scott took a few deep breaths before she began going over her questions. "Talisha, I am going to ask you a few questions. You don't have to say much—a simple yes or no will do. Agree?"

Talisha nodded her head in agreement.

"I want you to know that I received an anonymous call that you were raped. Is this true?" Talisha looked at the floor and whispered, "Yes."

"Did this happen when you and Danielle left the facility?"

Talisha continued to look down at the floor as she responded. "Yes."

"Do you know the person who did this to you?"

"No."

"Last question. Do you have the logbook?"

Talisha wished at that moment that she could have reversed the course of time. She realized how her actions had jeopardized a great

opportunity at Florence Courette. Talisha was terribly remorseful. "Yes, I have the logbook. I hid it in the ceiling on the East wing upstairs. I'll go get it." Talisha strolled through the facility and retrieved the logbook. She was saddened by the thought of leaving. The staff and residents were extremely kind to her. She had learned new skills and had made new friends—something she hadn't done in the past. Now she would have to take what she had learned—both bad and good—and make the best of her life.

Talisha went back to the administrative office. Mrs. Scott informed her that she had no choice but to report what happened to the authorities, and that the police and paramedics were on their way. Talisha nodded her head again in agreement. She had finally come to terms with the extent of the situation.

Anguish

———

TALISHA SAT IN self-pity, as Aunt May's hurtful words echoed silently within. She briefly reminisced how Aunt May used to hover over her and scornfully berate her with vile remarks and comments. For a moment, she thought, "Maybe Aunt May is right. Maybe I was born to be a failure." Talisha felt like an overachiever in her self-made, collapsing world. She wanted to flee, run away again, but the sad reality was that she had nowhere left to go.

A familiar sound rang close, that of sirens emanating from the ushering ambulance. Although it was only just outside the facility, Talisha fantasized that the blaring vehicle was blocks away, en route to a real medical emergency. Her mind was trapped between her conscious and subconscious thoughts, and the darker side had gained the advantage. She tried to focus on her next steps, the part of the story yet to come—including her next home—but Talisha wasn't in control of her fate. She couldn't run, neither from her seat, nor from her mistakes. She was literally suspended in time, trapped in the past. That is where Talisha lived for now.

Mrs. Scott briefed the paramedics and the police on the weekend events, explaining that Talisha had been discharged from the facility and that her social worker arranged for her to be transported to the private residence of an elderly woman who took in foster children. The

paramedics walked Talisha across the short distance to the ambulance. Not visibly scarred nor soiled, Talisha's scars were hidden, sequestered deep in mental anguish and emotional turmoil, far from what the eye could see.

It wasn't long before Talisha reached the hospital. She was taken into a private room and told to get undressed. Shortly thereafter, the emergency room doctor, accompanied by a nurse, entered the room and asked Talisha specific questions regarding the attack. Trauma had taken its toll, and Talisha was terrified to speak. Flashbacks of the strange man, trapping her in an unfamiliar room and committing a most heinous act against her continued to replay itself in front of her eyes. The evil on her perpetrator's face haunted and taunted Talisha, an endless loop of savagery. She wanted to confront him. She wanted revenge. She wanted the police to arrest him, put him under thick rock and stone of the jail, so that the warm sun couldn't penetrate his skin. She wanted him to suffer as she did, but her thoughts and feelings were overshadowed by a mantle of shame mixed with fear, lurking inside Talisha's battered mind.

Talisha often wondered how other people had seemingly happy lives. She thought about how her life had been shattered and uprooted so early on in her childhood, how H.J. had chosen another life, how her mother succumbed to the terrible fate of a broken heart, and how she was moved about like a pawn in a chess game, only to end up having to survive yet again, under the disturbed oversight of her mother's evil sister. "Why is this happening to me?" Talisha sobbed in front of the doctor and the nurse. Surely, they thought, Talisha's shed tears were from being attacked. They had no clue what a young, sixteen-year-old Talisha had endured thus far in life.

The nurse consoled Talisha. Her voice was calm and unwavering. Her kind words helped soothe Talisha at that moment, for certainly in its absence, there would be nothing to coax Talisha out of her horrifying reverie and disengage her from her troubled past. "Hon, you

wanna tell me what happened?" The nurse knelt at Talisha's foot and looked up with genuine concern. Talisha wasn't a hardened teenager. Her eyes were soft and remorseful. She was also terribly frightened and confused. She didn't dress provocatively, so the assumption of Talisha being a streetwalker wasn't up for grabs either. The nurse reached out for Talisha's hand. "Hon?" she repeated, "Come on, baby, share with me. What's up?"

Talisha withdrew her hand, thinking, "What if he finds me? What if he is standing outside the door? What if I say anything and he gets locked up? Will he try to kill me or send someone to do it?" Talisha remained silent, paralyzed with fear and self-loathing.

The nurse approached Talisha. "Hon, I understand this is difficult for you, and it's okay if you're frightened. I would be too if I was in your situation, but you don't have to be scared, because the police are right outside this door, and they won't allow anything to happen to you. Plus, we won't allow anyone to hurt you, alright?" A despondent Talisha looked the nurse right in her eyes. Talisha was the type of person to follow her heart, even if it lead her to jump off a 100-mile-high cliff. She believed the nurse's words to be sincere, so she nodded "yes" in consensus.

"Okay hon, I am going to take this device and scrape under your nails and then I am going to use this little comb on your private parts. Once I am done with that, the doctor will take this swab, stick it inside of you to check for any sperm. Okay?" Talisha didn't want to go through with the test. She was mortified that she was at the hospital being picked at and probed while her perpetrator remained free from punishment. Suddenly, Talisha exclaimed, "What about him!? Where is he! Where is the person that raped me! Has he even been arrested?" The nurse was startled, yet empathetic to Talisha's overly aggressive line of questioning. She continued to gently peel back Talisha's layers, in an effort to get Talisha to tell her more about the incident.

But there would be nothing more to say. Talisha was ready to leave the hospital at once. Nothing else mattered. Then came a knock on

the door. It was a burly police officer talking on his radio. He asked to enter the room. He was very tall and imposing, and his voice was highly intimidating. His eyes, however, told a different story, one that gave Talisha a ray of hope, and the impression that just maybe he was on her side. Right then and there, and directly in front of Talisha, the police office spoke, first talking to the ER doctor, but staring into Talisha's eyes the entire time.

What came out of his mouth gave new life to Talisha. "We went to that location of the address provided and spoke to a Mr. Darnell, allegedly the victim's boyfriend. We discovered that the victim's boyfriend is twenty-two years of age and lives with his mother. His mother was unaware that the girls stopped by. Obviously, she was upstairs thinking it was just her son and a few of his male friends. Nonetheless, we found the room described in the report. Per the victim's statement, a blanket matching the description was retrieved from the location and sent down to forensics for DNA profiling."

The officer's delivery pierced Talisha's soul. He spoke beyond his authority. He gave her just enough information so that she may tell what happened and at the same time, and with so little words, he somehow reminded Talisha of her mistake. The officer's tone now softened. "Did you know your boyfriend is twenty-two and does he know that you're only sixteen? You know there is a statutory law involving minors—you—and two people could be going to jail." Talisha grew increasingly frightened by the minute. She had no inkling of the definition of statutory, even less so the law behind its meaning, and she could care less. Her focus was on the officer's last words—two people could be going to jail.

A muffled voice was heard. Talisha asked, "Why am I going to jail, sir?"

The doctor smirked and covered his mouth. The officer sighed then proceeded. "That is not what I meant, miss. You are not going to jail, but your boyfriend sure is once we hear more from your story."

Talisha didn't want Darnell to get into trouble. After all, she was the one who pursued him. She was the one who jeopardized a great opportunity at hand and created an unnecessary scene at Florence Courrette. It was all her fault, not Darnell's. Besides, he wasn't even there when she was attacked.

The nurse became weary with the doctor's smug disposition and the officer's authoritarian rule. She asked, "So, you have the person in custody who sexually assaulted her?"

Talisha clawed her nails into the hospital sheets.

The officer said, "Frankly, no. But we have the suspect's name and address and a cruiser was sent to that location."

Talisha trembled, "What is his name?"

The officer replied, "Your boyfriend gave a name, Mr. Terrence Darbell, and said they call him Rabbit." The officer noticed how Talisha stared at the floor. She was empty, clueless—lost. "Miss, are you saying you don't know the suspect?"

This latest information lifted a great weight from Talisha's already overly burdened shoulders. She went over the entire story, scene by scene, right in front of both the doctor and the nurse. Talisha wanted to be free of the anxiety, the shame and mental anguish of the attack, and for the moment, telling the story relieved her of those ill feelings.

Talisha's mouth was parched from speaking. She felt a slight victory within reach. Her attacker was about to be captured, and he was about to pay not just for his violation, but for all the horrific things that happened to Talisha.

The officer thanked Talisha for her bravery. Before leaving, he took one more glance at her, and then shut the door. Talisha traveled back to fantasy land again, wishing the officer was her real daddy. She thought maybe she would be in a beautiful home, with her own room, decorated with all beautiful glitz and glam. She thought about being disciplined and guided, that she might be an honor roll student, competing in spelling bees or math contests.

"Hon, do you hear me?" Talisha snapped out of her fantasy world and back into reality. With a puzzled look, Talisha said, "Huh?"

"Hon, we are about to start everything and get you out of here. It won't take long. I promise."

The nurse gently scraped under each of Talisha's fingernails. Talisha asked, "Why are you doing that?" The nurse responded, "This is the procedure we go through any time someone has been assaulted. We do this to gather evidence." The nurse paused. "I know that this incident took place two days ago and you've since showered, correct?"

Talisha nodded yes.

The nurse continued, "Have you washed inside of you with any douches or anything like that?"

Talisha wished she could have washed away the entire incident, but it would have never been possible. She answered, "I just used Ivory soap. That's all."

The nurse nodded. She then picked up a small black comb. "Talisha, I need you to lay back. I am going to comb through your pubic hair and then the doctor will take a sample from inside you."

Talisha laid back and placed her feet in the stirrups. She took a deep breath and allowed her mind to take her into a far more favorable future.

Talisha anticipated a quick arrest, then a court appearance where she would be required to testify. She projected what she would say when faced with her perpetrator. She thought about his rebuttal and how he would probably say something like "Your honor, she agreed to having sex with me." Then she considered that the judge wouldn't believe her story, and that he would penalize her for lying and send her to one of those locked facilities for unruly teens.

Talisha jumped up in horror. "Oh my God!" She hyperventilated from the thought of being locked away.

The doctor was frustrated. "Nurse, please hold her down so I can finish up."

Talisha apologized. "I'm sorry. I guess I had a bad dream."

The nurse held Talisha's hand and smiled. "He's almost finished."

The doctor looked up at Talisha, saying "You can get dressed now."

Talisha asked, "Did you see anything?"

The doctor informed Talisha, "I will send the samples we took out for testing and you will have to wait for the results."

"Well, how long will that take?"

The doctor said, "I don't know—weeks maybe."

Talisha wanted the satisfaction of knowing that her perpetrator wouldn't just be visiting jail. She wanted all the evidence for a solid conviction, but now she must wait for not only due process, but for the collected evidence to substantiate her claims.

Talisha was almost dressed by time the doctor and nurse left the room. She was anxious to leave and even more nervous to find out where she was going.

Talisha opened the hospital door. It felt to her like a trapped world with the doors closed. Besides, Talisha was curious about almost everything, so she opened the door to take in the busy and watchful eye of the hospital staff, buzzing around, all over the place.

A woman walked up and knocked on the door of the room in which Talisha continued to wait. "Hi Talisha. I am here from intake. I am going to transport you to a foster home not too far from here. Gather your things."

Talisha had two plastic bags of belongings. It wasn't much. Most of the items were hygienic supplies and a crochet blanket with some yarn. Talisha planned on crocheting her mother a blanket for her birthday that year. She always thought about her mother and delighted in doing things that would make her mother smile, but then she considered how she disappointed her mother with her self-sabotaging behaviors. She thought to herself, "Man, what is wrong with me?"

Talisha was taken to another home, on the opposite side of the city, one that was stunning on the outside. There were three levels of

steps to the house entrance. The lawn was well-manicured, accented by tulips and hasta plants. The front porch was draped in bright yellow, sheer curtains, neatly tucked away at the sides, and in between the curtains hung a vibrantly healthy fern.

Talisha thought, "Wow, this place is nice!"

An elderly black woman, appearing to be in her late sixties or early seventies, was waiting at the door.

"Come in."

Talisha couldn't believe her eyes. The inside of the home was even more luxurious than its exterior. Talisha felt like she had landed in one of those episodes of "Lifestyles of the Rich and Famous." The woman introduced herself. "You must be Talisha. You can call me Mrs. Ethel. Are you hungry?"

Talisha cheerfully answered, "Starving."

"Okay, I prepared a sandwich for you. It's on the kitchen table. You can take your stuff upstairs to the second room on the left. Once you finish eating, you can go upstairs. There is some sort of play-game or whatever it is called up there. Let me talk to your social worker and then I'll be right up."

Talisha felt comfortable right away. She couldn't believe how her luck was turning around. For the longest time, she wanted a loving home, complete with appealing décor and acts of kindness. Only one thing was missing from this otherwise perfect place: this wasn't Talisha's home.

A week went by, and Talisha started feeling uneasy. She missed her friends at Florence Courette. She was lonely at her new foster home and outside of playing video games, there just simply wasn't anything to do.

Talisha ran away without saying goodbye. She was convinced she could live out a much happier and loving life living with Keisha. She recalled those happy feelings when she would visit Keisha. Talisha refused to let go of the memory of those moments. Now that Florence

Courette and foster homes were out of the picture, Talisha felt like there was nothing else standing in the way of reconnecting with her older sister—except for Terry.

Talisha always wondered why her family separated her from Keisha. It never felt right to Keisha and it just wasn't a logical thing to do, especially after the passing of Tasha. Talisha believed family should stick together, even under difficult circumstances. Talisha rehearsed what she would say to Terry. She anticipated Terry being able to use added help in keeping things clean and neat, or an extra set of hands for runs to the store. Whatever was on that to-do list, Talisha was up for the challenge.

"Taxi!"

Talisha didn't have any money and she was sure Keisha wouldn't pay for the cab. She didn't know how she would pay for the ride, but she somehow had to make it across town. Talisha gave the taxi driver an address one block over from Terry's address. She got out and told the cab driver she was going to get the money from her mother. Talisha cut down an alley, circled the block and ran up to Terry's door. She knocked so hard on the door that everyone inside thought she was the police.

Terry came to the door. "What are you doing here? Scratch that. How did you get here?"

Talisha was quick with her answer—even though she fudged the truth. "I walked."

A troubled look came over Terry's face. "You walked? From where?"

Talisha wasn't prepared for all the questions Terry was throwing at her. "I left that place. I came to stay with you—with Keisha."

Terry didn't say another word. She pointed upstairs. "Your sister is up there. Go tell her what you've done."

Talisha darted up the steps. She was delighted that Terry hadn't forced her to leave. She thought this was the dream she had waited for. She will be together with her sister. Talisha was so excited, she didn't even knock. Wham! Talisha busted through Keisha's bedroom door.

"Keisha!"

Keisha jumped up out of bed like she had seen a ghost. "What in tarnation?! Your tail damn near scared the piss out of me. Luckily for you, I didn't pee. What are you doing here?"

"You not happy to see me?" Talisha jumped on Keisha and poked her stomach.

Keisha turned her nose up. "Get your dirty sausages off me. I don't know where your hands been."

A disappointed Talisha said, "Now that wasn't nice."

Keisha lit a cigarette and sat on the edge of the bed. "You ready to tell me the truth? Cos you're about two seconds from getting out my room."

Talisha's plan of happiness was swiftly met with defeat. She was under the impression that Keisha would be excited to see her, but the odds were not looking favorable.

"I left."

Keisha took another puff of her Newport cigarette. "You left where?"

Talisha uttered, "I left the group home."

Keisha slowly blew out the cigarette smoke she had so eloquently inhaled. "Well, you can't stay here. Those people will be looking for you and they better not show up here. You got to go."

Talisha was heartbroken and could not believe what she was hearing. She even felt betrayed. How could Keisha feel this way? Why was she so quick to turn Talisha away? Talisha thought, *This is my kin treating me like I am some strayed dog on the street.*

Talisha began to cry.

"Don't give me those crocodile tears. You ain't slick."

Talisha was tired of the charade. She wanted to stay with Keisha, but knew that she had overstayed her welcome in a matter of minutes.

"Okay, I'll leave. Let me just take a quick nap. I am so tired. Please, Keisha? You can even wake me up in a few hours and I'll go."

Talisha was exhausted. She wanted, however, to bask in the moment with Keisha—even if she was unwelcome. Talisha watched Keisha run in and out of the room and talk on the phone. Talisha might as well have left. Keisha pretended Talisha didn't exist anyway.

Talisha was bored with watching Keisha and fell asleep. She was awakened by a bright flashlight and taps. Two police officers were inside the house telling Talisha to wake up. Talisha couldn't see their faces. She could only hear the voices.

A discombobulated Talisha asked, "What's going on?"

One of the officers responded, "Don't act stupid. You know exactly what's going on. Come on. These folks don't want you in their house."

Talisha became outraged. "You called the cops on me! Your own flesh and blood. I am your sister! Why would you do that?"

Keisha laid in her bed with a smug look on her face and waved bye.

Talisha was devastated. She had been betrayed in the past, but never expected for Keisha to partake in the ring of fire, and even with the striking blow, Talisha would forgive Keisha—time and time again.

Talisha was taken to the local precinct—but not for booking like most criminals. She was held there for a few hours while her social worker planned her next recourse. Talisha didn't mind her short stay at the precinct. For her, it was just another adventure, a short stop on a long journey. She spent her time watching desk officers loading up on cups of black coffee, taking nagging calls and writing lengthy reports. It was almost as if she wasn't there. She thought, *Am I dead? Everyone just seems not to notice me.* Then an officer approached her.

"Hey, someone will be here to get your shortly. Hang in there."

Talisha just stared at the officer with a blank face. If looks could kill and if people could read minds, the officer would've known at that precise moment that Talisha had had a change in character.

She shrugged, "And?" she said, not really listening for or expecting an answer. Talisha thought, *I don't even care anymore. Nobody cares about me or what happens to me. I just don't give a shit.*

Sadly enough, throughout the years Talisha internalized her outside world. Her abandonment as the youngest child, the physical abuse by H.J., the hospitalization following on the heels of parent absenteeism, Aunt May's vile shenanigans, the substitution of love for her father replaced by men, the sexual assault, and finally the illegitimate love from Keisha, brought Talisha' world to a crashing halt. She had reached her wit's end. Her life was about to change—and it wasn't for the better.

Contemptuousness

M ATTHEW WAS FIGHTING in the Gulf war at the time of Talisha's tumultuous upbringing. He wasn't aware of any of the events that had transpired back in the States and, to be frank, his family was the least of his problems. Matthew had headaches of his own.

Matthew was at sea on a three hundred thirty two meter long, nuclear powered aircraft carrier named the USS Theodore Roosevelt. Afloat at sea, the ship's massive size equaled three and a half football fields. Every now and again, Matthew would leave his quarters and head for the top of the ship, just to observe the colossal carrier grip the mighty waves of the relentless sea.

Matthew was a petty officer in the military. He was also a religious and disciplined man, anchored in his faith and beliefs, and for the most part, Matthew appreciated being at sea, far away from his dysfunctional family. He traveled across the great oceans, visiting continents he would not have otherwise seen on his own account, and enjoyed the taste of learning about their cultures, particularly when he visited the Great Pyramids of Giza. This was the turning point in Matthew's belief system. He never questioned God's existence, not once. Before Diane's unfortunate downturn, she made certain to sow the unshakable seeds of spirituality in her kids, and this kept Matthew buoyed in his faith while away at sea.

There was something else, though, that sparked the flame in Matthew's spiritual lamp. He was taken aback by the different sects of religious worship and communal prayer in the same temple. Back home, people of different faiths and beliefs were divided up, and Matthew couldn't recall a time when he had witnessed the coexistence of faiths. Then came the trip to Giza. Matthew was flabbergasted by the girth and depth of the pyramids, and awed by the spectrum of their beauty. To Matthew, he was staring directly at God's fingerprint, and may have even found himself right under it.

Matthew occasionally thought of his family, and during those moments truly wished that they could have shared in these experiences as well. He knew that Talisha was far too young to enlist in the military, but he was still hopeful that one day she too would have the chance to embark on such an impressionable journey.

Outside of the war, Matthew would have remained in the military up until retirement. The constant takeoff and landing of fighter jets, however, was wearing on him. Living at sea and touring unfamiliar lands was quite different from being trapped in the vastness of the ocean and in the middle of a war. Matthew had to keep his mind focused on the task at hand, and not give in to the great mental and emotional traumas that loomed in the back of his mind. It was tough, though, not to think about the "what ifs." The probability of the carrier being hit with ballistic missiles by the opposition or operational errors with fighter jets was indeed a reality he couldn't help but ponder. The USS Theodore Roosevelt, however, was a part of a fleet of great vessels, and those other carriers weren't going to allow danger to come to his ship; it was too important to the mission at hand.

While Matthew was at war in the Middle East, Talisha was back in the states, at war with herself and anyone who came against her. Talisha had changed—not like her mother or Ms. Sumby though; instead, Talisha had developed a rebellious heart. Things became clearer to Talisha, at an impressionable and critical time in her life.

She no longer looked at life through naive eyes, as the time for that way of being and behaving had long since passed.

Talisha came to terms with the absence of her parents, and the lack of attention and affection that comes with that reality. This loving, caring experience was something that every child yearned for from their mother and father, but for Talisha, this was no longer an option. She struggled, but eventually came to terms with this harsh truth. She even made peace with the memory of a two parent, loving home, complete with warm smiles and sweet aromas of cooked meals. She made a vow with herself and with God. She shouted out, "God! When I become a mother, I will never give up on my children! Ever! I will be the best mother possible and they will receive everything I didn't get!"

Going forward, Talisha would continue to entertain her future fantasies. She imagined being a housewife, like her mother, with a beautiful house, landscaped with an array of flower beds and children happily playing safely nearby. The thought pleased Talisha, bringing some joy to her otherwise drab and disappointing existence.

Talisha hardly pictured herself finishing school, going to college like Tasha, and landing a well-paid and prestigious career. That was the least of her desires. Talisha was fixated on her childhood, and stunted in her growth and development. She grew with the years, but her fanatical inner self wanted to remain childlike.

Later that day, Talisha was taken to a group home in Severna Park, Maryland, which was approximately forty-five minutes outside of Baltimore city. Her social worker was hopeful the distance would curve Talisha's impulses to run away. Contrary to expectations, however, Talisha was dead set that no matter where she was placed, she wasn't staying.

Talisha somehow found interest, though, in her new and temporary shelter. That year's summer was the hottest on record, and there was a pool on the grounds, which to Talisha was the next best thing to a

water park. She was tempted right away to make friends, but not for closeness; she still felt too vulnerable. For that moment, Talisha just wanted to be innocent again and have some unadulterated fun. She gazed down on the diverse bunch from the upstairs window, thinking how fantastic it would be to join in the diving and handstands. She recalled the times Aunt May kept her away from her friends, especially during the summer months, and she remembered thinking despondently of her time living with Aunt May. *Enough dwelling on that depressing time*, she thought, and then ran downstairs so fast, any bystander would've sworn she wore a cape.

The group cheered and clapped their hands as soon as Talisha stepped out on the patio. One of the male teens whom Talisha found strikingly handsome took the first step towards breaking the ice. "About time you stopped being antisocial," he ribbed her, a disarming smile spreading across his face. Normally, Talisha would have smiled with kindness or just shrugged her shoulders, but under these new circumstances, her guard was up. Just this once, though, Talisha ignored what she thought to be an offensive statement; she was the new kid on the block, so to speak, and outnumbered. Besides, the young man was very pleasing to the eyes.

Talisha sat at the shallow side of the pool while the other teens played Marco Polo on the deep end. "Hey, come down here with us!" Talisha followed the raspy voice. It was coming from one of the older girls Talisha had seen come into the office during admission. The unassuming teen did absolutely nothing to put Talisha at ease. Even though this girl wasn't all that pretentious, she nonetheless set the nerve endings going up Talisha's spine on edge. It wasn't Talisha's fault that she had developed a capricious temperament. She was just exhausted from so much misplaced hope and unanswered prayers.

Talisha snapped at the girl in a snarky voice, "I'm okay just where I am."

One of the boys in the pool, looking for extra excitement, decided to agitate the pair, "Oooh, she told you."

The teen remained calm in light of the provocative situation, shrugged her shoulders, and said, "Suit yourself."

Talisha rolled her eyes and continued swishing her feet through the water. She could see her reflection in the pool. She didn't recognize herself. She was split. On one shoulder was the birthed devil, egging her on, and on the other shoulder, there was her higher self that reminded her of her humanity. She thought, *What happened to me? I don't want to turn out like Aunt May. She is a fuss box and just plain ole mean.* Then Talisha thought about her mother—Diane. *I love my mother,* she ruminated, *I love her so much and I miss her dearly, but I damn sure don't want to be like her either. Tasha is gone and Keisha don't love me.* At that moment, Talisha decided to settle for heartbreak, deal with it, and just make the best of a bad situation.

Talisha had no role model. She idealized singers and entertainers for direction, which meant that she lacked guidance and discipline, much to her detriment. Thankfully for Talisha, she was conscientious and tried her best not to look the other way when it came to her wrongdoings. *Must have been those spiritual seeds Diane sowed years ago,* she mused.

Later that evening, and after dinner, Talisha decided to befriend the young girl who had tried to draw her in earlier that day.

"I apologize for earlier. I didn't mean to come off rude."

The young girl was still polite in her response. "It's okay. Everybody is like that when they first get here, then after a few days, they either loosen up or leave."

Talisha sat down, intrigued to learn more. "Oh, for real?"

The young girl explained, "The Weinsteins had me since I was little. They told me that my mother used to get high and eventually gave me up. She probably somewhere still doing that stuff. Sad."

Talisha was empathetic to the young girl's story. She felt compelled to share her own. "Yeah, I know what that's like. My mother is in New York. She got sick after my dad left and was never the same."

The young girl, now eyeing Talisha curiously, replied, "Oh, so you're from New York?"

Talisha was used to that type of response. When most people heard Talisha's New York accent or sized up her style choices, there was generally a level of intrigue that followed. Talisha sighed.

"Yeah, you could say that."

Talisha contemplated her next moves that night. She felt awkward that she shared a glimpse of her story—especially about her mother. Talisha was purposefully secretive about her life. Only a select few were privy to understand what was behind those mysterious eyes. She thought, *Man, I should've never told her anything. I don't even know why I said anything. She don't need to know anything about me or my mother.*

The next morning came. Talisha was gone. She left in the middle of the night, after everyone fell asleep. Unlike those times in the past when she had run away, Talisha failed to come up with a plan. She had nowhere to go and even if she had had a place in mind, she had no money, no available transportation to get there, and was far away from what she deemed to be civilization.

Talisha walked off the grounds into a wooded area. The only light she saw was from the moon and the stars shining down from above. She held her hand up in front of her eyes but couldn't even see a finger and with every step, she thought she had been followed. Her imagination was getting the best of her. She paced her breathing with her feet until she was sure someone was about to grab her. That's when her feet outpaced her breaths. She ran as fast as she could until she luckily stumbled upon a highway. She was so out of breath, she had to sit by a nearby ditch to control her breath, which was now coming in gasps. She stood up to see where she was and saw a sign that read 'Annapolis.' She thought, *Annapolis?*

There were no rest stops in sight or traffic lights—the area was strictly for highway traffic. Talisha was faced with three decisions.

Take a chance back through the dark, wooded area to the group home and hope that no one noticed she had left, remain seated by the ditch until sunrise, or attempt the unthinkable—hitch a ride. Talisha chose the last of the three.

After she scooped up her heart from the ground, she had to hold in it place while she flagged down a ride. It didn't take long before a kind soul pulled over. A middle-aged, Caucasian man yelled out, concerned, "What in God's name are you doing out here alone?"

Talisha ran up to the vehicle. "Sir, I need a ride to Baltimore. Me and my boyfriend got into a fight and he put me out right here on the road."

Talisha wasn't bruised or battered; not visibly at least. She was, however, shaken up from her lone wolf walk in the woods, which made her story very plausible.

The man turned on the lights inside the vehicle. "I wasn't going that far down, but seeing you out here alone and all, by yourself, I would feel terrible if I turned on the news in the morning, and saw you laid up dead along this here road. Hop in."

Talisha casually took a seat up front with the seemingly kind stranger. She pretended not to care about the possible consequences of her actions; she was still very gullible and thought the ride was worth any risk. She watched the driver's every move—how he shifted his eyes, how he grasped the steering wheel, and how he carefully paid attention to the road. Her mind did its best to control her rising anxiety. *She thought, There's no way this man is crazy. God, please protect me if he is.* Talisha felt like she was on top of the situation, even though the truth was that she was at the mercy of this stranger. She cringed at the thought of her made-up story about a fight with an imaginary boyfriend. *Oh my God, what an idiot I am,* She thought. *I talk way too much, and just need to say as little as possible.* Talisha grew fearful that the kind soul who pulled over onto the side of the road was the next opportunist. She gripped the car's door handle and waited

for anything unexpected to happen. The only plan she had now was to jump out of a moving vehicle.

Luckily for Talisha, the kind man kept his word. Talisha was delivered to her sister's house. She wanted to give the man a few bucks for the lift, as she felt a debt of gratitude for his servitude, but the only thing Talisha had in her pockets was a hope and a prayer.

"I really appreciate you giving me a ride. Thank you."

He replied, "Well, like I said, there are some bad people out in this here world. You best gone inside now and stay away from that boyfriend of yours. Any man that leaves a nice girl like you on the side of the road is no good."

Talisha got out the man's car unscathed. She briefly thought about the staff and the other residents at the group home. This time she uttered under her breath, "Well, they don't know me anyway. Perhaps they will stop chasing me. Stupid dummies."

The glow of the morning's sun started to light the sky. Talisha could feel the thickness in the air. She wanted to knock on the door just so she could sleep for a few hours, as she had fought the night to get there and was exhausted from the effort. She took a seat on the steps to think of rebuttals, but had none. She was so tired and empty. "Oh well, here goes nothing."

She modestly knocked on the front door. For a hairsbreadth of a second, Talisha's mind went blank. It then created visions of her falling asleep again, only to be awakened by police. She dismissed the efforts of her consciousness and silenced her mind. This time she would knock harder. Knock! Knock!

Terry sent her son to answer the door. He cracked the door open just enough to stick his head out on the side. His eyes were slightly closed and there were drool stains around his mouth from his restful, overnight slobbering. Talisha frowned at the sight. She pushed open the door. "Move, let me in."

Terry's son was five and a half years younger than Talisha and the least confrontational of the bunch. He was more of tattletale.

"Ma! It's Talisha. She pushed me!" Terry's son screamed through the house like a choir boy with the holy ghost. It was only a matter of minutes before Talisha would be ushered out again. Her anger had reached her breaking point. Had it not been for "Mr. Loudmouth," Talisha could have caught a few hours of sleep.

Talisha screamed back as the human alarm ran upstairs to jump back in bed. "You make me sick. Why don't you shut up sometimes?"

Terry was awake at this time and had heard the exchange. "Come here, Talisha!" Terry's tone had shifted from what Talisha was normally used to hearing. Talisha didn't pick up on the change. She was overtaken by sleep deprivation coupled with heightened emotions.

Talisha stomped up the steps. It was a standoff of fire versus fire. She approached the threshold of Terry's bedroom, arms crossed in front of her chest and a bad attitude on full display. "Yes!"

At first, Terry thought she had to be dreaming. There was no way that Talisha was back at her house after she was not too long ago taken out by the police. Terry was in disbelief. She couldn't believe that Talisha had returned to the house at five in the morning, interrupted her precious sleep, caused a disturbance throughout the house, and was now standing at her door insulting her with an expectation of privilege.

"Girl, you better lower your voice and uncross your arms right now!"

Talisha was at her breaking point. To Talisha, her life was off-track, moving in a sideways direction. It didn't matter at that point what Terry did. Talisha simply didn't care.

Talisha readjusted her body language. She uncrossed her arms and then placed her hands on her hips. "Okay."

"Why are you back at this house?" Terry scowled at Talisha.

Talisha moved into Terry's bedroom, with a much softer tone, and childlike manner. "Because I have nowhere to go."

Talisha knew just how far to push Terry's buttons. Terry had a good heart for the most part. Family said she sometimes acted like a

pushover, but there was another layer to her that most people were relieved to discover. Terry had this compulsive behavior that returned whenever she became frustrated. She would stretch her eyes so wide that she looked bat-shit crazy. Then she started shaking her leg. The act was intimidating to most people standing on the opposite side. To Talisha, not so much. If it wasn't for Talisha's emotional upset, she would've certainly busted out in laughter.

Terry firmly replied, "You was at Aunt May's and it didn't work out. You went from group home to group home, place to place, and you think you going to waltz your way up in here?"

Talisha was frozen. She couldn't focus on Terry's words. She wanted to reply but no sound came forward.

"Girl, do you understand the words coming out of my mouth?"

Talisha found the word 'yes' in her brain's memory vault. "Yes."

"Yes, what?" Terry lowered her tone. "Look, Aunt May almost went to jail behind you and now you keep coming back here. Where do you think those people will look first?"

Talisha wanted to tell Terry that she shared a role in Talisha's whereabouts. After all, she was the one who called the police and gave them her address. Otherwise, Talisha believed her social worker would have never found her. Likewise, Terry was like a gypsy. She moved to a different place every year. Family said she would stiff landlords and not pay the last two month's rent.

It was becoming more evident to Talisha that she had overstayed her welcome, and that no matter how hard she pleaded, Terry was adamant about Talisha moving on.

Talisha took a deep breath and turned to walk away. For a moment, she thought about what she had done to herself by leaving the group home. Talisha was so disgusted with herself for giving everything up again and gaining nothing in return, she wanted to just break down and cry. But like she normally did, Talisha suppressed the reflective thought and fought back her tears. She took a few steps to go down

the stairs and heard the voice of Terry's son saying, "That's why you can't stay." Talisha wanted to respond with vile and harsh remarks, but it would've been to no avail. As requested, Talisha left.

Always Misunderstood & Never Understanding

————

WITH NO OTHER source of rescue in sight, and her refusal to go back to foster care or worse, Talisha decided it was time to go back to New York. She made a collect call to her uncle who lived in Co-op City, in the Bronx. Talisha wasn't sure what had been told to her uncle, if anything at all, or whether he would accept the collect call or hang up. Oddly enough, he accepted the call.

"Hello," uttered a soft, unassuming voice. Family used to say that Talisha's uncle was 'cut from a different cloth.' Besides the fact that he lived boroughs away from his family, Talisha's Uncle was also very health conscious. He was a fitness trainer and looked remarkably younger than his biological age.

Talisha was excited to hear her uncle's voice. "Uncle Steve! Thank God you answered."

The voice quickened with curiosity. "What is it? I don't have long before I have to leave."

Talisha hesitated. This was her last chance at getting away from Baltimore and its system. "I need money to come to New York. I want to see mommy."

Talisha's uncle snapped, "What makes you think I have money? You know I don't hear from you unless you need something. Now,

that's not right. Besides, what are you fifteen, sixteen years old? Who will you be traveling with?"

Talisha was fond of her uncle. He wasn't like Aunt May or other people Talisha came across in life. He told the story as it was, without sarcasm and incendiary remarks. Talisha felt bad about the lie she was about to tell her uncle, but she was desperate.

"Uncle Steve, I am eighteen. Oh my God, you're getting old. You forgot your favorite niece's age and I will be traveling with Keisha. We are going to pay mommy a visit."

In Talisha's mind, she wanted to be eighteen just so she could be free from the system. She anticipated working, having her own place, and freedom to do just about whatever she wanted—and for Talisha, that couldn't come soon enough. However, Talisha was sixteen years old, and even at that age, Talisha was so far away from her biological and emotional age that her decisions were often immeasurably off target and unrealistic. She didn't perceive that, once she received the money to get to New York, she had no clue who she would stay with, or for how long. Talisha planned her life as the day unfolded, on a minute to minute basis.

Steve cut Talisha short. "Yeah, yeah, yeah." Steve was a true New Yorker. He was a smooth, fast talker and very witty. "How much do you need? When do you need it by?"

Talisha was terrified of heights, so taking a plane wasn't even up for discussion. She thought about if she would be allowed on the train without an adult, and just as quickly gave up on it. "I don't know, Uncle Steve. Can you wire the money now? We will take the Greyhound."

"Now?!" Steve scoffed. "You know, you really got some nerve calling me collect, and expecting me to send you some money, at the snap of your fingers. You know that?"

Talisha held on to the telephone receiver so tightly as if it was her uncle's leg. She begged, "I know. I am so sorry, but I really need it."

Mmmhmmm, there it is. The real story surfaces, Steve thought to himself. Steve was a fair-minded man and was empathetic towards Talisha. He heard about some of the horrors she had suffered and always felt sorry not just for her, but for the tragedy the entire family had endured.

"So how much do you need and make it snappy."

Gratefully, Talisha exclaimed, "One hundred dollars!"

Steve yelped, "One hundred dollars? You have to be kidding me! What do you think, I'm rich?"

Talisha jokingly replied, "Well, you asked me."

"Okay, smart aleck. Here's what I'm going to do for you just this once, and don't make a habit out of it neither. I'm going to send you seventy-five dollars through Western-Union. That will be enough to catch the bus round trip. You and Keisha come up here to see your mother, and then turn right back around and head back to Baltimore. Am I clear?"

"Yes, Uncle Steve. Thank you. I love you so much. Thank you. Thank you."

"Yeah, well, don't thank me yet. I haven't sent the money."

Talisha put her enthusiasm on hold for a moment, and stopped to consider whether her uncle would keep his word. Talisha was no stranger to broken promises. Her gullible nature created an opportunistic atmosphere time and time again. It wasn't Talisha's fault. She wanted what she couldn't have—she wanted her family back, right at the age she had lost them.

Talisha was grateful that her uncle didn't shut the door to her only escape route. She provided all the information for the Western Union transfer and dashed to the nearest check cashing store. She waited inside the store, nestled away from the blistering heat of the rising sun. Minutes felt like hours. *What is taking so long?* she wondered. Exhaustion began to kick in, along with hunger pains, and Talisha was anxious to leave town. Every so often, Talisha looked at the cashier

behind the stained glass. Talisha couldn't take it anymore. She thought maybe the money was transferred and the cashier forgot to look.

"Miss, anything yet? I really need to go."

The cashier could read Talisha's anxious body language, along with the fact that Talisha was tired and dirty from her overnight journey.

"I think so. Hold on." The cashier asked Talisha, "What is the name of the person who sent you money and how much did they send?"

By this time, Talisha's nerves were completely shot. She could almost feel the money in her hand. She replied, "My uncle sent the money. His name is Steve Roberts and I think he sent seventy-five dollars."

"Your transfer is here. Sign this sheet, please."

Talisha jumped for joy. *My uncle is the best*, she thought. The cashier handed Talisha an envelope with a receipt. Her uncle had wired seventy-five dollars, as promised. Talisha was thankful for the money, although she hoped he would surprise her by adding the twenty-five bucks.

This would be one of Talisha's ongoing problems in life. She vacillated between things never being enough or too much of one thing. Talisha wanted everything her eyes could see and more of it, but whenever she received it, it was never enough to satisfy her insatiability.

Talisha flagged down a taxi, praying it wasn't the one she skipped out on. "Take me to Greyhound bus station, please." The cab driver arched his eyebrow, which made Talisha uncomfortable. Her imagination had gotten the best of her. She wondered if the police had her picture plastered throughout the neighborhood, or if the cab driver heard about a teenager hitching rides and not paying. Her attention focused on the door. The lock was missing. Talisha gulped. There was only one solution that quickly popped into Talisha's mind. Pay upfront! Talisha handed the cab driver a twenty-dollar bill, hoping to quiet any suspicions.

Talisha's fast thinking paid off, and she arrived quickly at the Greyhound bus station. Talisha thanked the taxi driver, went inside, and purchased a one-way ticket for the next bus leaving for New York. She watched the other travelers place their luggage under the bus. Talisha didn't have a suitcase, only a carry-on. She chose a seat in the middle of the bus, next to the window for sight-seeing. Not too long after she had seated herself, she fell fast asleep. She woke once when the bus slowed down to pass a toll. Then there was darkness. The bus went through the Lincoln tunnel. Talisha knew at that point that she had touched down in her hometown—the Big Apple.

The first thing Talisha thought about when the bus pulled into the station was a slice of New York pizza and Italian ice. She was famished. The day was coming to an end and she hadn't had a morsel of food yet. There were cabs everywhere. But before she chose her next destination, she made sure to get a gigantic slice of greasy, cheesy New York pizza. Talisha ate it in a few bites, then made her way to catch the next cab.

Someone called her name, "Talisha?"

What the hell? Talisha thought. She was about to take off running, for fear she had been spotted, until she turned back. The voice shouted again, "Talisha!"

Talisha bent down and looked in the cab where the voice had come from. She could not believe her eyes. "Uncle Charles?" It was Talisha's godfather. She had only but a few memories of him, all from when she was a child. Talisha was really happy to see him. She remembered how nice he had treated her when she and her family had moved in with Ms. Sumby.

Talisha asked, "Since when did you become a cab driver?"

Her godfather had been wearing dark shades. He removed them to get a better look at how Talisha had blossomed into a pretty young girl. His eyes were bloodshot red. He had been drinking beer. Talisha remembered hearing stories about how her godfather was a drunk. She

didn't believe the stories, nor did she care what people said about him. All that mattered to Talisha was that her godfather was kind to her.

Her godfather asked, "What you doing in Manhattan by yourself?"

Talisha was going to make up another story, but after seeing the can of Colt 45 wedged in between her godfather's legs, she felt more compelled to tell the truth. "Uncle Charles, I just got off the bus. I left, Uncle Charles. I hated Baltimore and everyone there."

"So, where you going?"

This was the question Talisha never considered. Talisha didn't want to stay at Ms. Sumby's place; the house just symbolized death and gloom to her. Had Tasha been alive, or if Matthew and Keisha were still living there, it would have been Talisha's first choice. "Probably over one of my cousin's house. I just need a ride to Corona."

Being the youngest of Diane's children was a disservice to Talisha. She didn't understand the extent of her family or the secrets they held. Talisha's godfather was gay, and was her real uncle's boyfriend. Her real uncle had passed a few years after her aunt had died. Talisha remembered the two living together, one block from Ms. Sumby's house, but never suspected they were lovers. Back in those times, same sex marriage was unequivocally forbidden, and although family knew what was going on behind those closed doors, they pretended it didn't exist.

"Girl, come on. Jump in. I will drop you off on Northern Boulevard. After that, you're on your own."

Talisha talked a hole into her godfather's head with sobering truth. She told him all the things that happened to her until she noticed he that he had popped opened another can of beer. She then switched the conversation to a less intoxicating memory. Talisha told her godfather that she remembered all the beautiful gifts he gave her as a young girl, and that out of all the people in her life, he held a special place in her heart. She vowed she would remember him by those deeds, and not by anything else.

Her godfather got Talisha to Corona in record time. He had to hurry back to his post in Manhattan to compete for fares. He still lived alone in the same apartment that he once shared with Talisha's uncle. It was a challenge to wake up in the same place, absent the company of your significant other of many years, and even more cumbersome trying to manage all the bills and debt by yourself.

Talisha exited the cab. She bid her godfather farewell. It would be the last time she laid eyes on him—one of the few people that had made a lasting, loving impression on her. Talisha would be told in incidental conversation that her godfather had died. No one knew for sure what happened, but people speculated that he probably died from a broken heart.

Talisha walked up Northern Boulevard until she reached the block where her father's side of the family once lived. She walked up to look at the house, wishing her family still resided there. Then she noticed a gang of Jamaicans by the front of the building, puffing away on what looked like tree barks of marijuana. Talisha was amazed by the amount of smoke in the outside air. Then the parked car outside of the building rolled down the driver's side window and more copious white smoke floated out. The troop passed the tree barks of marijuana around. Talisha was scared to walk by. She had never smoked marijuana before, or what her generation referred to as 'weed.'

Talisha scurried by. One of the Jamaican men was making marijuana circles in the air when she crossed his path. "Wah gwaan, brownin?" The troops laughed, all but one.

"Man, why ya trouble de young girl? Leave her be and just smoke your stuff."

There was a man on the side of the stoop, who at first looked to be unaffiliated with the tree bark smoking group, until he walked over and started shaking hands and giving fist bumps. The man caught up with Talisha and introduced himself. "My name is S-Soldier. Please f-forgive my friends. They don't know b-better. You live around

h-here?" The man who called himself 'Soldier' spoke with a slight stutter. It was quite the paradox.

Talisha eagerly answered, "Yep. I am the new girl on the block." She waited for his reaction. Just before he could segue into his alpha male pitch though, Talisha interrupted, "Psych! I was just playing with you." The man could tell Talisha was young, but that didn't stop his burning curiosity.

He probed, "Me can tell you not from here. Y-you're from down south somewhere." The man's statement angered Talisha. She didn't want to be associated with Baltimore.

Talisha was intrigued by the man's comments. "So what you saying?"

The man smiled and Talisha couldn't help but notice there was something innocent in the way he came across.

He replied, "you g-got to know you are a little country." His smile grew wider.

"Oh my God, for real. I lost my accent."

Soldier said, "Baby gal, me can't be sure you ever had one."

Talisha giggled. "Ah, man, that's messed up."

Talisha asked Soldier if the Hutchinson family still lived up the block. This was the family of Matthew's high school sweetheart, Patricia. Everyone in Corona thought Matthew and Patricia would've gotten married, as the two were inseparable. But then free will changed the dynamics of any sweet future for Diane and her children. Soldier eagerly replied, "Oh, you know th-them? Yeh, them still there."

Talisha scanned the man from head to toe and said, "Let me go say hi. I haven't seen them in so long."

It wasn't love at first sight, although the pair would eventually fall for each other. Talisha thought Soldier was too old and she judged his heart by his appearance. There was something about him that piqued her interest outside of the oversized Kango cap, the pleated, beige suit pants and ran-over shoes. Soldier's heart was in the right place. He

felt equally desirous about wanting to know everything about Talisha, even her age. He laughed as Talisha walked away. He thought she had a funny walk that resembled a duck waddling. Soldier was impatient just like Talisha. The truth was that he didn't want Talisha to go, for fear of never seeing her again. If he had it his way, he would've sat on the steps and talked to Talisha until the next morning's sunrise.

In the back of Soldier's mind, he felt Talisha was too young for his liking, but he was nonetheless smitten. His heartstrings had been stirred and strummed by this mysterious young girl with an even more shadowy past. He had to know her age, and wanted to ask, but was ashamed should it turn out that his attraction to her be on the forbidden side of things. Soldier burst out, "Hey, how old are you again?" Talisha was used to being asked her age, since she frequently sought out the company of older men. They had what Talisha thought she wanted and needed—established homes, luxury cars and money. Talisha swirled around, "I never told you. Nice try, though."

Soldier blushed, "Come on. You not gwann to tell me?"

Without a second thought, Talisha said, "I'll be eighteen in a few weeks."

Talisha wasn't far from the mark, had time fast-forwarded a year. She had been waiting to cash in on her eighteenth birthday like a bond about to mature. Most girls her age dreamed of their high school prom and college plans, but not Talisha. She would fantasize about the future just to be free from state custody and the grasp of families with ill intentions.

Talisha walked up to the Hutchinson's house. There was a familiar face seated by the open window. "Mrs. Hutchinson?" Talisha hadn't seen the family in many years.

"Yep, that's me. Who's asking?"

Talisha became childlike. "It's me, Talisha. Matthew's baby sister."

Mrs. Hutchinson wasn't pleased to see Talisha. She had watched how she had flirted with Soldier from the window, and thought he

was far too advanced to mingle with such a young girl. "You just like your mother, girl. How is she and Ms. Sumby doing?"

The secret was out. Almost everyone in Corona had heard about what had happened to Diane and her children. "I don't know. I just got here, but I am going to see her and my grandmother soon."

"That's quite a walk in this heat."

Talisha wrinkled her forehead. She thought age had ruined the older woman's memory. "It's only a block over, Mrs. Hutchinson."

Mrs. Hutchinson protruded out the window. "A block? Try fifteen. You've been gone so long; you don't even know what happened. Your grandmother and your mother were moved to that nursing home in Elmhurst. Something happened to her last year and she was found outside in the snow. Must've been out there for so long, she lost her toes."

Talisha's already small world just got a whole lot smaller. She was devastated. Talisha wondered why her godfather didn't tell her this troubling news first. Then she remembered the Colt 45 beer cans. She thought, *Everyone knows what's going on with my family except me!*

"Peggy and Lala are next door. Go knock on the door. I know they will be surprised to see you."

Talisha believed that this was Mrs. Hutchinson's way of saying "get lost." Things started to become a little clearer. The entire neighborhood knew that my grandmother was crazy and that my mother lost her mind. For that moment, Talisha shared in her family's pain before she suppressed the reality.

Talisha rushed next door to see her childhood friends. A new eye was keeping close watch, so Talisha played it cool. Two knocks later, Lala opened the door. Now, Lala was a few years older than Talisha and was quite mature for her age. She was also Corona's girl next door. Lala had a golden brown complexion, and long thick, wavy hair with slanted eyes and shapely hips. A decade later, most people end up telling Lala she reminded them of a young Kimora Lee.

Lala was equally excited to see Talisha. "Hey girl! Oh my God, what are you doing here?"

Talisha became perturb by the fact-checking of her sudden appearance. She quickly snapped back, "Why does everyone keep asking me the same question about why I am here? I live here, or did y'all forget?"

The pair busted out in laughter.

Lala said, "No, it's not like that. We just haven't seen you in years and nobody knew anything, and all of a sudden you pop up out of nowhere."

Talisha agreed with Lala that her unanticipated arrival deserved answers. She just wasn't ready to revisit the horrors she been through. Besides, she needed to settle somewhere. Given that she was the opportunist who knocked on the next door that presented itself, Talisha decided to ask Lala if she could crash at her place.

Before Talisha could raise the question, though, Lala invited Talisha inside. Talisha scanned each room she passed by. She thought to herself, *puke green must've been the only affordable paint color in Corona.* Yikes. Lala rushed Talisha to a back room, on the first floor. Talisha asked, "Who stays here?"

"This is my mother's house. She ain't never home. She be running these streets."

Talisha replied, "I don't think I remember your mother."

"You probably don't. Do you remember Peggy?"

"Who?" Talisha asked.

"Peggy? My sister."

"Don't remember her either."

Then, out of nowhere, arose the question Talisha had been waiting to ask came up before she could open her mouth; Lala asked Talisha where she would be staying.

"I don't even know. My uncle lives out in Co-op city and told me I could stay there with him, but I would be so far from my mother."

Talisha knew she had lied, and she almost always felt bad for doing so, but the truth was that Talisha had no plans for her life. Her one plan was to escape to freedom, to retrace her steps, and account for the years she had lost.

"Don't you have more family in Corona?" Lala inquired further.

Talisha affirmed, "Plenty, but I haven't seen them in years. Who knows what they will say?"

"You can stay here for now. Like I said, ain't nobody here but me."

Talisha was thrilled by Lala's generosity. The absence of a plan just became a concrete recourse, or at least for Talisha, a definitive resolve. "Girl, thanks." Talisha uttered. She went on to tell Lala, "I am really tired. I haven't slept in days. You mind if I take a nap?"

Lala was so unbelievably cool about things. "A nap? Girl, go to bed somewhere."

Talisha caught up on some well-deserved sleep that night and decided to head out the next day to visit Ms. Sumby and Diane. Talisha was excited to see Diane. Years had passed since she last saw her mother and she wanted to make a good impression.

"Lala, you have anything I can put on? I didn't bring much with me."

"Like what?" Lala answered.

"Just some shorts and a clean shirt. I'm going to see my mother and grandmother, and I can't look like this."

Lala gave Talisha a white and black polka-dot blouse and white slacks to wear. It was more suitable for the occasion and made Talisha feel quite spiffy. It took Talisha hours to get ready. Lala wasn't sure if she was going to see her family or going on a date.

"Okay, I'm leaving out. I shouldn't be that long and then I'll be right back."

It was near lunchtime when Talisha headed out. The sun was seated high in the sky, and Talisha had to walk nearly fifteen blocks to get to the nursing home. She passed her great aunt's house—H.J.'s aunt on the way, and thought she would one day stop by. Strange

that Talisha didn't stop to say 'hi.' She had always admired her great aunt and thought that she shared the same kindred spirit with her as she did with Diane.

Approximately thirty-five minutes later, Talisha reached the nursing home. She took a deep, uncertain breath and walked in. Her voice caught in her throat, and Talisha was instantly struck dumb, horrified by what she saw. She thought the place more resembled a psychiatric hospital than a loving and caring nursing home. Residents were running amok! Some were clearly overdressed for the season, others openly expressed what was on their minds, and a handful puffed away on cigarettes. The noise from everyone's chatter made Talisha feel like all her thoughts had spilled out of her brains and onto the filthy floor of the room. She wanted to run again, but this time she stayed put, looking to speak to anybody that might be in charge and could direct her.

"Hi. I am looking for Diane Johnson and her mother, Ms. Sumby." Talisha's voice cracked, and she withdrew into her mind, trying to disappear from the horrors she had witnessed. Talisha wasn't a stranger to what she had seen. She remembered the legacy H.J. left behind, but didn't know that the toll it took on her mother was so severe. For her to end up at a nursing home in her mid-forties seemed like such an untimely, tragic fate, and Talisha felt nauseous the more she thought about it. Suddenly a voice called to Talisha from nearby.

"Hello. Everyone is in the dining room having lunch. Walk straight down this hall and you will see them."

Talisha gulped in anticipation at what her eyes might now see. The closer she came to the dining room, the louder the chatter grew. There were circle-shaped tables draped with picnic tablecloths and at least five people to each table. Talisha counted the tables as she walked in to quell the rising anxiety inside. She scanned the room in an instant. Her eyes focused on the far-left side of the room, where she saw that her mother and grandmother were seated. She saw her

grandmother first. Ms. Sumby was frail looking, her shoulders and torso caved in and slanting toward the front of her body. Talisha could also tell tell Ms. Sumby was sad by the flat facial affect and the way she stared blankly at the other residents. Then Ms. Sumby spotted Talisha in the crowd as she approached the table. This was the image that would impress itself on Talisha's subconscious for years to come. Every muscle in Ms. Sumby's face protruded upwards. It was such a glorious moment! Ms. Sumby had that same surprised look on her face like Talisha had when she was a child, and Ms. Sumby would suddenly pop up with gifts she saved from every holiday and birthday that year.

Talisha wanted to relish in the moment, but then Diane was seated next to Ms. Sumby.

"Grandma! Mommy!" Talisha reverted to that little girl from her childhood. "How are you two doing?" Talisha looked over at Diane. The last memory of her mother had not improved. Diane was skin and bones. Her teeth had rotted from lack of dental care and her skin was pale and dry. Diane rocked back and forth in her chair as if an invisible force had taken control. Talisha stood in silence. She tried to hold back the tears, but the sight was too much to take in. Talisha broke down.

Ms. Sumby attempted to get up out of the chair to console Talisha. "Wat you crying fer?"

Talisha didn't want to exacerbate whatever was going on with Diane and Ms. Sumby, so she decided to tell them that she was just so happy to be in their presence after many years of being separated. Diane cracked a smile of acknowledgement as she rocked back and forth in her invisible rocking chair. The irony of that moment was ironically symbolic of Diane's unfortunate fate. Talisha returned the smile, but felt awkward by the exchange. Talisha could not grapple with what had happened to Diane. She felt like her mother was physically there, but that her mind was elsewhere. Talisha had hoped that Diane

had moved forward with her life, and that she had progressed to a state of motherhood once again. But as it turned out, Diane was stuck between a hopeless past and an unfamiliar existence.

After lunch, Talisha escorted Diane and Ms. Sumby to their rooms. The nursing home had placed Diane and Ms. Sumby in separate rooms. Talisha had felt so uncomfortable seeing Diane in such poor condition that she walked Diane to her room first. Talisha told Diane that she would visit often now that she was back in town. Diane gave a nod of understanding, then stepped unsteadily into and across the threshold separating her room from the busy hallway. Talisha then followed Ms. Sumby one floor up to her room, and watched as her grandmother took small steps across the floor with her wheeled walker.

Talisha did not think very highly of Diane's and Ms. Sumby's living conditions. She wished she could have kidnapped Diane and Ms. Sumby out of that nursing home, the same way she had so easily escaped the grip of others, but Talisha was at an unripe age. She lacked the necessary knowledge and discipline needed to care for Diane and Ms. Sumby, who were both vulnerable to the potentially negative outcomes of poor care. Ultimately, Talisha had to walk away knowing there was nothing further at that time she could have done, reasoning that Diane and Ms. Sumby belonged in a supportive facility and that to think otherwise was simply futile.

Talisha kissed Ms. Sumby goodbye. "Grandma, I will see you tomorrow, okay?"

Ms. Sumby replied, "Where are you going?"

"Heading back to Corona. I walked up here and now I'm hungry from walking those long blocks."

Ms. Sumby looked up at Talisha with a glowing look of approval and esteem. Something was different in her eyes, tone and spirit, to the point that Talisha could feel the room palpitate with its energy. Ms. Sumby reached down in her bra and pulled out a black purse

wallet. She twisted the two knobs and unfolded a toilet paper roll of twenty-dollar bills.

"Grandma, what are you doing?"

Ms. Sumby called to Talisha with her pointer finger. "Here take tis."

Talisha began to walk away. "Grandma, I am okay. I don't want your money. You keep it." Talisha was near the door when she heard Ms. Sumby gaining speed after her.

In a much forceful voice, Ms. Sumby demanded Talisha take the offering. "Me say take it! Buy yourself some food. Ye hear?"

Talisha was humbled, not by Ms. Sumby's gesture alone, but by the sincere look of concern in Ms. Sumby's eyes. Talisha was low on cash, and the extra funds could buy her a few more days' worth of needed supplies, but she felt selfish taking the money from Ms. Sumby.

"Okay, okay grandma." Talisha laughed. "Thank you, grandma. You're the best." Talisha kissed Ms. Sumby on the forehead, the same token of love that had been given to her as a child. "See you tomorrow." Talisha left Ms. Sumby's room and turned back once more to glance back and watch as her grandmother got in the bed.

When Talisha closed Ms. Sumby's door, she felt an ache in the pit of her stomach, an emptiness that she was sure was the place from which her tears flowed. Talisha wanted to break down and cry, right there, outside Ms. Sumby's door, but as she would learn through the years, Talisha would suppress her emotions, and so she headed back to Corona, choked up but resolved to swallow her pain.

Later that night, Lala cooked dinner. Talisha couldn't believe her eyes. Lala served a plate that three people could've eaten from. There was a golden fried pork chop the size of half the plate, a mountain of mashed potatoes and gravy, and broccoli smothered in cheese. "Oh my God! This is for me?" Talisha asked.

Lala sarcastically shot back, "Well, who else do you think it's for, the invisible man?"

Talisha clutched the man-sized plate like she was handling the Church's offering basket. "Well, if he's eating like this, I hope he stays invisible because I sure don't want to meet him." The two busted out in laughter. They talked most of the night until they decided to take a midnight stroll down Northern Boulevard. They walked past the space that the Langston Hughes library once occupied. "Wait, what happened to the library?"

Lala brought Talisha up to speed. "Girl, that's been gone. Where you been at?"

Talisha looked at Lala and said, "Guess I've been gone so long many things changed."

Lala agreed, "Yep." Lala went on, "I forgot to mention I had a trip already planned to Florida. I'm leaving on Friday and I'll be gone for about a week, but you are welcome to stay until I get back."

Talisha was caught off guard by Lala's statement, and even more shocked that she gave her the keys to the house. "My mother is still at her boyfriend's, girl, but she knows you're there. I think she is coming over tomorrow."

"I just can't remember your mother. I wish I could, but okay."

Then Lala snapped her fingers to get her thoughts aligned. "Did I say my mother? I meant Peggy is coming by. I don't know if I am coming or going sometimes."

Talisha reminded Lala, "Yeah, you said your mother, but that's cool too. We all get a little forgetful."

Lala agreed. The two walked from one end of Northern Boulevard to the next, then across Astoria Boulevard, back to Lala's home. By time they reached the house, the sun was coming up, and Lala thought they might as well push through the day, so they journeyed to the laundromat. The two were inseparable. Talisha felt like she had Tasha back in some odd way.

Friday came and by the time Talisha woke up, Lala already had her bags packed and was ready to leave. "My train leaves soon and I haven't

even purchased my ticket. Don't ever ask me to plan something. It will be all wrong." Talisha chuckled. "Noted. Oh, I'm just making sure, you said you will be gone just for one week, right?"

"Why? Don't be having no wild orgies in here, tearing up the place."

Talisha was beside herself after hearing Lala's comment. "Girl, I'm not into that. I was just making sure you won't be gone for like a month or something."

Lala picked up her bags and said, "Oh, I see. Yes, Talisha. I will be gone just for one week."

At that time, Talisha didn't really understand her own motives for asking the types of questions that came out of her mouth. What was clear, though, was that she had suffered so much, early on and at such an impressionable age, that she had deeply internalized the pain and anguish of being abandoned. Talisha didn't even grasp how truly anxious she was as she watched Lala head for the door. The only way to gain the comfort she needed to feel like she was in control was to secure Lala's promise to return one week later.

Talisha's mind was all over the place that day. She had unhinged visions of what would happen to her if something happened to Lala. What once seemed like a golden opportunity felt more like a pipe dream. Talisha kept busy around the house. She felt like a little housekeeping was necessary to tidy up the place and to quiet her racing thoughts.

Hours passed before Talisha was able to calm herself down. She was about to visit Diane and Ms. Sumby when Lala's sister, Peggy, showed up. "Hey girl!"

Talisha jumped off the bed and ran towards Peggy. "Hey Peggy! Long time!"

"Tell me about it." Peggy stood by the old radiator that divided Lala's room and the living room. "So, what made you come back?" Talisha told Peggy what she had told everyone else thus far. The

question had become so redundant that Talisha had memorized her response, verbatim.

Peggy acted as if she was shocked. "Oh wow! I am sorry to hear that. Wow. Just wow." Then Peggy delivered her sales pitch. "You smoke weed?"

Now Talisha had never smoked anything in her life, not even a cigarette. She remembered how Ms. Sumby chain smoked all day, and how the attic was stuffy with smelly tobacco fumes. Then she thought about Keisha and how she looked so adult-like inhaling on a cigarette until it evaporated right before her eyes. Talisha wanted to feel what it was like to be an adult, but without the grown-up responsibilities. Up to that point, Talisha had enjoyed the sweet taste of freedom and anything she desired to do was practically within reach.

Talisha dishonestly answered, "Girl, yes."

Peggy was extra excited after hearing Talisha's response. "Cool. My friend is outside. I doubt if you remember him. He got the weed, girl. It's about to go down."

Talisha was a little nervous about saying yes. She felt that if she backed out she would be called on it, labeled as soft, and alienated from the pack. Back in those days, in the black community, if a person received the title 'soft,' it was almost always an inescapable invitation to be exploited. Talisha remained firm on her reluctant consensus.

Peggy invited her friend inside. "Talisha, this is Devon. Devon-Talisha. Now y'all met." Talisha couldn't help but notice the man's size. He was tall and stocky, and had to have been the height and girth of a linebacker. Shortly after Devon walked in, Peggy started to ramble, and about almost anything and everything. Peggy's non-stop patter didn't help to ease Talisha's anxiety one bit. Talisha watched Peggy's wall-size friend pull out some Tops paper and a tiny bag of marijuana that had more seeds in it than weed. The group telepathically formed a circle. One by one, they puffed away until the joint came back to Talisha the second time around.

Talisha didn't feel right. She started to have hot flashes and she could see her image doubling. She looked towards the wall where the old radiator stood, and noticed that the paint had changed colors right before her eyes. Talisha didn't know what had happened. All she knew was something was terribly wrong, and she needed to get out of that house. She jumped up and waved her shirt up and down to cool her body temperature. Peggy asked Talisha what was wrong, but Talisha was terrified to the point where she felt mute. Talisha fled for the door, but Peggy blocked the exit. "Wait, Talisha. What is wrong with you?" Talisha tried to speak, but every word echoed back in her mind like a tape recorder on repeat. She looked through the open window and saw Soldier sitting on the neighbor's stoop. He had been keeping a careful watch after seeing Peggy and Devon enter the house.

Talisha screamed, "Soldier!" "Soldier!! Help me!" Then Talisha fainted. When Talisha woke up, she was outside on the pavement, surrounded by the paramedics and neighbors. Onlookers demanded to know what had happened, but Talisha was too lethargic to speak. One of the paramedics looked at Talisha's pupils. "We don't know. She overdosed on something and we need to get her to the hospital right now."

The paramedics strapped Talisha to the stretcher and rushed her to East Elmhurst Hospital. Talisha was in and out of consciousness the entire time in the ambulance and it continued after she was brought into the emergency room. When she became alert, she couldn't turn off the hallucinations, so she decided to just fall back asleep and let whatever was in what she had smoked run its course.

Once she entered the hospital proper, an army of doctors and nurses swarmed Talisha's stretcher. They bombarded Talisha with all types of questions; none of which she answered. One of the emergency room doctors screamed across the room, "Nurse! Bring me two liters of activated charcoal, stat!" Talisha was unfamiliar with the medical terminology, and got panicky, immediately trying to jump off the

stretcher and break free from the medical team, but one of the male paramedics used a little force and restrained her. "If you know what's good for you, you will stay," he stated bluntly. "I suspect you had something very bad, because your heart rate is about to send you under."

"Send me under?" Talisha asked, a jangle of nerves causing her head to clatter up, down and sideways. She was hoping, through her fog, that the paramedic would clarify what he meant, but just then the doctor interrupted. "Your heart rate is triple the normal rate and if we don't get it down, things will go south for you, very fast."

Talisha tried to focus on what was being said, but the hot flashes were intense. "Ow!" Talisha yelped. "What are you doing?" Talisha looked down at her arm. The nurse had already taken blood and had inserted an intravenous line. The nurse brought over two large white foam cups that contained a thick black liquid that smelled like melted charcoal. The nurse instructed, "You have to drink both cups." Talisha looked at the solution and then smelled it. "What is it?" The nurse replied, "Something that's going to save your life. Now drink it." Talisha took a few sips and spit out the liquid onto the floor. "It tastes horrible. I can't drink that." The nurse had grown weary of Talisha's behaviors. "That's fine. All you need to do is take small sips until you finish it all." Talisha started to regain some sense of awareness. She did as the nurse instructed and took small sips of the activated charcoal until both containers were nearly empty.

Hours later, Talisha was still awake. She laid on the hospital bed, as she relived the events from earlier that day, repeatedly. Talisha believed that if Lala had stayed, she would never have ended up at the hospital. She imagined Lala would have smacked that joint out of her hand and scolded her like Tasha would have, had she been alive.

The doctors finally made their way around to talk to Talisha about her blood work. Talisha was told she had PCP and crack in her system and that was the cause of her unusually rapid heart rate. The doctors

told Talisha people lace marijuana with all types of illicit drugs to enjoy psychoactive effects, and that she was one of the lucky ones, as they had seen many people go on trips and never come back.

One of the doctors asked Talisha if she had a relative they could contact, because the hospital couldn't let Talisha leave their custody without an adult. Now, the last thing Talisha wanted was for her family to find out what had just gone down, especially Aunt May. Everyone in Baltimore looked at Talisha as a complete failure and, sadly enough, she was faced with the same outcome in New York once her family found out what had occurred. Talisha thought about giving the doctors her uncle's telephone number, but then she considered what he might say. To Talisha, scornful words backed by discipline were equally as brutal as physical beatings. She cringed at the thought of what her uncle would say. Talisha was out of time and options. There was no one left to run to, and she decided that she had no other choice but to give the doctors her uncle's telephone number.

Talisha spent a restless night at the hospital. She didn't get much sleep or rest due to the hospital alarms going off and the hourly wellness checks. The feverish anticipation of what her uncle would do and say to her the next morning also rang alarmingly in her mind. Talisha didn't want to return to Baltimore or to the system, even if it was just for another year. She was set on the thought that she could make it on her own, and at any cost, she would do just about anything to prove that she could.

CHAPTER TEN

Mission Unstoppable

───

S TEVE PICKED TALISHA up from the hospital the next morning. Contrary to what Talisha had expected, Steve kept a relaxed demeanor, briefly discussing the events from the day before and willfully skipping the part about why Talisha came to New York in the first place. Talisha was nervous about Steve's omission. She had always seen her uncle in a calm state. She was used to his rhythmic tone, his short-on-words personality, and his witty sense of humor when he was in the mood for a good laugh. *What is he waiting for?* Talisha thought to herself. *Go ahead and tell me how much I screwed up my life and that you finally wrote me off for being a repeated failure. Just do it and get it over with already!*

Talisha had grown accustomed to the psychologically damaging and traumatic impact that her childhood had so gracelessly imparted. It was a gradual, yet progressive autonomic response; she would stand in silence, waiting for the next snarky comment and vile remark, only to run off somewhere once it arrived and suffer in silence until her eyes swelled. Those toxic words and comments had become the wrecking ball that sought to demolish Talisha's existence, and, sadly, most people in Talisha's life at that time were more inclined to destroy than to build.

Meanwhile, Talisha was jolted back to reality, shaken to the point where he teeth rattled by the dilapidated infrastructure of the 59th street

bridge. She wondered why her uncle had not taken the Bronx Expressway. Her heart began to pound, and her mind began to race with thoughts of false hope. *He's giving me another chance. This is so nice of him. He really loves me.* Even after all she had been through, Talisha was still naïve enough to believe that, after an unattended New York excursion accompanied by a psychedelic trip that landed her in the hospital, her uncle would still be forgiving enough to have made the same mistake twice.

Steve turned onto Lala's block. Talisha, of course, canvassed the area for Soldier, but all she saw was the usual suspects entertaining themselves with smoke chains. Then there was Mrs. Hutchinson, seated in her favorite position next to the front window. As soon as she saw Talisha, she shook her head and rose up from her seat. Indignant, Mrs. Hutchinson let her uninvited opinion be know, stating, "I can't believe they would bring that girl back around here." Then Mrs. Hutchinson saw something that quieted her protests. Matthew was parked on the opposite side of the street; he had been there, waiting for Steve to drop Talisha off. Once Matthew exited the car, Talisha knew that she was no longer free to roam about on her own. Matthew was Diane's only son, and although he was raised around mostly women, Matthew was still the typical alpha-male.

Talisha walked up to Matthew, and said, "What are you doing here?"

Matthew was fueled with anger. "No, don't worry about why I am here. What are you doing here in New York alone and at your age? And who were you smoking pot with?"

Talisha's mind was racing and once her thoughts went into autopilot, it was difficult for her to follow the flow of words. At that point, Talisha no longer heard what Matthew was saying, only familiar sounds of disgust and disdain. Talisha stood in silence. Matthew wanted answers. He grabbed Talisha by the arm and walked her across the street to Mrs. Hutchinson's house. Steve waited in the car. He was impressed by Matthew's handling of the situation.

Matthew asked Talisha again, "Now, are you going to tell me who you were smoking pot with, or do I have to make a scene?"

Talisha was reluctant to answer. She wanted to tell Matthew to mind his own business and just leave her alone, but she thought twice based on the look in Matthew's eyes, and decided that it was better to tell the truth. Talisha murmured, "Peggy and this guy named Devon." Matthew clarified Talisha's response. "Lala's sister, Peggy?" Talisha focused on the crack on the sidewalk she stood upon. *Maybe I'm about to make a new crack next to that one when he smashes my head in this pavement,* she thought.

Talisha confirmed her response. "Yeah."

Matthew turned to look at Mrs. Hutchinson. "Do you know anything about this?"

At that time, Mrs. Hutchinson was halfway out the window with her ear pinned to the street. She didn't want to miss a said word. "Don't put me in that mess," Mrs. Hutchinson said. "She's not my responsibility. That is your sister." Mrs. Hutchinson turned her head in the opposite direction. Matthew turned his attention back to Talisha. "You're going to show me where this guy lives," Matthew barked, staring Talisha down and implying that refusing his request was not an option. Talisha responded, "I don't know where he lives. I don't know anything about him. I never saw him before."

"That's why you shouldn't be up here by yourself." Matthew glanced at Talisha. He looked at her carefully, as if he was confirming an already made decision. "Get in the car." A confused Talisha asked, "For what? Where are we going?"

Matthew pondered for a little longer. He was reluctant to tell Talisha anything. He had always been the type of person to give someone information on a need-to-know basis. Those same folks that used to whisper rumors about the family thought of Matthew as a ritualistic, private person. Talisha persisted, "Well, where are you taking me?" Matthew walked to his car and gestured for Talisha to do

the same. Talisha's feet started moving, but her mind remained fixated on the question he had asked. Talisha opened the front passenger door of Matthew's car, stuck her head in and said, "I'm not getting in unless you tell me where we're going."

Matthew had already grown weary of Talisha in only a matter of minutes. He questioned his decision for coming to New York and thought he should have never made the trip. Talisha was beyond his control and he understood that. But Matthew felt that he shared responsibility for Talisha's misfortune. H.J. had bowed out of his responsibilities years ago. Diane had missed so many years of her children's lives that her own children had become strange seeds in her womb of care. Then Tasha succumbed to an untimely and ill-fate, which left Keisha next in line in Matthew's absence. Matthew believed that if he didn't intervene right here and now, Talisha may, sooner or later, end up sharing the same fate as Tasha.

Matthew looked Talisha squarely in the eye. "I am taking you to Baltimore with me." Hearing this latest assault on her senses, Talisha backed away from Matthew's car. The only thing Talisha heard from Matthew's statement was 'Baltimore.' Talisha had detached herself emotionally from everyone back in that city, and felt that it was futile to return to that dreadful plac, filled with venomous relatives and duplicitous backstabbers. "Oh no you don't!" Talisha exclaimed. "I am never going back there again. No way, Jose!"

Matthew raised his voice just enough to keep the peace, but loud enough to get Talisha's attention. "Talisha, you're coming to live with me!" Talisha stopped in her tracks. She wasn't sure if she misheard what Matthew had said, or if he had lied to her just to get her in the car. Talisha approached. "Say what?" Matthew had to maintain his sense of authoritarianism. Outside of his natural abilities, Matthew was trained to never show weakness; for him, it was a sign of defeat. "You heard me correctly. Now get in the car. I have to be back in Baltimore by 6pm today." Talisha was intrigued. Matthew gave Talisha

just enough information to persuade her and pique her interest to learn more. "Be back where and why?" The probing continued. Matthew was getting hungry. The challenge of coaxing Talisha to follow his instructions and come along had worked up his appetite. "Get in this car, girl. Let's go get a slice of pizza and an Italian ice, and I'll tell you everything on the way to Baltimore."

Upon hearing the promise of pizza and Italian ice, Talisha mind shifted into a different gear, and she eagerly jumped in the front seat and started to give Matthew's car the once over. Up until that point, she hadn't even realized that Matthew had bought a new car. She asked, "What kind of car is this?" Matthew smiled. He had recently returned from the Gulf War. While away, he had saved all his money to pay up the rent on an apartment for the year and to buy his first vehicle—a sports car. Matthew couldn't contain his excitement. He screamed out, "This is a 1992 Toyota Supra, baby, complete with turbo kit!" Talisha's eyes gleamed. She had no clue as to what any of that meant, she was just excited to share in on Matthew's enthusiasm. "Want to see what this baby can do?" Matthew revved the engine. He had become one with his car. He was about to mash the pedal into full throttle until he realized Steve was still parked in his car, waiting for a final decision. The car screeched to a halt. "Oh, man! Uncle Steve! I am so sorry. I was about to take off, forgetting you was still in the car."

Steve was thrilled. He silently watched, marveling at how Matthew had had to pull Talisha's strings to get her in the car, and how Matthew became childlike again, revving the car's engine. It was a heartfelt moment. "Oh, that's okay. I'm just glad things are working themselves out." Steve paused. "So, you two are heading back to Baltimore now?" Steve waited for confirmation. Matthew responded, "Yeah, we are about to get on the road after we stop to pick up something to eat." Steve agreed. "Okay, call me once you get back safely." Then Steve looked past Matthew. He yelled out to Talisha, "Make sure you behave yourself and keep out of trouble." Talisha shook her head

in agreement. Matthew and Talisha waved their farewell and then Matthew zoomed down the street.

Before Matthew got on the highway, he stopped at a local pizza parlor for pizza and Italian ices. He watched as Talisha wolfed down her food before they even managed to exit the Lincoln tunnel. Once outside of the tunnel and in New Jersey, Matthew rolled the windows down and popped a cassette into the cassette player. Then he started to seat dance and clap his hands to the music. Talisha heard the melodious voices of the choir, followed by the beginning of a song. "The blackness, keep, keep on." Matthew had staged that very moment. He knew he was about to embark on a great adventure with Talisha. He just didn't know how colossal the challenge would be. He had hoped that Talisha would reflect upon moments like that in her life, should she decide to drum to her own beat again.

Talisha raised an eyebrow and asked, "What is this?" The question made Matthew even more enthusiastic. "What?!" Matthew exclaimed, "You never heard this song before? Talisha, you don't know what you're missing. This is the Hunter's Theme! Listen to it and tell me what you think."

Talisha agreed to tune into the song's lyrics. However, the truth was that Talisha had difficulty focusing on one task. Her mind was almost always caught up in a whirlwind of swiftly moving ideas, and asking her to focus on one thing at a time required a bit too much concentration. By time the first few lines of the chorus had passed, Talisha's attention was everywhere except where she had been asked to put it. She thought about the bridge they had to cross, the sky above and the water below. She thought about Soldier, her short-lived experience in New York, and then she started to think about what it would be like to live in Baltimore with Matthew. Then she thought about Diane and Ms. Sumby.

In Talisha's overactive mind, Diane and Ms. Sumby were always last on the list. Without properly understanding, Talisha had created

several defense mechanisms. She thought her love for Diane and Ms. Sumby, irrespective of their deteriorating states, was unconditional. But the harsh truth was that it wasn't that simple. When it came to Diane, Talisha was conflicted, in part because Talisha held a burning flame of anger in her heart for her mother that no one knew about. She was infuriated by the thought of how she had been robbed of any chance to have a decent childhood and how her ensuing years spiraled out of her control. She always faulted Diane and bypassed H.J.'s role in the family's hardships. But Talisha also held a level of empathy and mercy for her mother. She had watched how Diane had metamorphosed into a hollow vessel, abandoned by life. She wished by year's end that God would reset her life and give her another chance at full happiness, complete with her family. But at the end of the day, that would be a narrative for another life, and not the one she was living.

The hook of the song stopped Talisha from daydreaming. She tuned in when she heard, "As long as you keep your head to the sky." In that moment, she thought about God and she remembered how she was taught that God sits above and looks below. She wondered if the line implied that one should look to God first. Then she considered why Matthew chose the song as the "Hunter's Theme." She had to find the meaning. Surely there must have been more significance to it than she initially suspected, but after giving it more consideration and coming up blank, Talisha settled for the former meanings. "Hunter's theme," though, would take on a very different meaning in the years to come.

The cassette player stopped. Matthew was smiling from ear to ear. "Well, what did you think?" Talisha didn't want to disappoint Matthew. She only paid attention to the hook. Everything else was just background music for her thoughts. "I like it. I like it a lot." Once Talisha gave Matthew the answer he expected, Matthew yelled out excitedly, "Yeah, baby! That's what I'm talking about!" Talisha giggled.

She was more focused on Matthew's emotional reaction than what he said and meant.

Matthew began to explain to Talisha how he had ended up in Baltimore. He told Talisha that he was previously stationed in Virginia Beach, but had requested a transfer prior to going overseas. Upon returning to the states, Matthew discovered that his request had been granted. Matthew transferred to Maryland, and stayed on base for a few months until he was able to find a two-bedroom apartment, right off the I-95 Beltway. It took him just a few more months to furnish the apartment, along with making some other necessary adjustments. After that, he intended to set out to find Talisha and move her in. However, right before he embarked upon that quest, he received a telephone call from Steve telling him that Talisha had been hospitalized from smoking angel dust.

Meanwhile, the ride back to Baltimore was a three-hour breeze. Matthew darted in and out of traffic, pushing his Toyota Supra to its limit. Matthew worked overnight and had to be back to barracks for his assigned shift. He scurried inside the apartment and started getting ready for his tour-of-duty.

Matthew signaled to Talisha to come down the hall. He turned a light on and jumped in the shower. Talisha cautiously walked down the hallway, with her mind already in the future. She was under the impression that Matthew would be home with her and that they could binge-watch movies or play checkers—one of Talisha's favorite board games. Talisha entered the room and her hands went up to cover her mouth in sheer surprise.

The first thing Talisha noticed was the smell of newness from the recently bought items. Her attention was then captured by the full-size, oak bedroom set that still had plastic on it. The bedroom was completed with coral peach décor. When the sun peeked through the blinds and reflected off the curtains, it cast a radiant orange color that made Talisha feel like she was on the beach. Then Talisha looked

down at her feet. The room even felt good. Matthew hired a crew to install peach colored, frieze-style, plush carpet.

Talisha was in absolute awe. She never had her own bedroom, especially one of that magnitude. It made Talisha feel like a princess or movie star. Most things she owned were of second-hand quality and didn't have the brilliant luster that Matthew thought she deserved.

The bathroom door swung open. Matthew exited looking like a distinguished serviceman. He had on a crisp, white shirt, neatly tucked into his dark navy-blue pants, which were precisely steam-pressed, with transverse creases and accented with high gloss, heavily polished Oxford shoes. Talisha thought Matthew looked like a G.I. Joe figurine.

Matthew headed for the door, grabbed his hat on the way, and told Talisha he would be back in the morning. There was plenty of food in the refrigerator should Talisha feel the need to have a late-night snack. "Huh? The morning? You mean to tell me I have to stay here by myself all night?"

Matthew shrugged Talisha off, not giving her question a second thought. "You're a big girl now. You'll be alright."

Talisha watched Matthew go to his car and drive off. She closed the door and sped down to her tailor-made bedroom, proceeding to rip off the plastic from the furniture like she was having a pillow fight. Then she put her special touch on the room. By the time she had finished moving things around and remaking the bed for the fifth time, she decided it was getting late, and she should get ready for bed.

The next day Talisha was awakened by Matthew coming in from a long night's work. She had slept so well, like a newborn baby tucked away in their crib, that she forgot where she had set her head down for the night. Matthew was too tired to engage in any conversation, and headed straight past Talisha, making a beeline right for his bed. Half the day would be gone before Matthew woke up for his next shift.

Matthew's juggling act between his tours-of-duty and his guardianship of Talisha would soon become mundane. Overall, Talisha

was the type of person who got bored with routine. Her inability to concentrate on one task at a time, coupled with an unyielding passion to explore an unknown world, nagged at her almost daily. She decided fairly quickly that she had had enough of the "same old," and headed out to scout out some of her former friends.

Talisha went to visit her friend, Loketa. The pair met at middle school, when Talisha used to live with Aunt May. Loketa was such a compassionate friend to Talisha that Talisha never forgot about her. She used to listen to Talisha's horror stories, without judgment, about how Aunt May treated her like a locked animal in a cage, and how she would sling the belt at any available spot on Talisha's flesh. When Loketa found out what Talisha had gone through, she begged Talisha to leave her imprisonment with Aunt May and invited her to stay with her and her parents.

Loketa was sure her parents wouldn't have said "no," but neither would've found out, as Talisha declined each time. Too much psychological damage had been done to Talisha in such a short space of time, and anything other than the necessary mental and emotional healing Talisha desperately needed would have been a further disservice.

Loketa was also Talisha's hair stylist back in middle school. Loketa had a flare for putting together some of the best hairstyles in the city, and it was one hairstyle Talisha wanted for her reintroduction—front finger waves with curls. Loketa would slap globs of hair gel on to Talisha's head, take that comb in between her thumb and pointer finger, and then press down a deep ocean wave of hair. Some days Talisha thought Loketa's fingers would come crashing through her skull because of her heavy hand. Talisha didn't mind. To her, the unintentional torture was worth it. Once Loketa would put her final touch on the 'do, she would spin Talisha around and hand her a mirror with a smile. Loketa was a faithful friend. She never asked for any form of payment, even after working the hot comb for hours through

Talisha's tightly coiled hair. In fact, when Talisha didn't have a dime for after-school purchases, Loketa would split her weekly allowance with Talisha to pay for them, never giving a thought about being paid back.

Talisha caught the bus to Loketa's house. As one might have guessed, the pair were ecstatic to reconnect. Loketa filled Talisha in on all the neighborhood drama, and Talisha burdened Loketa with the sordid story behind her latest feat.

"They did what?!" Loketa was livid to find out that Talisha tried smoking marijuana, and even more disgusted by the thought that someone she knew would trick Talisha into smoking angel dust-laced weed.

"Yeah." Talisha saw the look on Loketa's face, and immediately could sense the empathy. "I ended up in the hospital and everything. I was bugging out."

Loketa shook her head and counted her blessings. Just hearing some of Talisha's stories always reminded her how fortunate she was to have escaped some of these everyday horrors.

"So, can you fix this head of mine?" Talisha asked, curious as to what her friend's response would be this time.

Loketa looked at Talisha's hair and sulked, the same way a child does when they are tasked with a seemingly unbearable chore. "Why do you continue to put me through this? Your hair is so thick. Ugh!" The pair laughed.

After hours of washing, blow-drying and pressing out Talisha's hair, the next step was the add-ons. Loketa learned an easy way of drying fake hair in record time. She would simply roll up the fake hair onto inflexible rods, place the fake hair in the microwave, and a minute or two later, the hair would be fried-dried. Sometimes Loketa left the hair in the microwave too long and the rod's rubber bands would snap off or break apart. This was every hairstylist's nightmare, yet every beauty salon's owner dream come true. Young girls like Loketa rotated beauty stores daily, buying more rods just to have the rubber band snap a week later.

Loketa asked Talisha to go with her over east. She had asked one of her cousins for some extra money since Talisha was in town. Loketa thought it would be nice for the two to hang out for the remainder of the evening, especially since Matthew would be working the rest of that night.

Loketa and Talisha walked from one side of the city to the next, but neither one of them noticed that it took them hours to reach their destination. They were too busy discussing house parties and boys.

They took a cab back to Loketa's house. Hours of walking had drained most of their energy, and besides, Loketa had enough cash to cruise around the city if she liked. However, after a box of chicken and fries seasoned with salt, pepper and ketchup, and washed down with Baltimore's finest half and half—which is a sub-cultural term for a half lemonade and half iced-tea beverage, Talisha and Loketa were on to the next adventure.

Talisha ended up staying out most nights at Loketa's parents' house. Matthew was rarely home, and even when he was home, he divided his time between well-deserved rest and his girlfriend. Talisha essentially fell through the cracks and it was only a matter of time before she was faced with another travesty caused by her self-defeating behavior.

Although time continued to march on, Talisha was at a standstill. An entire year passed, and she hadn't grown a millimeter in her emotional development. She was running the streets every day, hanging out with friends and associates, and sleeping at any welcoming spot she deemed suitable at the time. During one of her those times, Talisha was told that Keisha had moved out of Terry's house and was living nearby, close to Loketa's side of town.

Talisha certainly missed Keisha. Given that the two were the closest in age out of all the siblings, Talisha had always hoped that they would have created a closer friendship. Throughout the years, Talisha imagined what that would have looked like. She pictured

how the two might have swapped a pair of jeans here and there, or how they might have played with each others' hair while talking about boys. But then, and always lurking in the back of Talisha's mind, was that old companion, cognitive dissonance, chipping away at Talisha's unrealistic thoughts. She would be reminded of the last two encounters the sisters shared, and as she briefly reflected on the last time she saw Keisha and how Keisha had nonchalantly waved goodbye to Talisha the same way a person swats away an annoying gnat, Talisha began to feel less enamored with the notion that they could have been best buds.

Then Talisha thought about her time at Florence Courette. Ruminating on that awful experience brought on feelings of deep remorse. On holidays and birthdays, some of the girl's family and friends would visit. It was always an exchange of endearments. The girls would surprise their loved ones with their newly developed talents. Some gave away beautiful crocheted blankets, while others boasted about how well they had performed on tests at school. It pained Talisha to know that she had a handful of family in the city, yet not one of them called or visited to check on her well-being. It was a painful,searing and lasting memory that played on Talisha's psyche for decades.

Talisha never questioned whether the family—H.J., Diane and Keisha—ever actually loved her. She refused to think otherwise, so she did what any other individual nursing deeply rooted emotional scars would do; she rationalized her family's behavior. For the most part, Talisha faulted herself for the way she was treated, as is typical of anybody trying to recover what's called Stockholm Syndrome. This terrible condition causes victims to identify with their perpetrators, almost always placing themselves at the center of blame and making all kinds of excuses for another person's unacceptable behavior. As a result, she introduced a shadowy self-hate into her existence, and at times, when faced with adversity, she would incorrectly assume that

her challenges had been self-inflicted, then silently cry and whimper, *What's wrong with me?*

Talisha was plagued by self-doubt, a heavy sense of unworthiness, and little understanding or insight into the causes behind the trouble she had caused, resulting in a twisted vow to love her family unconditionally.

Talisha decided to pay Keisha a visit.

Keisha lived in a duplex, just outside the Baltimore Beltway. The place wasn't much to brag about. The structure of the house had fallen apart and it was situated in a crime-riddled community. Talisha didn't care. She would have walked to hell and back just to be in her sister's presence. Talisha knocked on the door and, to her surprise, a strange man came to the door.

"Is my sister here?" Talisha asked.

The unidentified man answered with, "Who's your sister?"

Talisha took her hands out of her pocket and demonstrated "who else?" with her hands, then sarcastically stated, "Keisha."

The man opened the door just enough to yell back. "Ay Keisha! Some little snotty, nappy-hair girl is here at the door, looking for you."

The man's snide remark didn't bother Talisha. It was all the confirmation she needed. She pushed by the man. "Excuse me!" Keisha approached from the adjacent room. Talisha was prepared for all types of responses. She thought Keisha might have brushed her off again or kicked her out the apartment, but to Talisha's surprise, neither happened.

Keisha was surprised to see Talisha. She rushed to Talisha with open arms. "Hey, big head. How did you know I lived here and how did you get here? Aren't you still at the group home?"

Talisha happily obliged her sister and proceeded to fill her in on all the details. "See," Talisha remarked with a snarky smile, "that's how much you love me! I left that place a long time ago. Had you called or stopped by, you would have known at least that much." Keisha grinned, hung her head, and concurred.

Talisha was baffled that Keisha willingly sided with her, but she was nonetheless appreciative of Keisha's easy-going spirit. Keisha continued, "So where are you staying?" Talisha was hopeful that her sister was about to offer her a place with her, but Talisha didn't want to show too much enthusiasm, so she cagily answered, "Well, you know, here and there. I was staying with Matthew for a little while, but he's too intense." Keisha lit a fire to the end of her Newport cigarette. "Yeah, that chump is all on himself," shot back, rolling her eyes.

Talisha remained silent. She knew deep down that Matthew had always tried to make her just like him. Had Talisha taken considerable time to define what that meant, she might have concluded that it wasn't a raw deal. There were times when Talisha considered moving back in with Matthew, but each time the idea came up, she would cringe at the thought of how disciplined Matthew was, and how he would alter her current life, making demands on her that she just wasn't ready to keep.

Talisha quickly changed the subject. "I want to apply for a job this week. Think I can use your address and number?"

Keisha had gained employment a few months before she moved out of Terry's place. She worked at the local McDonald's as a cashier, and understood the concept of having to work in order to survive. She admired Talisha's initiative to do something for herself. Keisha consented.

Talisha ended up finding two jobs. She worked at Roy Rogers during the day and on a food truck at night. Her commute from place to place, then from one job to the next, had become increasingly cumbersome. She welcomed herself, uninvited, to stay at Keisha's place most nights. There was generally high traffic going in and out of the place, and someone was always awake to let Talisha in. Although she didn't know most of the people that stayed at the apartment, Talisha had begun to feel a sense of completion being privy to Keisha's world, along with a sense of purpose that came with working two honest paying jobs.

Most days, Talisha was too tired to do anything outside of catching up on rest, so her habit of going from place to place temporarily ceased. She was so exhausted from work, she one day answered the telephone at her sister's place and said, "Good evening. Welcome to Roy Rogers. How can I help you?"

A good portion of her money went towards Keisha's bills, as her unofficial stay was not without expense. Keisha required that her sister pay a couple of dollars out of each paycheck for a night's sleep on the wicker chair or floor. Talisha never minded. She was just eager to please Keisha.

Then the unthinkable happened.

Talisha had marched her way to Keisha's place, just like she had done before, but when she knocked on the door, all she heard was a hollowness echoing back in her direction. "Humph. That's strange." Something felt eerily different on the other side of the door. Talisha knocked again; this time much harder. Knock! Knock! Talisha turned the knob on the door, unsurprised that the door was unlocked. So many people rotated in and out of that place, it was standard practice to leave it that way. Talisha walked in. "Hello. Is anyone home?" Her words echoed off the walls. All the furniture was gone, and someone had left all the lights on. Talisha walked to the corner room where Keisha stayed. She thought to herself, "What is going on?"

Talisha pushed open Keisha's bedroom door. Keisha and all her belongings were gone, and all that remained was an old mattress. Talisha panicked. Her anxiety had heightened by the minute. She ran to each room, thrusting open all doors and hoping that Keisha had played a cruel and dirty trick on her. As much as Talisha wanted to think otherwise, the ugly truth was right in front of her face.

Keisha never mentioned to Talisha that she had planned to move out. Neither did she leave a note of explanation, her new address, or a telephone number. She and her friends moved out while Talisha was at work, and all they left for Talisha was an old mattress.

Talisha fell to her knees. "Not again!" Talisha screamed out with ear-shattering force. "Why does my family keep treating me like I'm shit?! God why?!" Talisha pounded the hardwood floors, forgetting that there were other people that lived beneath her in the apartment below. Talisha could hear the disgruntle tenant from the floor below, as they took a heavy object and banged back on the ceiling. "Shut the fuck up!" Talisha screamed through the wooden floors. At that time in her life, she was ready to take on any person that dared knocked on the door, or on the ceiling for that matter.

Talisha had had it. She went on an hour-long rant. "If I play the game and play by the rules, I get fucked and if I don't play the game at all, I still end up getting fucked! How is that possible?!" With each passing moment, Talisha boiled over with increasing anger. Talisha had never been this mad in her entire life. Her thoughts vacillated between hurting Keisha and blaming Diane. Then she thought of H.J.

"If I didn't have a sorry-ass excuse for a father, I wouldn't be in this mess." The more she thought about her past, the more enraged she became. "Just when I try to get my life on track, this shit happens. Fuck you, Keisha!"

Hours passed before Talisha's body temperature returned to a cool normal. She was then able to think logically once again. "What am I going to do?" she asked herself. "I have no telephone, no food, nothing. These bastards didn't even leave the TV!" Talisha didn't even have a watch to tell her the time. Her only way of determining the approximate hour was by looking up at the moonlit sky.

Talisha decided to walk to the nearest telephone booth and page one of her male friends whom she had dumped weeks ago. It was now kissing up time, as she was in desperate need of immediate help. Talisha didn't even notice all the night crawlers out and about; it was literally the land of the living dead. Talisha was out on the streets, in the middle of the night, with the type of people who sleep all day just so they can terrorize others under cover of darkness.

Talisha called the ditched wannabe boyfriend. Ring. Ring. Someone picked up. A groggy voice said, "Who the hell is this calling my house this time of night?" Talisha was already irritated with Keisha, her family, and the devastating circumstances surrounding her life, and the person on the receiving end wasn't helping to relieve the pressure. She had no choice at this point, though, other than to speak with humility and civility.

"I am so sorry to wake you up this time of night, but it's urgent. May I speak to Lamont?" That little girl voice had returned without much effort.

The voice on the opposite side expected for Talisha to apologize and hang up, but when she didn't, the voice grew harsher. "Lamont!" The phone was silent. All that could be heard was Talisha's breathing. She had been taking deep breaths to keep her patience under control. Talisha heard footsteps. Then a door. "Lamont. Damn it, boy, you better answer me!"

Finally, the young man answered. "Yeah. What is it?"

"Some girl is on the phone asking for you. Pick up the damn phone."

"Hello?" Lamont was half awake and curious who would call at such late of an hour.

"Oh, thank God you answered. Lamont, it's me, Talisha. I know you may be mad at me and everything for not calling, but don't be."

"Wait. Wait. Wait. Why are you calling so late? Are you pregnant?" The kicked-to-the-curb boyfriend shook off the rest of his sleep state. He didn't want to miss one syllable of what would next come out of Talisha's mouth.

Talisha rolled her eyes. "Boy, no." Then she put her hand over the phone's mouthpiece and thought to herself, *As if I would allow you to father my kids. Yuck*!

"Can you come over to my sister's place; well what used to be her place? I am in serious trouble and I don't know what to do."

Lamont wanted to know more. "What is going on, Talisha?"

Talisha knew Lamont would swim across the ocean in a rabbit cage just to be near her, but she was at her wit's end with things, and she didn't feel like explaining at the payphone and again when he got there. "Look! Are you coming or what? I am outside at a payphone with all these dummies walking around."

"A pay phone? Talisha, go back to your sister's place. I will be right there." Talisha said, "Okay" and walked back to Keisha's old apartment. Lamont rushed right over, making it there in under the ten-minute mark.

Lamont wasn't Talisha's type. He was soft-spoken and gentle, and at that time, Talisha was more attracted to the brash, rough type. If it wasn't for his generosity with taking Talisha to work and picking her up, and splitting his bi-weekly earnings with her, Talisha wouldn't have even blinked an eye at him. However, there is a season for everything, and in that season of Talisha's life, Lamont served his purpose. He came to her immediate aid, stayed up with her that night, and, as he had done so pleasingly in the past, Lamont gave Talisha a few dollars for transportation and food.

Talisha spent the next two days at Keisha's vacant apartment. She tried to keep up with the same routine of working both jobs, but she became riddled with emotion every time she returned to the abandoned place. She eventually found out the reason why Keisha and her friends had left so abruptly. The landlord, accompanied by the sheriff, showed up to evict the rent-ditching crew. Rent hadn't been paid in months and Keisha was all too aware. She decided to save up her money and move to another place, only to repeat the same pattern of behavior.

Talisha returned to her same routine of hanging out with her friends. She had everything mapped out to a science. She plotted to stay at this one's house during the first part of the week, then someone else towards the end of the week, and then she would freely bounce around on the weekends, doing whatever tickled her fancy.

Unfortunately, she couldn't keep up with that routine and work at the same time. Talisha lost both jobs.

It was one thing to have a place to crash and money, and another to be completely without either one. There would be no more extended empathy, pseudo-consolable moments, or fragmented reassurance; these things were, by definition, merely false hopes. By law, Talisha was an adult. Pressure was mounting from her friend's parents. They too were growing tired of Talisha's uninvited and increasingly unwanted presence.

By then, Matthew had moved out of his apartment, and Keisha was out of sight and out of mind. Talisha called everyone she could think of for Keisha's new address or telephone number. She overwhelmed folks so much that one of her uncles finally passed along Keisha's new address and explained what happened. Talisha was told that Keisha had moved out with another woman. Folks said the woman was married, and that she left her husband to be with Keisha, and that they had rented a house, near the inner city.

Keisha had always been the type of person to live her life like an open book. Everyone who knew her understood that Keisha enjoyed wild parties, forty-ounce beers, Newport cigarettes and a little of Mary-Jane here and there. Talisha would grow to learn about this side of Keisha. The two were seven years apart, and had been separated for at least a decade. For Talisha, however, that time had never passed. Talisha had loved Keisha since Talisha was a child. But to love Keisha in the present and without conditions, Talisha had to know her, and this was simply not the case. Outside of family ties, Talisha didn't know anything about Keisha. She didn't know Keisha's personality, her preferences or her interests.

As usual, and at that time, it didn't matter to Talisha. She was caught up in a mental and emotional state of limbo. Talisha had been branded by the isolated incidents of her childhood and fixated on molding people and situations into what she thought they should be, instead of seeing them for who and what they really were.

Talisha would later find out that Keisha, like her, had also been raped. One evening, Keisha had had a little too much to drink and decided to give Talisha a glimpse into her implosive world. Talisha had never seen Keisha in such a vulnerable state. She always thought that she had inherited the weaker genes out of anyone in the family, and that that particular curse somehow bypassed Keisha. Keisha had always been strong, courageous—and adventurous. However, Talisha's perception of Keisha changed that night. Keisha cried and whimpered so much when she told Talisha what had happened, Talisha could only gather bits and pieces of the story. Talisha watched Keisha break down from being the tough, tomboyish type to showing a softer side that Talisha had never before encountered. Talisha was in shock—from both the story and from the change in Keisha. Talisha didn't know how to approach the situation. She wanted to hug Keisha, offer her deepest apologies for what had happened, and comfort her, but Talisha didn't know how. She felt awkward by seeing that side of Keisha. Talisha was numb and Keisha could sense the coldness from Talisha's heart.

Talisha was so emotionally immature, she dealt with Keisha's once-in-a-lifetime revelation with a quick pep talk and some music. She thought Keisha needed to hear her words at that time, and that somehow the music would redirect her mind away from the tragic events she had suffered and onto the words of some of her favorite songs. It would be situations like this one that gave others the false impression that Talisha didn't care or that she was somehow shallow. The truth was that Talisha cared deeply; she just had no clue how to show it. She cared so much about what people said and thought of her, especially Keisha, but she kept repeating vicious cycles of unthinkable heartbreak, committed by honoring disloyal friends and family members, remaining lost to herself and unable to heal the scars that crisscrossed her soul and bound her like a straightjacket.

The pain burned within Talisha. She was paralyzed by regret over the past, numb to her present, and terrified of the future. She had no tools,

no friends, and no one to rely on. It was all just too much. She sank into a deep depression, sleeping for days and going without food and drink until pangs drove her to quench the pain. She sleepwalked through hours, days and weeks of life, without purpose, alone, lost. *Something has to change, God,* she thought. *I can't go on like this, maybe not even another day.*

One night, Talisha fell into a dead sleep, thinking morosely that it might be all that bad to just not wake up. But wake up she did. It was sunny. A bird was outside the window singing. Nothing in the world outside was any different. But Talisha felt different. Something inside had shifted. She didn't know if an angel had touched her heart, or if it was just time to say "fuck it" and get on with the business of living life without so many damn conditions. The one thing Talisha knew with certainty was that no one and nothing was going to change her life for her; she had to do it, or give up. And she wasn't ready to give up. Not yet. Hopefully not ever. So with a mighty, outstretched heart, and a burning desire to become someone—anyone—other than who she was at the moment, Talisha moved forward. The once prisoner and now fugitive from her past, decided to pay Keisha a visit in the hopes of mending their friendship.

It had been months since Talisha had last seen Keisha, and she was both excited and nervous for what the visit might bring. Although Talisha was a bit unrealistic most times, she was hopeful that her unannounced stop-by would be received with smiles and open arms. Most people would have cut ties with Keisha and written her off as a bad seed. That wasn't the case with Talisha. Talisha was still afflicted with addictive, maladaptive behaviors and with the need-to-know. She wanted to know why Keisha abruptly moved out, and why she neglected to mention anything about it. Closure was vitally important to Talisha, simply because she had never received any throughout her life. She had to know the whys, even if they weren't readily served up. She would always say that the crime definitely mattered, but to Talisha, the intent meant so much more.

Talisha was in a particularly good mood the day she chose to go see Keisha. She and Loketa had enrolled in a computer class, and Talisha had been recently hired as a sales clerk at a store in Mondawmin Mall. Things were looking up.

When she reached her sister's address, she couldn't help but notice that Keisha had chosen a neighborhood very similar to the last. Talisha thought, *she might have as well stayed put.* This place was the pits, but Talisha had ventured across town to visit her sister, whom she hadn't seen in months, so she decided to continue with the visit.

She banged on the door. It was the kind of knock that made most people miss the last three steps just so they could get to the door. Talisha was looking her best that day. Loketa had just did Talisha's famous finger wave, with the microwaveable, rodded ponytail. She had on a black, spaghetti strap sundress with a black and paisley gold vest and clear, wedge shoes with jewels going across the straps. The neighborhood guys had followed her to Keisha's doorstep, trying to outbid one another for Talisha's number. Talisha gave them a few insincere smiles, quickly glanced at each, deciding whether or not to place them in her category of date-able men, and then silently telling herself, *Not a chance in hell.*

Moments later, a woman cracked open the door just enough to protrude her face. "Yes?"

Talisha was already on the top step, waiting to be invited in, so the men turned wolves could go about their merry way. "Hi. I'm here to see Keisha. Is she home?"

The woman, who moments ago was guarded, opened the door further and asked, "And who are you, and who are they?"

Talisha turned back and saw the lustful looks and glaring eyes. Then she laughed. "I don't know them. They followed me up here, trying to get my number. But anyway, I am her sister."

The woman became bolder in her actions. She came onto the step and told the men if they didn't get off her front, she would throw

boiling water on them. Then she said, "That don't make no damn sense! They act worse than a dog in heat." She then looked at Talisha and said, "And I see why. Where are your clothes, girl?"

Talisha was flabbergasted. She was completely caught off guard by the woman's comments, and until that moment had felt rather sporty in her newly purchased ensemble.

The woman dropped the thought and invited Talisha inside. She stuck her hand out with a greeting and waited for Talisha to do the same. "Hi, I'm Venus."

Talisha shook the woman's hand. She was short on words due to her readiness to see Keisha. "I'm Talisha." Venus offered Talisha a seat and told her that she would tell Keisha that her sister was downstairs. As in the past, Talisha had scanned everything within view by the time Keisha had made her down. Unlike the outside environment, the place was immaculate—the furniture, the floors, the woodwork, and even the walls were all intact and spotless.

Keisha came downstairs puffing away on a Newport. "Lord, I tell you. No matter where I go, you will end up finding me. That's for sure." Keisha jokingly laughed, but for Talisha it was no laughing matter. She had intended to visit Keisha with the purest of emotions and intentions, but after Keisha's remark, any chance of civility went out the door. Talisha followed up with Keisha's remark. "Yeah, that part. So why didn't you tell me you were planning on leaving?"

By that time, Keisha had almost inhaled the entire cigarette. "Shorty-doo-wop, I thought you knew."

"How could I have known if you didn't say anything? I mean, I came home that night and everyone was gone."

Keisha became indignant. "Home! Man, you didn't live there. I don't recall your name on the lease or one bill."

Keisha's fiery rebuttal made Talisha think. Talisha believed that she had no true entitlement to the property and that her sister had presented a valid point, but then Talisha thought about how many

checks she handed over to Keisha just so the two could have a roof over their heads and food to eat. Talisha's tempered flared.

"Keisha, riddle me this. How many times have I given you my entire check? How many times have I helped put food in the house? Huh? So why did I do all of that if you weren't going to pay the rent and then up and leave and not say anything to me!"

Keisha realized at that moment that Talisha's anger wasn't without warrant. Talisha was visibly angry, and by what was stated, she had every right to be.

"My bad, shorty-doo-wop." Keisha's colloquialism was another way of admitting the error in her actions. Most people wouldn't have accepted nothing short of a sincere apology, but as with anything else, Talisha settled for the off-script version instead.

Talisha quickly brushed the topic to the side and began telling Keisha about her enrollment in class and her new job at the mall. She had hoped Keisha would have been proud of her initiatives. Talisha was the type of person that always looked to be praised, but when the acknowledgement didn't come, she would fill the void with something comforting, like a cheap bottle of Peach Schnapps or Long Island Iced Tea. The attention, affection and love that she so badly wanted and needed—but was rarely or never forthcoming—became void, turning instead into a sought after habit of comfort, and like anything else, that nasty way of discounting her value made deep inroads into Talisha's character. It was a vicious cycle.

Keisha had just gotten home from work and was in the mood for a house party; which was never far away and in between. If Keisha had had it her way, she would party every day, from sunup to sundown. "Me and Venus was just about to drink some beers and listen to some music. I got three dollars for you if you want to stay and drink with us."

Talisha wasn't much of a drinker—at least not yet. But she felt comfortable at Keisha's new home, and having a sip or two of some cold ones sounded pleasing at the time. Talisha happily agreed

and took aim at Keisha with a final reminder of how she felt being abandoned. "I'll go get it as long as when I come back, I don't find the place empty and you gone." Keisha grinned and said, "Touché pussycat. Touché."

Talisha drank herself into a stupor that night and ended up sleeping on Keisha's couch, which would be the scene that played out over the next couple of weeks. After a while, Talisha found herself spending so much time at Keisha's that she had mounds of clothes and belongings piled up in one of the rooms. Talisha had unofficially claimed her territory and, as before, she shared her paychecks with Keisha to express her gratitude.

Life was grand for Talisha. She was under the same roof with Keisha, had an easy-going job, and was working towards building skills. To Talisha, everything was perfect.

One day, though, after standing on her feet the entire shift, and just when Talisha was about to make her way home, something caught her eye. Just before Talisha was about to punch the clock, a most gorgeous girl, even more attractive than Lala, walked in. Talisha thought to herself, *Wow, she looks like a movie-star.* The young girl was there for an interview, and if the job criteria was based upon looks alone, she would have been hired on the spot!

Talisha did something right then that she would not have otherwise normally done; she approached the young girl. "Umm, excuse me. I hope you don't mind me asking, but are you here for an interview?" Talisha was curious about the young girl. She never seen anyone in Baltimore dress like that before.

The young girl, who had already deduced that Talisha worked at the store, had hoped to get a few pointers from Talisha. "Yes, I am. Why? You work here?"

"Yeah, I just started working here a few months ago."

The young girl got much more interested at that point. "Cool, so can you tell me what is what? Like who's doing the interview and what

are they looking for me to say?" She went on to say, "I just moved here from the Bronx and I have no clue how Baltimoreans get down."

Talisha exclaimed, "Oh, you from up top? I thought I heard an accent. Plus, most chicks down here don't dress like this."

The young girl asked Talisha, "What you know about New York?"

Talisha proudly replied, "I'm from Queens."

"Oh, that's what's up, so what you doing down here?"

This was the question Talisha dreaded the most. "Long story. What are you doing after the interview? I was headed to my sister's house. It's not far from here. Do you drink?"

The young girl was now captivated. "Drink what?"

Talisha didn't want to insult the young girl with her three-dollar drink, so she dressed things up a bit. "I don't know. I guess we can get some Alize or something."

The young girl replied, "Now you're talking."

"Okay, so let me tell you everything about the job." Talisha babbled on about what the girl should and should not say. It was her way of feeling important and necessary. The truth was that the young girl didn't need extra coaxing. Her looks alone solidified her position in the store. It was no secret that most managers hired young, strikingly beautiful girls to attract money into their store. The old playbook worked every time, even on the most frugal consumer.

The young girl took about thirty minutes to interview. She exited the store smiling, which was always the prospective candidate's way of letting everyone know that they just got the job. Talisha asked, "Easy, right?"

The young girl replied, "Too easy."

"Girl, I told you." Talisha then thought that she had spent the past forty-five minutes talking to a stranger, her then future coworker, and that the two had never bothered to exchange names. "I don't think I caught your name."

"That's because I didn't give it." The young girl was fiery, had a strong attitude, and appeared to be more mature than Talisha.

"Well, I'm Talisha. Your turn."

"Priscilla."

Talisha said, "Fitting."

The two traveled to Keisha's for drinks. Talisha didn't mention that her sister was into women, and that she lived an alternative lifestyle. She kept her sister's information private, the same way she handled her own affairs. Talisha would only share what was deemed relevant and necessary to know, and only then if she felt that the information would have remained sacred and secret. She used to think it was bad enough that some of her past had leaked out, and that family and friends had had a glimpse of her and her spiraled out-of-control world, and that they would judge her based on her past. It was an uphill battle for Talisha, trying to keep people and situations at bay. People never understood the secrecy behind her eyes and she never bothered to share anything intimate with anyone. Talisha was the proprietor of her life, and anyone with illicit ownership was immediately, and sometimes permanently, excluded.

Talisha and Priscilla hung out almost every day that week. They had developed a kindred bond. It wasn't like the bond Talisha and Loketa shared. It was a different type of friendship. At that time, Priscilla was more Talisha's speed. She was adventurous and more of a spur of the moment type of person, a character trait that spoke to Talisha's heart. Talisha had a similar personality, well, at least one that had been personally sculpted that way. Talisha had been caged up for so many years, and had bottled her emotions up for so long, that once she was finally set free, she wanted to experience everything all at once. This type of mindset would become problematic for Talisha throughout the years.

The following week, Talisha ventured over to Keisha's place after work. Talisha had kept up with the same impulsive and risky behaviors as before, like staying out with strange men and getting drunk, but that particular day, Talisha was exhausted from her daily shenanigans.

When Talisha reached Keisha's house, her key wouldn't work. Talisha thought she had suffered so much fatigue that she must have put the key in wrong, so she began to knock on the door. She waited for a few moments, and then placed her ear to the door, listening for any sounds from inside. The place was silent. She looked down at her watch and thought that either Keisha or Venus should have been home by now. Then she wondered about the lock and why her key didn't work. She tried the lock again, but to no avail.

Talisha took a seat on the steps, with her wedge in between the rail. She had been on her feet the entire shift and had partied the night before. She was in desperate need of sleep and rest. Talisha sat outside the entire afternoon until ten o'clock at night. The thoughts of how Keisha had abandoned her a few months earlier swept across her mind, but Talisha immediately brushed them aside, like she did everything else that didn't agree with her version of how she wanted to see the world. It had gotten late, and Talisha had fallen asleep outside on the steps. There was no sign of Keisha. The house remained dark and silent. Talisha didn't have any money to take the bus to Loketa's place, and besides, Talisha didn't want to go there anyway. She called Priscilla.

Priscilla told Talisha that she too was staying with a friend, but that Talisha could stay for the night until she could reach Keisha, and that Talisha would have to find a way to get to the house. Talisha had a stable of people she could have called, but most guys she knew at that time would have wanted something in return even for just a ride across town. Talisha called one of her classmates from a computer class she had taken. She pleaded with the young man for a ride. The desperation in her voice could be heard and felt, so the young man agreed to give Talisha a lift.

By time the courtesy driver picked her up, it was nearly one o'clock in the morning. Talisha had been told not to knock on the door or she would have been sent away at once. Instead, she was to tap on the

back window. To her surprise, Priscilla slept in a room with two other girls, and there was literally no available space on the bed. She would have agreed to sleep on the floor, on the side of the bed, but was told that if the mother of the girl Priscilla was staying with woke up and saw Talisha, both Priscilla and Talisha would have been kicked out. The next best thing was to sleep in the closet. Talisha didn't imagine her night would end with her having to sleep in a three by three-foot closet, but it was the safest option at that time.

The next day Talisha called Keisha's house, almost on the hour, every hour. She left several voice messages, urging Keisha to pick up the phone. Then later that night, Venus answered the one-thousandth call Talisha made that day.

She answered with such attitude that Talisha was sure the two had been home the entire time. "Why do you keep calling and leaving all these messages? What is it?"

Talisha had no more fight left in her body. She was tired of arguing with her family and pleading with them to love her. "I came home the other day and couldn't get in. Then, I sat outside and knocked, but you two never came home."

Venus scornfully replied, "Yeah, well I changed the locks, and this isn't your home. Sorry to be the person to tell you this, but you have to find somewhere else to live."

Talisha was devastated. She had no available room left in her heart for another dagger. She had allowed Keisha back into her life, without conditions, and without Keisha having to prove she was worthy. "What about my stuff? I haven't even been to work because I don't have anything clean to wear."

"You can pick your stuff up in the morning, but other than that, I don't know what to tell you."

Talisha was speechless. There was nothing else left to say, and for the first time in Talisha's life, things had become abundantly clear. Talisha hung up. Her temporary shelter buddies were all gathered

around, anxious to hear the verdict. One of the girls asked, "Well, what did she say?"

Talisha placed the phone on the receiver and began to cry. "They put me out."

Priscilla asked, "Why?" Although the two didn't know each other longer than a week, Priscilla didn't think Talisha's hanging out was worthy of getting kicked out. Talisha never had company over Keisha's, and she paid her fair share in rent. The only charge Keisha and Venus could have brought against Talisha was that Michael—Talisha's former childhood crush—faithfully called every day. Otherwise, whatever complaints the two concocted were simply unjustified.

Priscilla asked, "So what are you going to do?"

Talisha looked at the girls, then at the floor, and said, "I really don't know what I am going to do."

Peril

———

TALISHA HAD COME up against an impenetrable wall. Her world had waxed and waned but never seemed to improve. She tried to conjure up every imaginable reason possible to explain her repeating demise, but she just couldn't come up with a logical explanation as to why people in her life continued to throw her away, ignoring her like a dead animal left to rot on the side of the road.

Talisha went from being restricted in her wrecked childhood home, to the confinement of being held down by Aunt May's eagle-like talons, to being set free by the unfettered desires of her inner child, only to end up getting what she thought she wanted and then being treated with disdain for having it. Talisha would reflect upon her life in that manner for decades to come. She searched for answers for years, but none were forthcoming. At times, she thought she might have said or done something to offend her would-be attackers, and like the people in her life had done in the past when it came to ill-fated taboos, they brushed them under the rug and pretended they didn't exist.

It had been five days since Talisha's arrival, and the girls had become concerned they would face serious consequences if their quietly kept secret was discovered. Priscilla thought it was quite strange that Talisha would over-extend her welcome at the house,

and she thought it was even more questionable that Talisha didn't have anywhere to take refuge.

Truth be told, Talisha was conditioned early on in life to normalize moving about, from place to place, and meeting, hooking up and being taken care of by different people. She was taken from Diane at an early age, sent to group home after group home, and kidnapped by an aunt she had never met and taken to a completely different state, only to repeat the vicious cycle again and again until she finally managed to free herself. Talisha could have always returned to Loketa's place. At that time, Loketa left her parents' house to go live with her grandmother and her beloved aunt, two women who both loved and adored Talisha as if she was their very own. Loketa had always been Talisha's truest and most loyal friend, but it was too late for Talisha. Decades of trauma were deeply embedded within her scarred interior, and Talisha was now at the point where she was going to do what she wanted to do despite any and all warning signs and indications to the contrary.

One of the girls was lying across the bed. She got up and exclaimed, "I got the perfect idea for you, Talisha. You won't ever need your family, ever again."

The girls were all excited to hear this claim to fame master plan.

"I heard girls be dancing for money, down on Baltimore street."

Talisha frowned. She had absolutely no idea what the girl meant by her statement. With a look of utter puzzlement, Talisha grunted, "Huh?"

Priscilla, who was more seasoned than Talisha, chimed in. "Oh, yeah. What's it called again? Those chicks be making like a stack in one night."

Now Talisha was far from the status of being an angel. She met different guys here and there, mostly from New York, due to the heavy influx of street drugs. But Talisha was no dancer. She had two left feet, no rhythm, and no clue as to what she would be getting herself into if

she went ahead with such a crazy plan. But she was yet again desperate to change her life, and for the better. She wanted more than anything to prove to herself and to her family that she could make it on her own.

Sadly enough, that "better" would take another decade to arrive. Talisha scraped up a few dollars for a bathing suit, her favorite alcoholic beverage, and a taxi to what was called "The Block," and sold her soul for a dollar bill.

The taxi pulled up to what was then called the Ritz Club. By the time Talisha got out of the cab, she was nearly tipsy. Talisha wished that Priscilla or one of the other girls would have joined her in that endeavor, but it was Talisha's journey alone.

Once inside, Talisha was entranced by all the nightclub lighting. She had never been inside a gentleman's club before, so her only basis for comparison was to the scenery one might find in an amusement park. *Wow*, Talisha thought. She took a quick glance around the interior of the club and immediately felt like she had stepped into the wrong place. The entire place was all white—white men and white, young girls that looked to be in their late teens, just like Talisha. Then Talisha tuned into the music. One of the teens turned entertainer danced to a sad song. The nightclub was so dry. Talisha thought about what the girl had said about making a stack a night, and then she wondered how that was possible, with a handful of white men who were obviously less attracted to a black girl.

Then the deejay waved for Talisha to come near. "You working tonight?" Talisha reluctantly nodded 'yes.' "Well, you ain't going to get tipped standing around in that. Go get changed, and when you come out, give me your list of songs for the night."

Talisha looked around to where the deejay pointed. There was a small entryway on the other side of the club. Talisha walked past the other girls, who seemed to be enjoying the penetrating stares from the handful of lustful men. She changed into her swimsuit and came up with two songs, like the deejay asked. She wrote down Tina

Turner's, "What's Love Got to Do with It" and George Michael's "Father Figure." Both choices of songs had been on Talisha's top ten playlist for many years. Whenever Talisha heard the chorus, she would immediately go into a trance-like dance. Most times when she did this, she was under the influence of alcohol, and her friends would laugh, thinking that Talisha had just had too much to drink. Little did they realize that Talisha's choice of songs and her hypnotic dance were a silent cry for help.

Talisha had been embroiled in psychological and emotional warfare for more than half her life, and during those turbulent, frightening years, and especially following the sexual assault, Talisha never received any professional help, the kind that would have helped her gain the mental clarity she so desperately needed. Had just a little bit of that kind of assistance been forthcoming, Talisha would have probably managed to pull her life together, regain her self-worth and reclaim a fruitful life. Instead, she got doors slammed in her face, and insults, vile rumors and sometimes even vicious lies hurled at her without warning. If Talisha had been born a welcome mat, she would have been worn out long ago.

Later that night, Talisha walked away with twenty dollars. She had been at the club for four hours, which averaged five dollars per hour, minus the deejay's tip. When everything was said and done, Talisha had just enough money to catch a cab back to her space in the closet.

The girls had been waiting for Talisha to come back with tales of how men worshiped her with loads of dollar bills, but by the look on Talisha's face, the girls realized that they needed to come up with plan B. They were up all night on the phone, practically into the next morning, trying to locate a club that catered to black girls. Someone told Priscilla that there was a gentleman's club over east Baltimore called "Colossal's," and that on any given night the club was at full capacity. Whoever Priscilla spoke to must have told a convincing story, because Priscilla and one of the other girls were adamant about going.

The girls rehearsed dance moves all day while Talisha laughed. She thought they looked more like drag queens on a runway, instead of sensual, exotic dancers. They continued to plan things out like they were about to go away on vacation. They literally went down a list while shouting out "check" until Priscilla realized that no one had cab fare to get to the club. Priscilla said, "Bitch, we don't have cab fare." The trio looked at each other and busted out in laughter. They had made all their preparations, only to discover that their hopes of collecting coins would be limited to the room they now occupied.

Then Priscilla suggested they hitch a ride. The idea of hitchhiking was well within Talisha's scope of "been there, done that," and one with which she felt more comfortable committing. The girls got themselves dolled up in all sorts of provocative wear. Priscilla wore a cross front, halter top, butt high shorts and knee-high boots. All Talisha had was a white cami shirt and blue denim shorts, so Priscilla dressed Talisha up a bit to fit the part. The other girl who was much taller, with stunning legs, had a more abstract look. She too decided to wear knee-high boots, shorts and a cami, but she accented her outfit with a foot-length sheer cover up and an oversize straw hat—the kind that Mary J. Blige sported at the time. The trio walked down, onto the main road, stopped at the local liquor store to get some party initiatives, and waited for about a minute or two before piles of willing drivers pulled over to offer the girls a ride.

Once the girls arrived at the nightclub, they saw scores of black men standing outside waiting to get in. The girls thought that they struck gold. As they walked by, they looked at each guy, sized them up and down, trying to guess how much they had in their pockets and how much they were willing to fork over.

Then a short, black man, roughly the height of a young boy at puberty, approached the girls. "Uh huh, and what are y'all supposed to be doing?" Priscilla was annoyed. "What? Who are you?" The conversation became heated.

"I am the person who decides whether you go or whether you stay."

Priscilla, the fiery person that she was, opened her mouth and said, "Listen, man, you need to get your little tail out the way somewhere."

The man stuck his arms out to block the girls from gaining entry. Priscilla became more outraged, almost to the point of being physical. She had been drinking Southern Comfort and was piped up to make some money.

She confronted the man, "What's your name?"

The man calmly replied, "Ace. Why?" Apparently, this wasn't his first encounter with Priscilla's type.

Priscilla said, "Well, Ace, go get your manager, so I can tell him that you will be the reason why this club will lose money tonight."

Ace grinned and replied, "You're looking at him."

Talisha smacked herself in the forehead. She thought she would never get the money to move out, and she didn't know how much longer she had left on her closet lease. Talisha decided to intervene. "Umm, excuse me sir, Ace, or whatever your name is. My friend didn't mean anything. She's from New York, and that's how we are at times."

Ace looked Talisha up and down, but not in a perverted, I want you in my bed right now kind of way. Rather, he was intrigued and a bit fascinated by her approach. He saw something in her that she rarely saw in herself.

He asked in a flirtatious way, "And who are you?"

Talisha was about to tell Ace her real name, or rather the name she used in place of her real name, which was symbolic of her dissociation syndrome, but thankfully the girls had rehearsed stage names to go along with their dance moves.

Talisha coquettishly answered, "Cover Girl."

"I like that. Cover Girl." He then pointed to Priscilla, "You not so much." Ace removed his physical barrier, which would not have taken more than slightest push, and said, "Lucky I like your girl because y'all two wasn't getting in."

The girls rushed past Ace. Priscilla rolled her eyes, and said, "Whatever, shorty." Talisha giggled. The girls had to climb a flight of stairs to reach what they thought would be their money-making stage for the night. To their surprise, it was anything but that. The upstairs was nothing more than a vacant room, with strobes lights and enormous speakers at each corner of the wall. Talisha was puzzled. The nightclub was vastly different from the gentleman's club she had ventured into the night before. Priscilla and the other girl, however, cared less. The pair would have danced in the back of a dark alley, next to a dumpster, to claim their winnings.

Approximately one hour after the crew's arrival, the music turned on, followed by droves of men flocking to get a good seat. Ace had placed folding chairs in a circle for a make-shift stage and the crowd lined up. Girls crowded the floor like bees to honey. Priscilla and the other girl were naturals. They found available space in front of their willing patrons and began to dance the way they had practiced hours ago. Talisha couldn't help but to giggle watching the girls strut their stuff. She felt more like a bystander than a would-be performer. That is, until one of her favorite songs played. The deejay catered to his audience. He was skilled at getting people to move, and for Talisha, she found herself moving more than she liked.

The alcohol had had its effect on Talisha, going straight to her head and loosening up her limbs. The girls were winded from all the dancing and gyrating, and they were ready to go. Talisha looked inside the tassel bag she carried around that night and found a bag of fake money.

She shrieked, "What the hell!" Priscilla had a half-twisted face at that time and rushed to Talisha's side. She sputtered, "Ma, what is it?"

Talisha opened her money bag and showed Priscilla the fake money. Priscilla immediately came out of her stupor. "Yo! What the fuck!" The girls were outraged. Priscilla picked up an empty beer bottle and threw it across the room.

Ace and two football size men that were moonlighting that night headed towards Priscilla. Ace yelled, "Are you crazy?" Priscilla stretched out her arms like a scarecrow and began to dance, then facetiously joked, and in an Eartha's Kitt voice said "Dahling, yes, I am." Then she purred.

Talisha rushed over just as the bouncers were throwing Priscilla out. "Wait! You don't understand. They gave us fake money!" Priscilla tried to fight back, but she was outmatched. She and her friend found themselves outside the club, getting dressed in front of anyone that drove past. Meanwhile, Talisha was upstairs making her case.

Ace said, "You know, you have some crazy friends." Talisha disagreed. She felt like the alcohol brought out the worst in Priscilla, and Priscilla's friend, who was as loyal to Priscilla as Loketa was to Talisha, felt compelled to remain at her side during her five second tirade.

Talisha defended the girls. "They're not like that. They just had too much to drink."

"What about you?" Ace probed Talisha to find out more about her. He could tell Talisha was out of her league and didn't belong in the club. He wondered why Talisha wasn't in school or home somewhere, studying herself in the mirror.

Talisha felt tipsy, but given her response, it was safe to say she had passed the line of being just buzzed. "What do you mean? I am not drunk."

Ace laughed. "No, silly girl. I mean do you act like that? I can't have no crazy baby mama."

Talisha smiled. "Oh, so I am your baby mama now. Well, where's the baby?" After the small talk, Talisha asked about the money. Ace told Talisha that was his way of doings things. Essentially it was his club and his rules. He told her that the way it worked was that at the end of the night, the girls cashed in their fake money, and in exchange they would receive the correct amount of cash.

Even in Talisha's drunkenness, she reasoned that Ace's way of doing things was unequivocally doltish. With a slip of the tongue, Talisha said, "That's so stupid." She then asked, "Why would you give fake money to the men, only to have us hanging around at the end of the night, waiting to cash-out?"

Talisha couldn't see past Ace's intentions, just like she couldn't see past the intentions of others in her life, who most times had hidden agendas. Ace was ambitious, but he wasn't totally honest. He would stiff girls that became too drunk, sometimes skimp on the money that was owed during the exchange, or just simply give out what he thought was fair. It was a cat and mouse game, and in the long run the girls were the cheese.

Thanks to Talisha, Ace ended up giving the girls their fare share of money owed. Otherwise, they would have ended up with money that looked like Aunt May's old food stamps. Priscilla and her friend had been busy sobering up with a greasy cheese steak that they bought from the only occupied store on the block. Talisha was ready to go. She flagged down a cab, the girls went back to their room, and Talisha went back to the closet.

Talisha and Priscilla would dance at the club over the course of the next few days. Priscilla's friend decided she would wait things out and Priscilla, of course, had to apologize, and limit her B.Y.O.B. On a given night, Talisha had made anywhere from seventy-five dollars or so, to a little over one hundred bucks, and from her savings, she had enough money to find a place.

But her plan was and had always been short-sighted. Talisha promised herself that she would only participate in her after hours affairs temporarily, and that after she made enough money for a down payment, she would find another job.

That turned out not to be the case. One evening, a different girl showed up at the club. She went by "Mercedes." She had been checking Talisha out from afar. Talisha never stayed in the club until

the lights came on. Talisha would shake enough tail feathers until she made a quota of seventy-five dollars or more, then she would leave. But on that night, and before she left, she would be introduced into a different world of entertainment.

"Hey, wait!" Talisha turned her head to see who had been talking. "Yeah, you. Come here real quick." Talisha went over. She wasn't sure what the girl wanted, so she had her guard up. Colossal's was the type of club that, at any moment, things could go downhill fast.

"Look, right. I don't know you personally, but I had to ask why a girl like you would be in a dump like this." Talisha wasn't as sharp with her rebuttals as she'd would have liked to have been. Ninety-nine percent of the time, she was almost always caught off guard, and then after things were said and done, she would think of things she should have said or done at that time. Case in point, Mercedes was in the same dump as Talisha, and had Talisha realized the paradox inherent in Mercedes' question, she would have been able to walk away unscathed, but Talisha continued to listen to what the girl had to say.

"You're too pretty to be in here. Plus, it's no money in here. I just came down here to see what's going on." Mercedes continued with her sales pitch. "You should come to the Eldorado's Club. That's where the real money is, and girl, let me tell you, the ballers are in there, not in here."

Talisha wanted to hear more of what Mercedes had to say, so Mercedes gave her a quick rundown, and then handed over her number. She convincingly told Talisha that she could easily triple the amount of money she made at Colossal's on any given night. When Talisha heard that, her eyes lit up, and at that point, Mercedes knew that she had reeled Talisha in. Although Talisha had no intention of making a career out of being an adult dancer, Mercedes had painted a picture for Talisha, and she just had to go and see for herself.

The following night, Talisha decided to take Mercedes up on her offer. She took a cab to the club and, surprisingly enough, the

Eldorado's was situated a few blocks away from the Ritz. From the outside, the club appeared to be small, and didn't seem too upscale to her, but she nonetheless went inside.

She was met by a bouncer; but not like the out-of-shape bouncer at the Ritz, or the overly aggressive bouncers at Colossal's. The front door bouncer was dressed as a distinguished gentleman. He had on a full black suit, with a white button-down shirt, classic collar, and red bow tie. The man was also polite. "Hello, Miss. ID please." Talisha's interest was piqued. She thought Mercedes had been right and wanted to know more.

Talisha pretended to search for an identification card, but she had none. She kept looking up at the bouncer, saying, "I just don't know what I did with it. I hope I didn't leave it at the Ritz last night."

A line had formed, and Talisha was holding things up. "Come on, come on, but you better have it with you the next time." Talisha closed her bag, dashed by the bouncer and said, "Okay, no problem." The club wasn't like the Ritz with all the flashy lights and all. It had more red lighting throughout except for the stage. The lights were situated in such a way as to force the gentlemen in attendance to focus on the girl on stage. Near the entry to the club sat the deejay booth. To the left was a long bar, and to the right were situated two-seater booths. Towards the back of the club was another stage. The owner would open the back part up when the club became crowded. Then there were two separate rooms off to the side. The offset rooms were champagne rooms, and they were designated for VIP clients only.

The girls also fit the part. They weren't half-naked like the girls at the Ritz or Colossal's. All the girls were dressed in some sort of cabaret style, evening gown or showy costume. Talisha was impressed. The girls also had a different mannerism about them. She thought about how the girls at Colossal's behaved when they didn't get tipped what they expected to receive.

The bartender was busy wiping down the bar after the girls crawled their way across the patron's drinks. The owner had things set up such that after each girl finished a set—which meant that the girls had to dance at least two songs on stage before they could go around the bar to each client—they could then circulate and collect whatever tips were given.

Talisha was fascinated by the girls in their fancy costumes, and with all the glitz and glam. She felt like she was in the right place, and wanted to become an Eldorado's dancer. Before she could earn the title of being called an Eldorado's dancer, however, Talisha had to interview with the owner.

Talisha ended up working that night. She had interviewed on a soft Tuesday and the owner wanted to get a feel for how Talisha would fit in, without the distractions. Talisha picked out an all-white costume with bustle feathers. She felt like a Vegas showgirl. The owner laid down the rules, explaining the code that the club had to follow, which pretty much boiled down to two rules. All girls had to cover their nipples with petal pasties if they chose to go topless, and there was absolutely no flashing of their pearls. Violators would be subject to fines that needed to be paid that night, or else they couldn't return until they settled their debt.

At the end of the night, Talisha couldn't believe her eyes. She had made over four hundred dollars, which to Talisha was an entire month's pay at most of the jobs she had worked at so far in life. She was over the top thrilled, as now she had more than enough money to finally move out on her own.

CHAPTER TWELVE

Grace

————————

WITH A LITTLE over a thousand dollars, Talisha was able to locate a modest apartment in Baltimore City; she had found the place in the Sunday paper's classified section. The property's owner only wanted four hundred dollars a month, and Talisha thought she had hit the jackpot! She reasoned that she could afford the expense, especially since she had secured a position at the local club. Talisha would venture out for a quick tour with money in hand, as she wanted to show the property owner that she had the means to pay three month's rent.

The building's owner had divided the place up into three apartments, and the only available apartment was the third floor. The building was nothing short of an eyesore and once inside, Talisha's skin began to crawl. The property owner had turned the attic into an apartment. The place was unkempt and reeked of tobacco smoke. Talisha thought the place was a bit shabby; in an eerie way, it reminded her of Ms. Sumby's house and how she would perch up at the attic's window, chain smoking for days on end. She smiled inwardly when she thought about Ms. Sumby and Diane. She thought if they were there to see her hand over the money for the run down, yet somewhat modest place, they would have been proud.

Talisha was ready to hand over her short winnings, but then she questioned if she should try to look for another place. The attic turned

apartment was not up to par and would need Talisha's special touch if she decided to stay. She looked around in the kitchen and saw how the pipes were on the outside of the wall. She looked down at the brown carpet and noticed it was old and soiled. Talisha felt like she deserved better, but she was fearful that if she declined the offer, she might not have had another chance of having a place of her own. After her thirty second tour, Talisha looked at the property owner and said, "I'll take it." Talisha handed over eight hundred dollars for the security deposit and for one month's rent. Once the property owner—who became her landlord in under a minute—gave Talisha the receipt, she ushered him out the door so she could celebrate.

"Yes! Yes! Yes!" Talisha jumped up and down on the floor and rolled around. "Ugh!" Just that fast, she had forgotten about the conditions of the place. Talisha had a couple of hundred dollars left for necessary cleaning supplies and for food. She ventured to the nearest dollar store and splurged on everything her eye could see and that her money could buy. Talisha wanted to clean the place and make it as comfortable as possible. She had plans on inviting Priscilla over for drinks.

It took Talisha all morning and half the afternoon to scrub down her apartment space. She thought a few splashes of paint would have also brought the place up to her liking, but that task would have to wait for another day. Talisha was exhausted. She had worked at the club the night before and had plans on working that night, but she was tired. She nonetheless would go to the club later that night, and almost every night thereafter. Talisha had no furniture, not even so much as a chair. She slept on a pile of clothes until she was given an old mattress. To Talisha, sleeping on a pile of clothes or on an old mattress was a much better deal than sleeping on soiled carpet or settling for closet space.

Talisha slowly but surely pieced together item after item, mostly used, in an effort to furnish and outfit her apartment. It took her a

couple of months to buy a bed at the Salvation army, a television from Kmart, and a few other items that she felt were needed and beneficial at the time.

Priscilla had reluctantly moved in. To be frank, she hated the place. Most nights she slept with a hoodie pulled up and over her head and face to ward off pests that so rudely ran across the bed in the middle of the night. Talisha had slowed up with going to the club. She and her crush from the computer class that she and Loketa attended had become romantically involved. Priscilla was in and out. She didn't want to be the third wheel. Besides, Priscilla had made new friends during her late-night adventures.

Talisha had forgiven Keisha yet again. She loved Keisha beyond merit and thought the day would come when Keisha would reciprocate. Although Venus wasn't in the same category as Keisha—not by a long shot—Talisha ultimately forgave Venus as well.

Talisha lived ten blocks from Keisha and Venus, so naturally she had started back spending time with them again. Just like before, Keisha would invite drinks and food into the mix to spice things up, but at Talisha's expense. Most times, Talisha would treat Keisha and Venus to whatever they wanted. Talisha's generosity, although perplexing, was Talisha's paradoxical way of snubbing the pair; in her own dysfunctional way of thinking, she felt that her big deeds made them appear smaller. Talisha was still hurt by Keisha's selfish and downright mean act. She just didn't want to admit it.

One evening Talisha didn't feel like going to the club. Instead, she walked over to Keisha's and Venus's place. As always, Keisha greeted Talisha with the same lingo. "Hey, shorty-doo-wop."

"Hey."

Although it didn't seem like the two were sisters at times, Keisha had an unbelievable intuition. She sensed something was wrong with Talisha.

"Well, damn. That's all I get is hey?"

Talisha was irritated and she didn't know why. "Yeah! Now leave me alone."

Keisha replied, "Well, alrighty now." Keisha thought Talisha might have been hung over or just needed her daily fix of Long Island Iced Tea, so she pulled out a five-dollar bill from her pocket and handed it to Talisha. "Here, go get you some of that tea to get your mind right."

Talisha felt sick to her stomach just thinking about the smell and taste of her usually favorite alcoholic beverage. "I don't want any."

Keisha's eyes almost popped out of their sockets. Folks that new Talisha at that time knew that she would have never turned down a bottle of Long Island Iced Tea, especially one that was free. Keisha said plainly, "You're pregnant. That's it. You done it now."

Talisha had tuned Keisha out and dismissed what she had said. In the back of her mind, she would travel to a conversation she and her gynecologist would have during routine checkups. Talisha's gynecologist would ramble on about how her cervix was tilted and how unlikely it would be for her to conceive. She would confidently respond, "Keisha, shut up. Dr. Mohammad told me I can't get pregnant." Talisha's statement was emphatically inaccurate, and nothing could have been further from the truth. She was what the old folks referred to as "a person hear what they want to hear." It took Talisha a considerable amount of effort for her to focus on what was said, and instead of working on her comprehension, Talisha would extract a few buzz words out of what was said and make her own meaning out of the statement. Talisha's entanglement of words, coupled with her perception of what people thought about her, explained why she would later in life become a recluse. It all became just too much to try to figure out what people were really saying, and it got easier and easier to exclude them, until Talisha was finally all by herself.

The following month, Talisha found out she was pregnant. She wasn't sure if Keisha was a fertility god or a voodoo priest, because

Talisha was positive her doctor said she couldn't get pregnant. Talisha had stopped working at the club. She found another retail job at Mondawmin Mall. There were times when she regretted not saving her money, as she had to stand on her feet daily. The guy she dated at the time didn't want Talisha's unborn child. He asked her to terminate her pregnancy.

Talisha strongly believed it was impossible for her to have conceived, and when she did, she believed her unborn child was a gift to her from God. Talisha refused to have the abortion. Talisha's relationship soon ended. Priscilla had also stopped coming by. Talisha had changed. She went from sleeping all day to ravaging the refrigerator, and when she wasn't doing either, Talisha was hugging the toilet bowl.

The last month of her pregnancy, Matthew moved in to help Talisha out. He would laugh hysterically when he watched Talisha pick her food choices. One of her favorite pregnancy cravings was a mixing size bowl of Kix cereal. Talisha would put a half tray of ice cubes in the cereal, and sprinkle Gerber rice cereal over the top, then chomp down on it each time as if she never had it before.

During one of Talisha's famous mixing size bowl episodes, her water broke. Instead of taking Talisha to the emergency room, Matthew drove her to Terry's. Terry was in disbelief. She gave Matthew a sincere look of concern and said, "You know you're special, right?" Terry would ultimately tell Matthew to call Talisha's doctor and head to the hospital. Matthew drove like a mad man, plowing through red lights while honking his horn. Based on Matthew's driving, Talisha figured she would end up at the hospital one way or another. Keisha and Venus were already at the hospital waiting for Talisha's arrival. She would tell them that Matthew's detour caused the delay.

Then Talisha was met with a pleasant aroma from McDonald's crispy golden fries. She watched how Keisha prepped her meal. Keisha was roughly one hundred pounds soaking wet, but her appetite was fitting for an entire football team.

Talisha said, "Mmm, give me one." What Talisha meant was she wanted the entire meal, and she wanted it right then and there. Talisha thought about how she didn't have the chance to devour her mixing size bowl of Kix, and the pleasant aroma from Keisha's meal was making her stomach growl.

Talisha's assigned nurse walked in right at the moment that Talisha was fixing to take Keisha's meal. "Nope. You can't have it."

Talisha growled like a famished dog going after its prey. "What do you mean I can't have it?"

The nurse must have been the leader of the pack, because she growled back, "Just like I said, you can't have it!"

Talisha twisted her face up at the nurse and looked at her family with one of those, "you better get her" looks. The nurse was quite snobbish and wasn't in the mood for Talisha or any of her shenanigans. She quickly performed her duties and left the room until she was needed again.

Talisha remained in active labor for about a strong seven hours. She gave birth to a precious six-pound, four-ounce baby boy. Talisha loved her doctor so much for the support he had given her during her pregnancy, she thought that her infant son looked like him. Talisha impulsively said, "Oh my God, Dr. Mohammad, he looks just like you." Talisha's comment, said in complete innocence, nonetheless raised all the eyebrows in the delivery room except for hers. She had grown accustomed to saying what was on her heart, instead of speaking from a politically correct point of view. Dr. Mohammad turned his head quickly around to face the giggling room and blurted out, "Girl, don't you say nothing like that." There was so much laughter and joy in that room that night. Talisha had birthed multiple lives, but her son's life was the one that touched her heart the most.

After a while, Matthew had to return to base, so he picked up Diane to help Talisha with her new bundle of joy. Diane had finally stabilized after years of medication and mental health therapy.

Talisha was pleased to have her mother at her apartment. Diane had cooked all the meals and helped with her grandson, allowing Talisha to recover from her baby boy's nine month residency. She didn't feel the same way about things, though, as she did when she was a child. Talisha's desire to be a child again with her family, at that awful time of abandonment and separation, was replaced with concern for her own child. Talisha had left her workplace months before. She had no maternity coverage to carry her over the next few months, and the little she received from social services wasn't enough to pay for her monthly living expenses. Talisha decided it was time to go back to the club.

Diane stayed for a month with Talisha. She had no idea where her daughter would venture to until wee hours of the morning, and Talisha offered no stories. When Diane asked where Talisha would go, Talisha would brush her off or fabricate some believable tale. Working as an exotic dancer wasn't Talisha's childhood dream. She was fascinated with astronomy. She used to think she would have become an astronaut had the family stayed intact. Talisha also had a burning passion for teaching. She remembered how she used to sit at Diane's side, pretending to teach an invisible class. Unbeknownst to Talisha, her childhood ambitions were mirror images of how she felt at that young age. But back on earth, Talisha wasn't close to being an astronaut and she wasn't proficient enough in any area to teach. Talisha settled for starry nights from the club's moonlit ceiling.

Talisha spent the next year switching off between caring for her newborn son and working at the club. She had moved out of her one bedroom shack to a two bedroom apartment in a much more suitable area. To Talisha, working at the club overnight was great for a single mother, and she rationalized that she was doing the right thing, both for her and her child. She cared for her son during the day and through the afternoons, then worked at the club for a few hours at a time. It was the perfect schedule for Talisha.

One evening, at the club, Talisha was in a salacious mood. The movie, "The Player's Club," had just premiered, and Talisha had just purchased a fuchsia pink costume. That night, she felt like the actress Diamond from that film.

A different crowd had came through that night as well to match the uniqueness in Talisha's mood. When crowds began pouring in, the girls' eyes always zeroed in on the front door, searching for their regular clients and potential prospects. Talisha as well followed this pattern of scouting, but that night an unlikely client walked through the door and, to Talisha's surprise, it was the guy that worked in one of the stores at Mondawmin mall. Talisha had seen him throughout the years, and had always thought he was fine, but dared not approach him because they were from two different worlds. In addition to being intimidated by their perceived class differences, this fellow was also the store owner's son...and he was white. Talisha had never dated outside her race before. Back then, it was cultural suicide to do so.

Talisha was on stage and was just about to finish her last dance, go around, and collect her tips. As she suspected, the onlooker had also been eyeing her. He gave her a fifty-dollar tip to show his interest. Talisha's usual clients were at the bar that night and each one had been waiting for her to take a seat next to them, but Talisha was more interested in the new catch. She approached him. "Hey, don't I know you." The guy was with two of his friends—two black men, and they had been throwing back shots as soon as they reached the bar.

The newcomer gave Talisha the once over, and then haughtily replied, "That's what they tell me." He pointed to an empty bar stool next to him that he had been saving for Talisha. "Come, sit down, I want to know more about you." Talisha sat down with who she thought was going to be her next client. He had bought her two $150 bottles of champagne to make sure he soaked up the next two hours with her. The guy invited Talisha to have a round of shots with him as well. Talisha enjoyed all the attention she was getting from the other

girls and from her waiting clients, but she knew just how far to push things. The owner was adamant about the girls drinking too much alcohol. He had taught the girls the art of hustling and believed that both a girl's and the club's value would diminish if she turned into a sloppy drunk or an addict. The irony of things was hard to escape.

Talisha, as in almost all situations, had to have things her way. At that moment, the club owner had become Aunt May, and Talisha's new admirer had transformed into Michael and her friends. Talisha had been denied the things she wanted in life too many times, so she made a poor decision and went against the club's code.

"Sure, I'll have a few rounds." Talisha proceeded to chug champagne and Cognac. It wasn't a good blend of beverages, and it didn't take Talisha long before she felt the effects. Her new admirer could also see that she had become messy. She spilled not just one but two shots onto the crotch of his pants. Talisha then spilled three shots onto the man's pants. The guy was easygoing about having Cognac-stained jeans, especially by the crotch, the thought of which titillated Talisha. The guy was equally smitten by Talisha's inebriated clumsiness, in addition to being inflamed with desire by her blazing costume, which highlighted her beautiful assets.

The two exchanged numbers that night. Talisha thought she would call her new favorite person later that week, just before the weekend began. However, once Talisha got home, she had so many missed calls and voicemails, which wasn't out of the ordinary for her. The difference was that the vast majority of these missed calls and voice messages were from the same guy whose pants had soaked up the drinks bought for and spilled by Talisha.

The guy never returned to the club. It was a one and done night for him. He had procured what he came for; Talisha. The two dated for nearly a month before he proposed to Talisha with a three karat, marquise cut diamond ring, and at his request, Talisha and her son moved in with her new fiancé.

Talisha never married her fiancé, but one year later she gave birth to another beautiful baby boy. The family spent a blissful five years together before Talisha's behaviors resurfaced. No matter what her fiancé did or bought for her, it just simply wasn't enough to fill the void in Talisha's needy psyche. She had operated as an empty yet functional vessel for decades now, and the cure she needed could never be found in a price tag. Talisha left her fiancé without notice, reason, or justification, taking her children with her, and never looked back. Her numbness to other people's needs and feelings had reached new depths.

Talisha left her relationship and lavish condo, and moved back to the city. Her family pretended that they couldn't see anything was seriously wrong with her behaviors, and Talisha was even blinder to these same ways of acting than those who knew her best. She left a promising relationship of five years and broke up her family and home, just so she could be free to do whatever she wanted once again.

Talisha's fiancé was devastated. Talisha had done to him what H.J. had done to Diane years ago, but Talisha's actions were not the result of some inherited condition. She had simply internalized those ways of responding and reacting to life situations very early on, just like a sponge soaks up water, so not only was Talisha programmed to behave the way she did, it became easier and easier over time for her to commit these same selfish acts over and over.

Talisha ended up working harder than she ever imagined. She worked at meaningless side jobs, here and there, and worked at the club, but only on certain nights. Even the club had become less important to Talisha.

In 2007, all the unresolved, internalized trauma that had built up in Talisha's mind and heart reached critical mass. Talisha was now habitually late on her rent, only paying it when she felt like it. Sadly, that had been Talisha's way of doing things all along. She had retired from the club and had been working as a car sales manager. The

money was lucrative, and at times Talisha scored bigger than she done at the club. But Talisha was wiped out. She was tired of being this self-made, independent woman, "I don't really need a man because I can be both," type of person. It was all a façade. Talisha finally realized that she had done things incorrectly and out of order. It was almost like Talisha's world had stopped spinning, and at the exact moment, someone set that same world of hers on fire.

Talisha was furious, both with herself and with her life. She began to feel like she was one of those people trapped in a coma for decades, only to suddenly wake up to a new reality. She imagined their first reaction, the emotions they must have experienced, and the confusion and frustration they would have to deal with knowing that they had lost out on years of their life. That had been Talisha. She had awakened from her self-induced coma, and the reality she awoke to shook her foundation. It was all too much, and Talisha thought about committing suicide. She even had intent and a plan; she laid in the dark one night, moderately intoxicated, debating if she should cut her wrists or overdose on whatever pills she had available.

The pain of her life and of her choices made ending it all seem so inviting, but then images of her mourning sons flashed across her mind, disrupting her morbid reverie. Talisha unquestionably loved and adored her sons. Anyone who knew her, even those who professed disinterest for her, understood that she loved her sons unconditionally. The last thing Talisha wanted for her sons was for them to feel the pain she felt as a child. She had already disrupted their two-parent home, but it would have been monstrously devastating and egotistically selfish for Talisha to take her life and leave her sons at the mercy of some stranger's home. Talisha began to pray, the same way she had prayed that night years before. *God,* she whispered silently, *I know You're here with me, but I need some big time help this time around. I can't do this alone. I can't do it at all. Please, God, help me.*

Talisha found strength in her search for God. She remembered the famous biblical scripture that teaches that faith without works is dead, so Talisha took the most important step in her life that day, and sought out mental health therapy.

Talisha also now knew that she couldn't return to her past, and in order to give her sons the best possible present and future, she would have to make permanent, sustainable changes.

EPILOGUE

TALISHA IS A survivor of complicated trauma. She went from being separated from her mother and siblings as a young child, to being abandoned, to later being placed in foster care, to be taken to a different state, with unfamiliar family and friends, and then subjected to further wrenching disillusionment and abuse.

Talisha is also a survivor of sexual assault and a victim of the self-inflicted, suppurating wound of losing her self-worth due to that violence.

She considers herself blessed and highly favored for getting through the myriad of obstacles and adversities she has faced in life. She owes a huge debt of gratitude to many people along the way who offered countless prayers, encouraging words, and who defended her character when she in fact failed to do so.

Talisha is especially grateful for having a mother who knew and taught her how to pray, and who instilled in her, at a very impressionable time in her life, unshakable seeds of faith. These seeds have grown, taken root, and turned out to be the hedge of protection that Talisha so desperately needed throughout her journey.

Talisha is not just a survivor of the kinds of unspeakable atrocities that no child or developing teen should ever have to endure. She has conquered her past, and now lives in way where she is far more at the cause of her experience, rather than at its mercy.

Talisha is now a Master-prepared Registered Nurse. She graduated with her bachelor's degree from Sojourner Douglass College in 2014, and then she further persevered, accomplishing her master's degree from Morgan State University in 2017, the same year of the university's sesquicentennial anniversary. Talisha also teaches at a local community

college, and is committed to doing her part to pass the torch of self-acceptance, self-reliance and godly aspiration to the generations that will follow.

❖

Dear Reader,

I know there are many people that also share some of the same experiences that I have endured throughout the years, and I also know these same people may feel like giving up. It's hard to find hope in a hopeless situation, and it's also difficult to be strong when one has been used, abused and taken for granted. To these amazing people, who are stronger than they can possibly know, I want to say: Don't give up. The end result is truly worth the effort. No matter how long it takes to fight and break down the walls of imprisonment, and irrespective of the hands that are keeping them from growing beyond their limits, one must push through, move forward, and remind oneself that we were each born into this life because God loves us, has faith in us, and knows that we can handle it. Stay strong.

Made in the USA
Middletown, DE
29 July 2022

70179797R00108